Images of America

of America

LOGAN COUNTY

ALEX. FINLEY

Made Diamonds in Louisville from Charcoal.

He Was One of the Pioneers In the Manufacture of the Stones.

"One of the pioneers in diamond making was my uncle, Alex. Finley, formerly a printer on the old Journal," said A. Finley, of 865 Seventh street, last night. "I was reminded of his experience by a story I saw in to-day's Courier-Journal. He is now a resident of Russeliville. He studied law while working at the 'case' and began its practice. He gave up the law work and devoted his whole time to scientific studies. He began making diamonds from charcoal as a result of his experiments. The operation was a dangerous one, as he blew up the house which he had built for his experiments. Out of the smoke and cinders and debris that resulted from the explosion came half a dozen diamonds, which experts pronounced perfect.

"My uncle was an eccentric man. He never wore an overcoat or underwear and never drank anything but water. Although he was never a member of any church, he was a regular attendant at Sunday-school. He never married. He is now an old man, past seventy, but he is able to read without glasses."—Courier-Journal.

Alex Finley (1830–1903) was Russellville's most eccentric citizen. A tailor, printer, lawyer, amateur scientist, and historian, he wrote the first history book on Logan. He had ideas on turning lead into gold and charcoal into diamonds, the latter of which he had more success with. He tried to obtain funding to have a giant cannon built that could shoot hollow projectiles (or rockets) to the moon. No one would back his project.

ON THE COVER: Logan Countians celebrated their first Tobacco Festival on November 25, 1941, with a parade down Main Street. Olmstead School created a float of Uncle Sam sitting on a throne guarded by a soldier and a sailor. Betty Trainer represented the queen for the school. The school won first prize, $25.

IMAGES
of America

LOGAN COUNTY

Mark Griffin

ARCADIA
PUBLISHING

Copyright © 2006 by Mark Griffin
ISBN 0-7385-4369-1

Published by Arcadia Publishing
Charleston SC, Chicago IL, Portsmouth NH, San Francisco CA

Printed in the United States of America

Library of Congress Catalog Card Number: 2006931758

For all general information contact Arcadia Publishing at:
Telephone 843-853-2070
Fax 843-853-0044
E-mail sales@arcadiapublishing.com
For customer service and orders:
Toll-Free 1-888-313-2665

Visit us on the Internet at www.arcadiapublishing.com

To the better half of the Power Couple.

CONTENTS

ACKNOWLEDGMENTS

This isn't meant to be a history book but instead a reminder of what makes this county unique—to show people what rich history and lore thrives here. As an obsessive photographer, I find that one of the great perks of working at the Logan County Public Library is seeing the wealth of photographs accumulated, which has been recognized by the state government. For this book, I selected the pictures that best represent Logan County. Tobacco, Red River Meeting House, Tom Rhea, Doc Beauchamp, and, of course, Jesse James are a must for this book. Other pictures were selected because they were such great pictures. I tried to credit all photographers, but most pictures were anonymous. This is not a definitive book on Logan County. A book double this size could have been easily done, but only so many pages were allowed and tough decisions had to be made.

Several people have helped to make this book possible: Monica Edwards, Evelyn Richardson, Speed Dukes, Jayne Thomas, Mute Boy of *Quake 'zine*, Robert and Marilyn Griffin, Logan County Public Library, Logan Arts Council, *News-Democrat & Leader* newspaper, Tom Noe, Nola Willeford, Judy Lyne, and Michael Morrow.

All of the author's proceeds from this book will go to the Leaders in Training (LIT) Program, the youth group at the Logan County Public Library (LCPL). The program was started in 2000 by Youth Services librarian Monica Edwards as a way to teach leadership skills in the youth. They assist in all of the library programs and volunteer their help with the staff on numerous occasions.

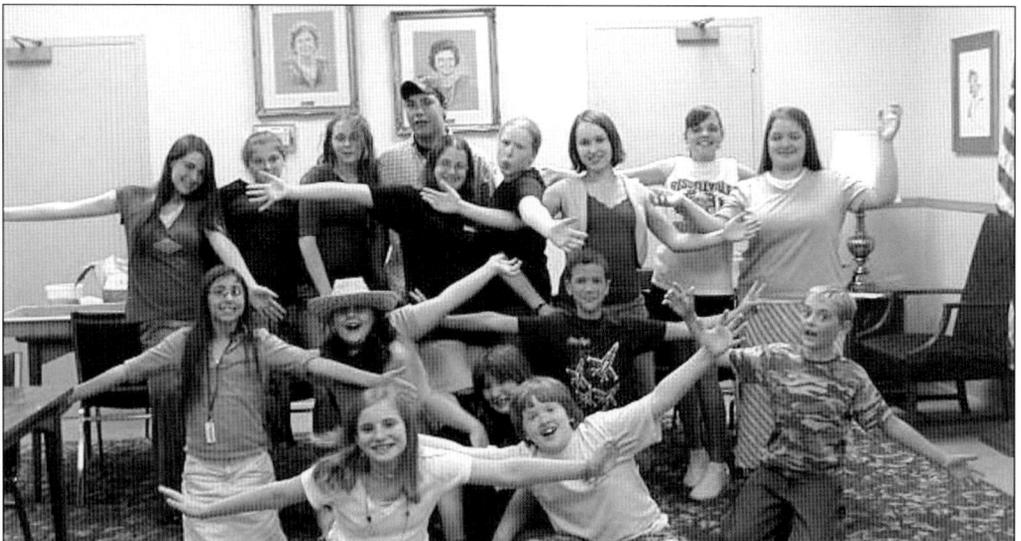

Pictured here are a few of the LITs. Above their heads are paintings by Meredith Stewart of LCPL's first library director, Lillian Noe (left), and former regional librarian and volunteer Evelyn Richardson.

INTRODUCTION

Logan County has been called many names. The Rogue's Harbor label was attributed by Peter Cartwright, a Methodist minister who lived here from 1793 to 1802 and who said in his autobiography, "Murderers, horse thieves, highway robbers and counterfeiters fled here until they combined and actually formed a majority." The Regulators formed, and many violent battles are told of them versus the rogues.

Eventually law and order prevailed, and Logan County became the site of the Second Great Awakening. Prof. Harry Harrison Kroll of University of Tennessee described the county seat of Logan, Russellville, as a Southern aristocracy.

"Russellville seems to have done a little better in preserving its pristine grandeur. The traveler with a taste for antiquity can leisurely trace its quaint streets and your hostess will point out this or that noble old pile where the flower and chivalry, properly dry-cleaned of tobacco tars and sweat, danced all night to waltzes, and gay blades drew their belles off into the district gloom of magnolias and recited, with slightly alcoholic breath, Byron, Keats, Shelley," Kroll wrote in *Riders in the Night*.

Logan County, named in honor of an early pioneer, Benjamin Logan, was once a large county when it was first created September 1, 1792, from Lincoln County. The county covered from the Little Barren River on the east to the Mississippi River on the west. Because of a state law saying the courthouse could be no more than a day's travel from any person's home, Logan has dwindled in size through the years until it is the spot in south central Kentucky on the Tennessee state line. Twenty-eight other counties were created as a result.

This county has its moments of pride and notoriety. Jesse James robbed his first bank here. Some experts on the outlaw may say differently, but I will cling stubbornly to that legend. Russellville has been mentioned a few times in a famous horror movie franchise.

We have been accused of unsavory behavior during the elections of the past. Logan did nothing that didn't happen in any other county, but we had some powerful enemies who wanted us to look bad.

We are known for having some of the best and most scenic farmland. Our cash crop once earned us the title of One Sucker Tobacco Capital of the World, though today we don't brag as we once did.

The name I call Logan is home. I was born and raised here. Its past holds such magical allure. When friends and family from other states and countries come to visit, I give them the grand tour of the county from the Russellville Square to Schley's Mill. All of it is beautiful.

Come on over and visit us.

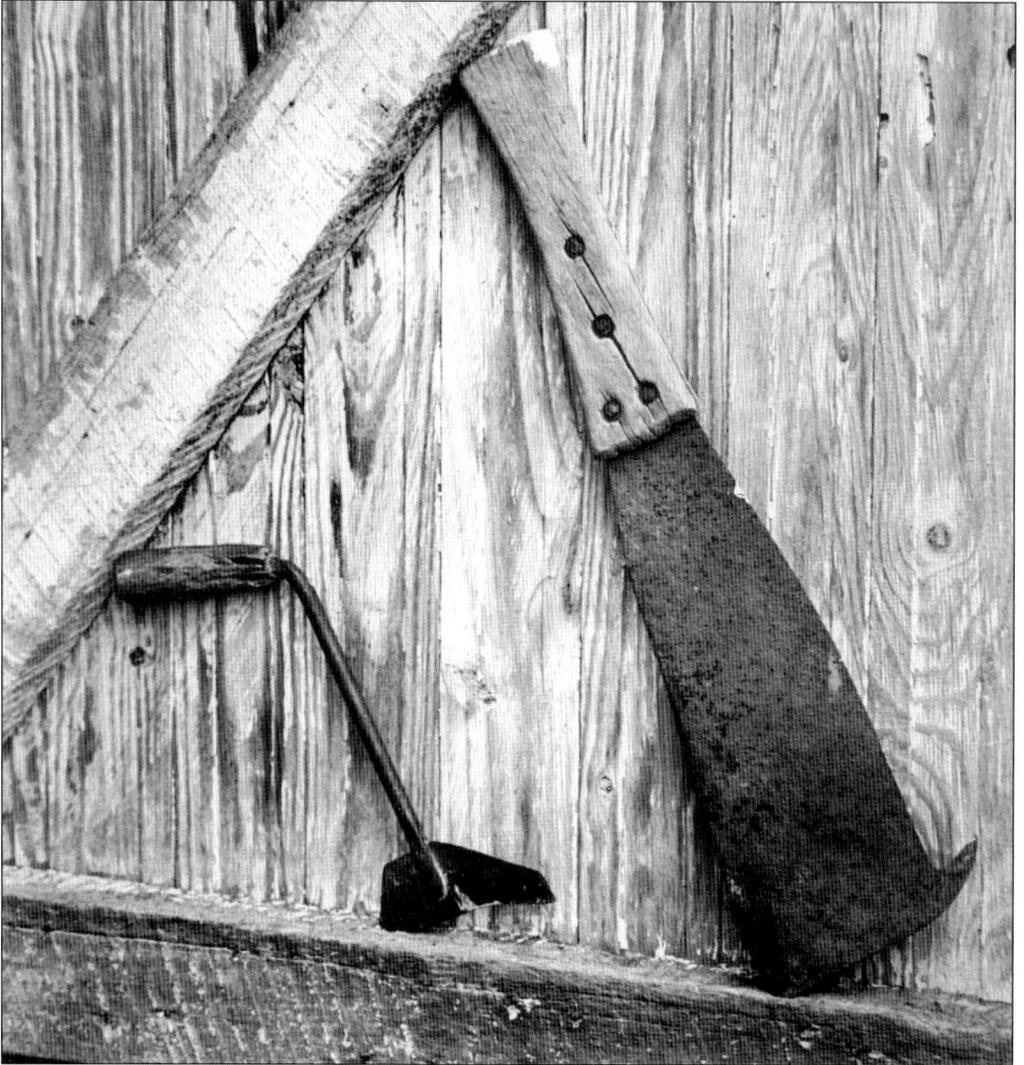

Tobacco is a labor-intensive crop. Tools such as the tobacco splitting knife (left) and burley knife are required during tobacco cutting.

One

TOBACCO AND FARMING

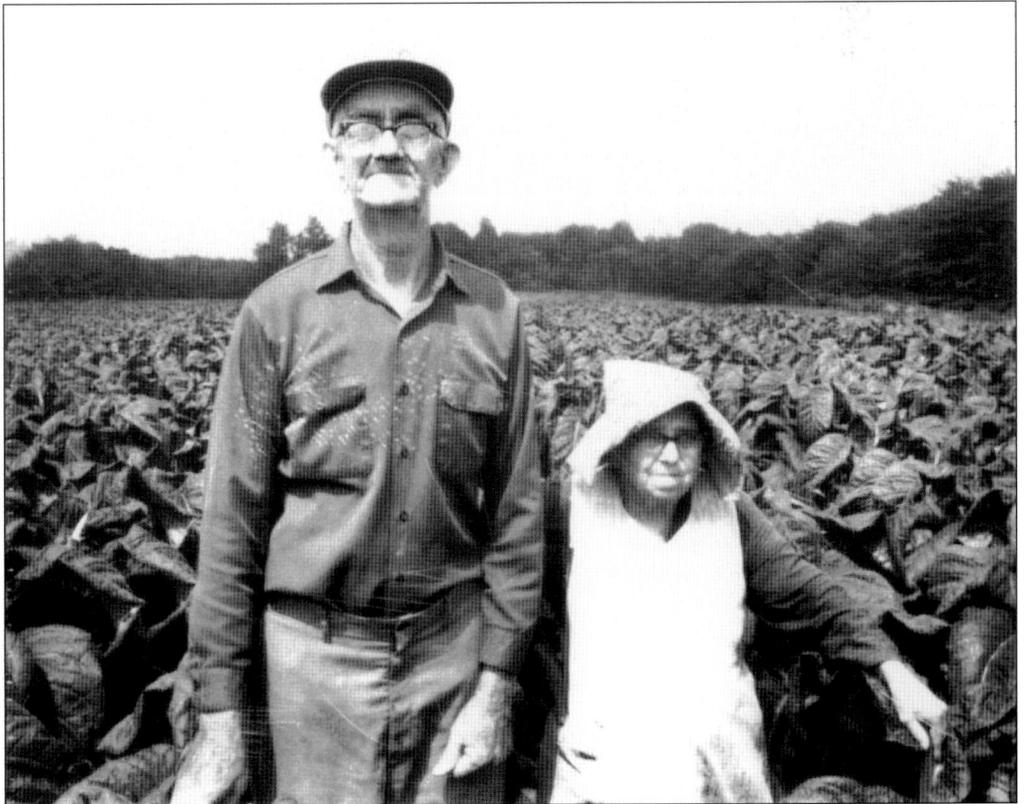

Tobacco is much maligned today, but once it was the most important crop grown in the United States. When settlers first came to the New World and discovered tobacco, the crop became the only commodity worth trading with other countries. The rich soil in Logan County made it one of the most ideal places to grow tobacco, and many farmers, such as Mr. and Mrs. Willie Adler, depended on it for survival.

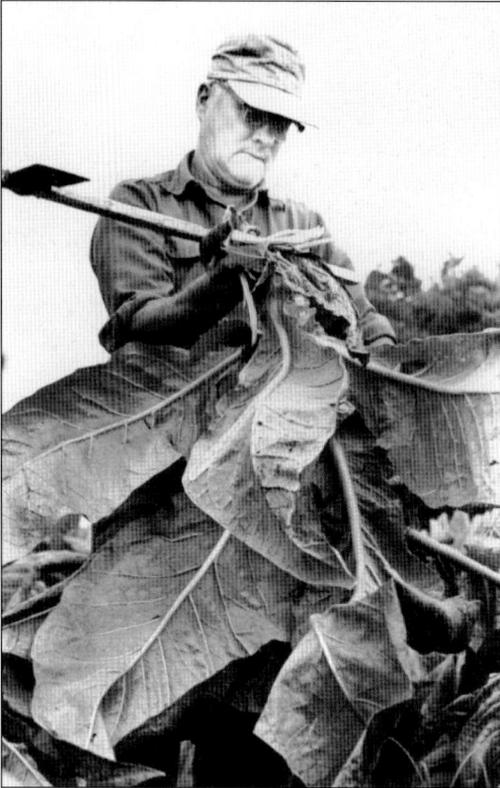

Traditionally tobacco season started in March with plant beds being sown. In May, the plants were transplanted to the field. Come August, the tobacco is ready to cut (as shown at left by M. Aaron Shoulders on a farm near Adairville). The crop is set out to dry on sticks (below) before being taken to the barn (top picture, opposite page).

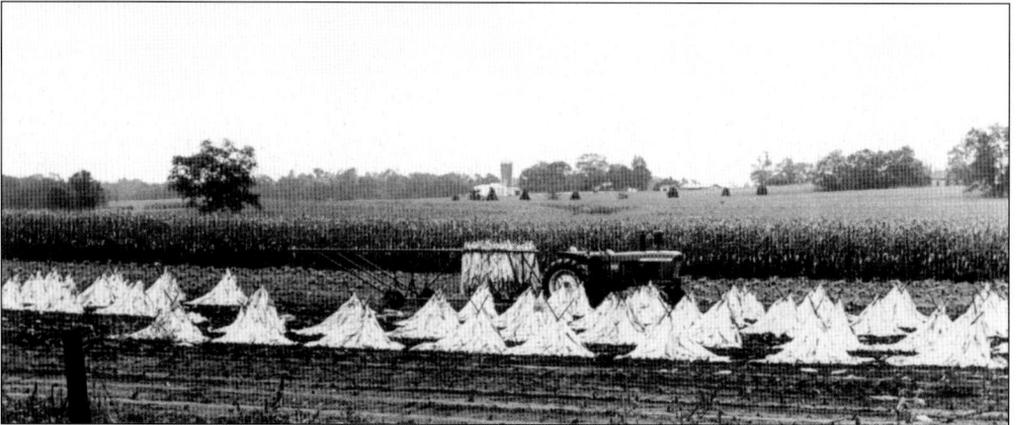

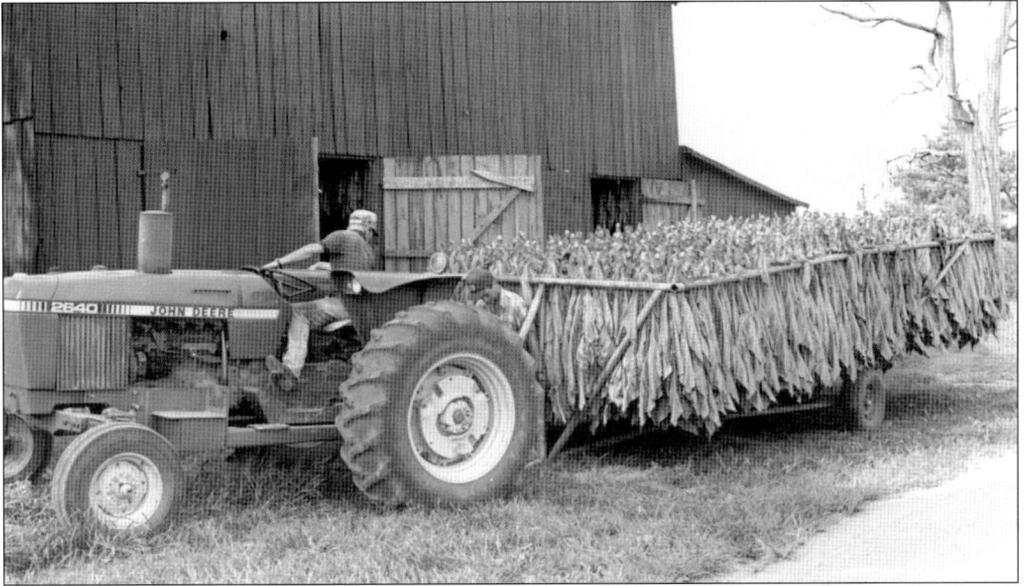

After being harvested, the tobacco would be cured in a barn for months. Three kinds of tobacco were grown: burley, one sucker, and dark fired. Dark fired, used for snuff, was smoked in barns (below) for flavoring. This tobacco was once so important to Logan and other counties that when prices became very low during the early 1900s, violent skirmishes called the Tobacco Wars resulted.

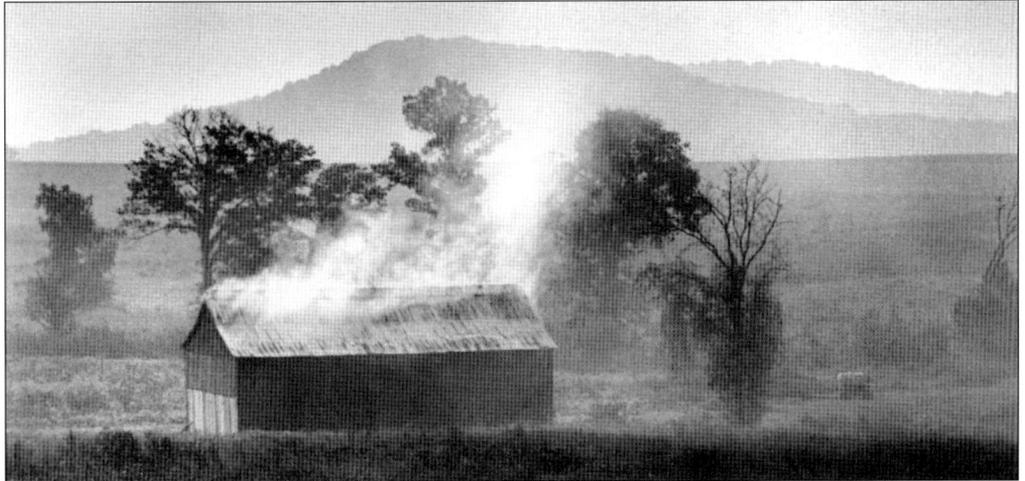

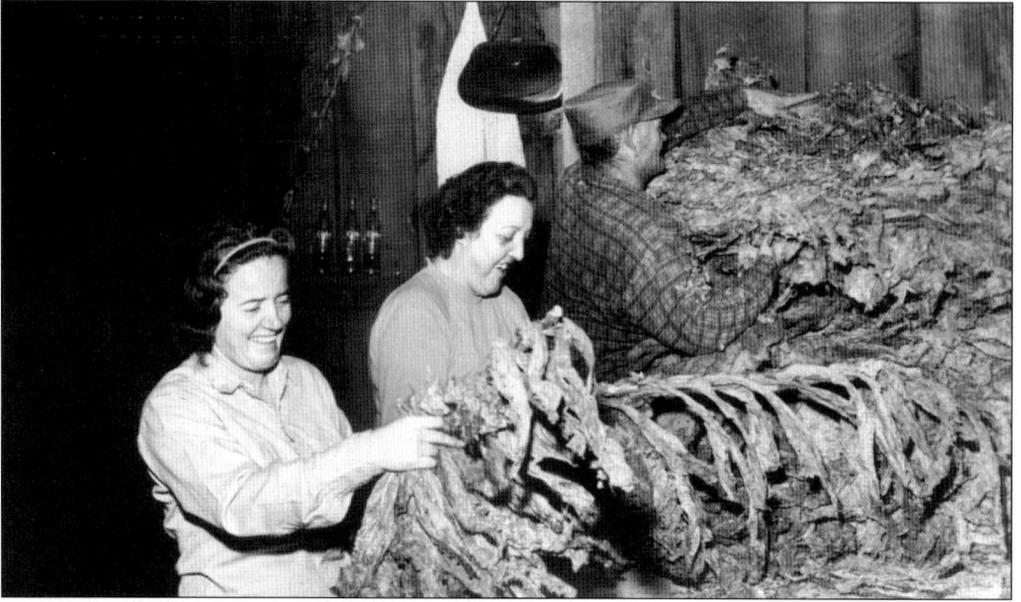

Once the tobacco was cured, it would be stripped from the stalks, as these unidentified people are doing above. The tobacco leaves originally would be tied together by another leaf. That practice later changed to where the leaves are simply baled (shown at left).

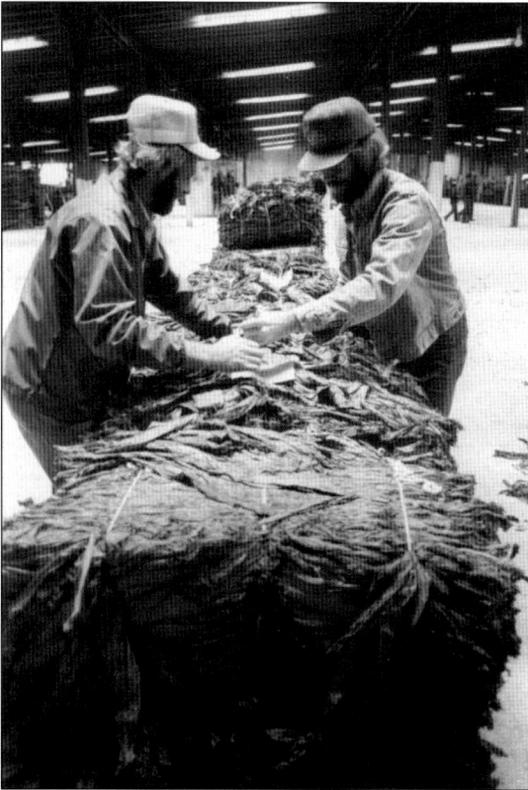

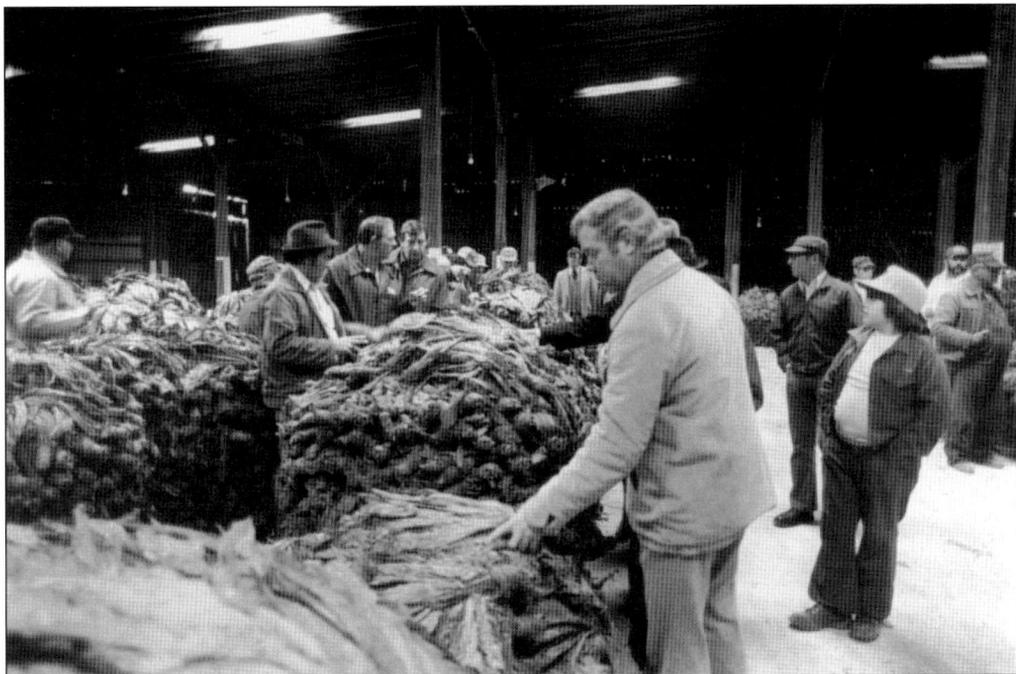

Farmers would take the tobacco to markets in November, where it would be sold through auctions. Buyers would examine and bid on the worthy tobacco. The warehouses where tobacco was sold have been closing through the years for two reasons. The first is that tobacco isn't grown as abundantly as it used to be, and second, farmers now enter into private contracts with tobacco companies.

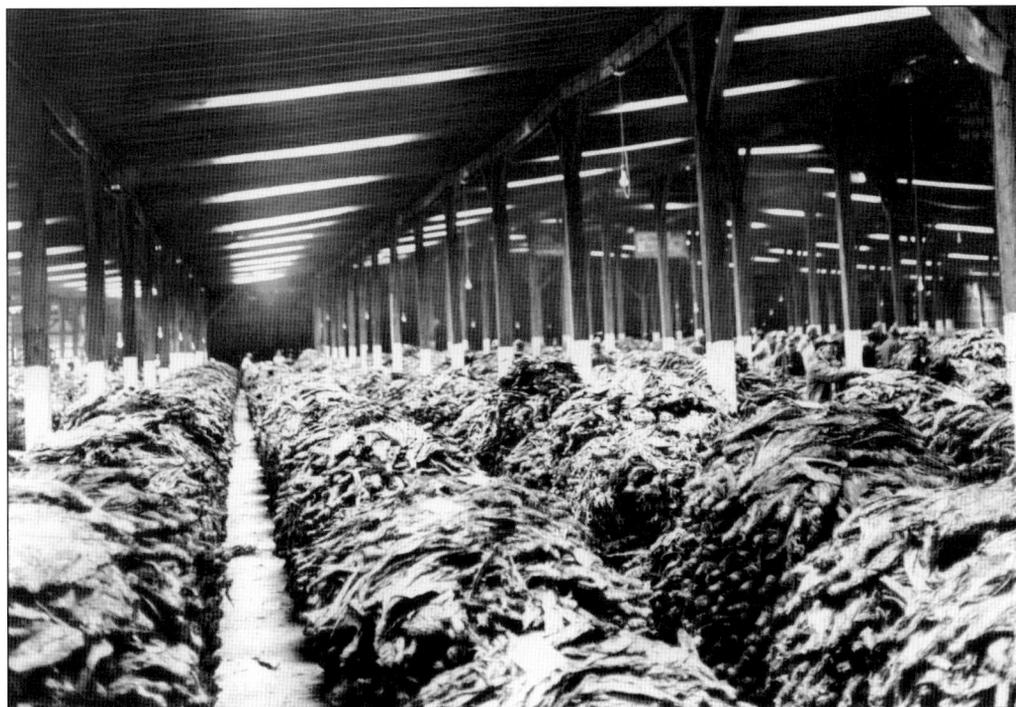

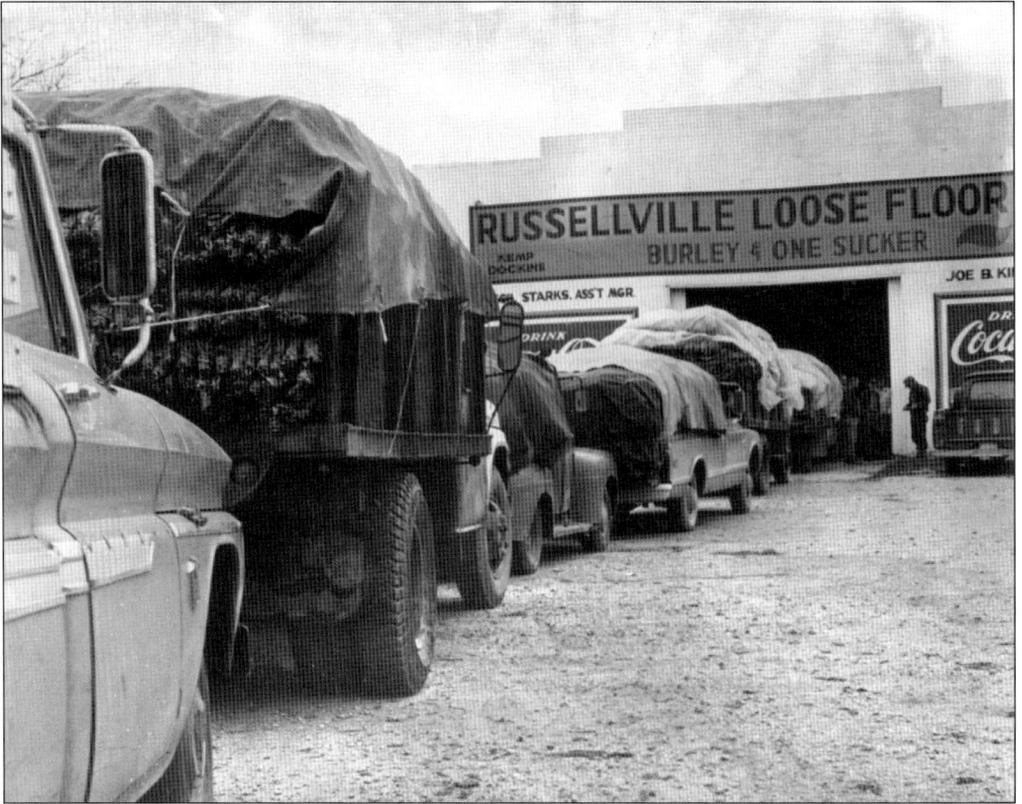

On auction days, trucks hauling tobacco lined up in front of warehouses, as these did in the 1970s. (Top photograph by J. J. Johnson.)

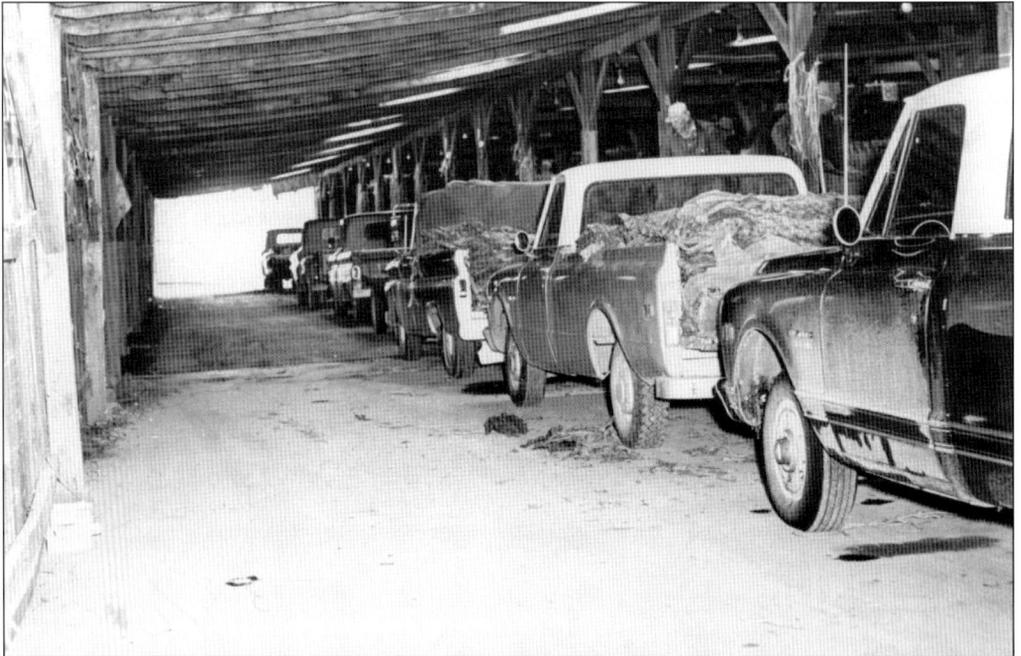

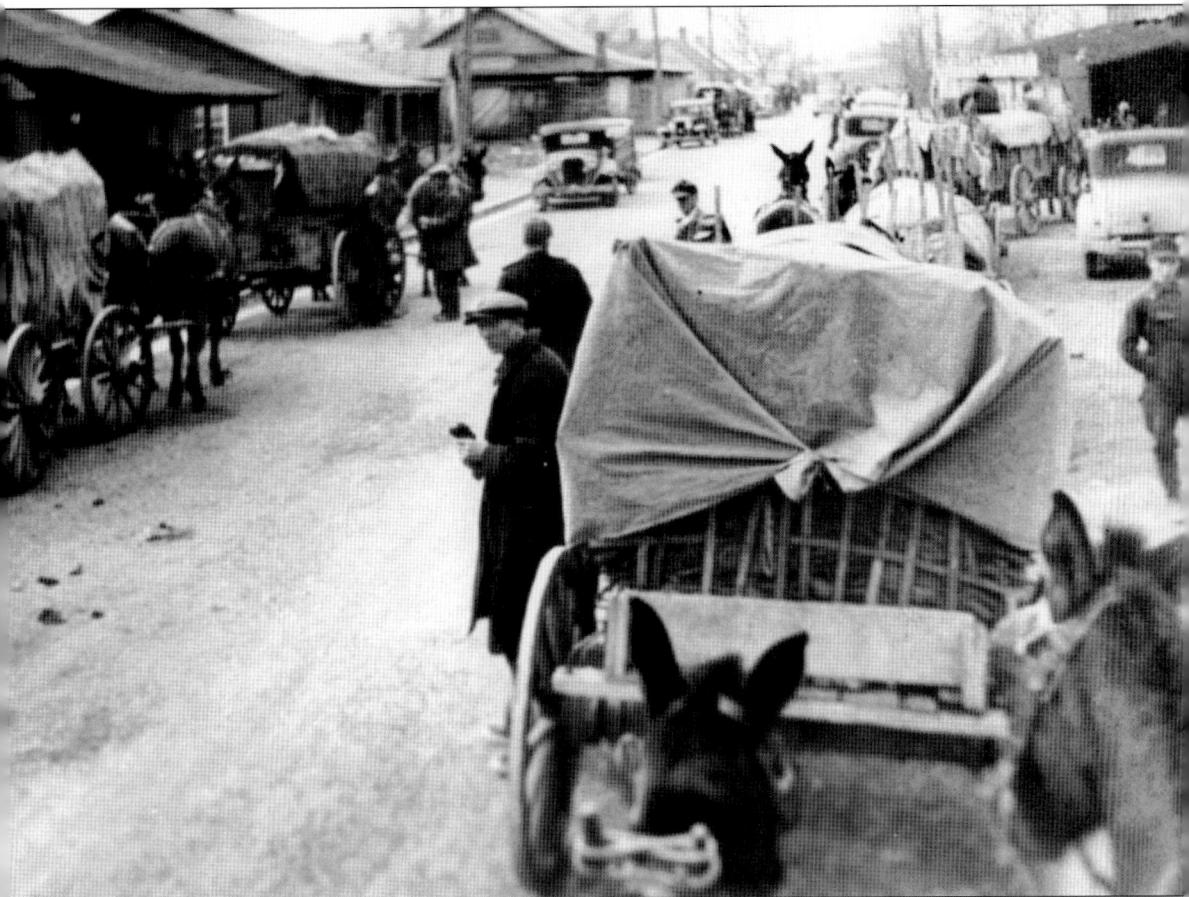

In the 1930s, tobacco was carried by a mule-drawn wagon on dirt roads to markets in Russellville as this scene on Third Street shows.

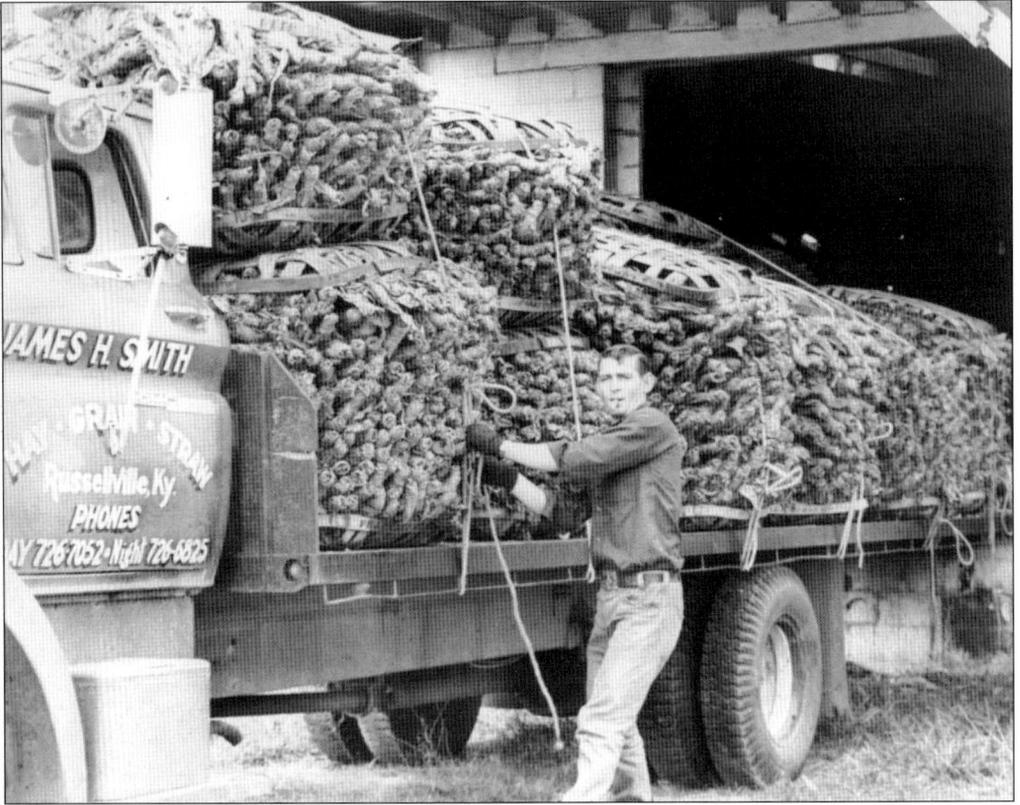

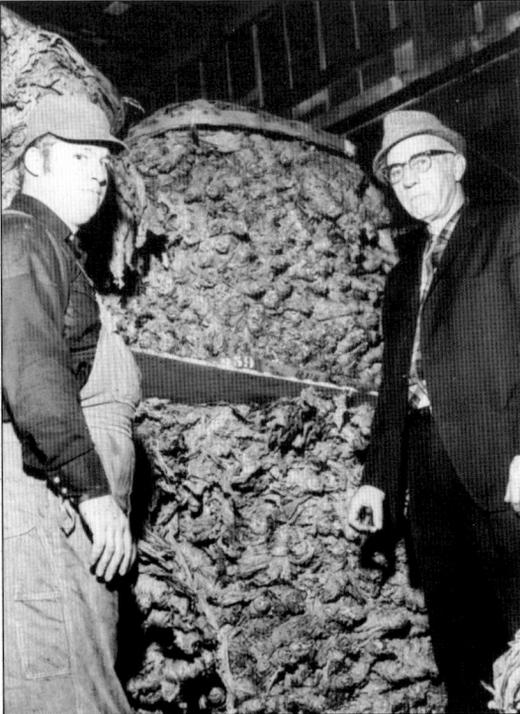

Once the auction has ended, tobacco is transported from the warehouse to the tobacco companies (shown above). J. W. Murrey (1914–1990, pictured at left wearing glasses) owned and managed both the New Burley and Farmers warehouses.

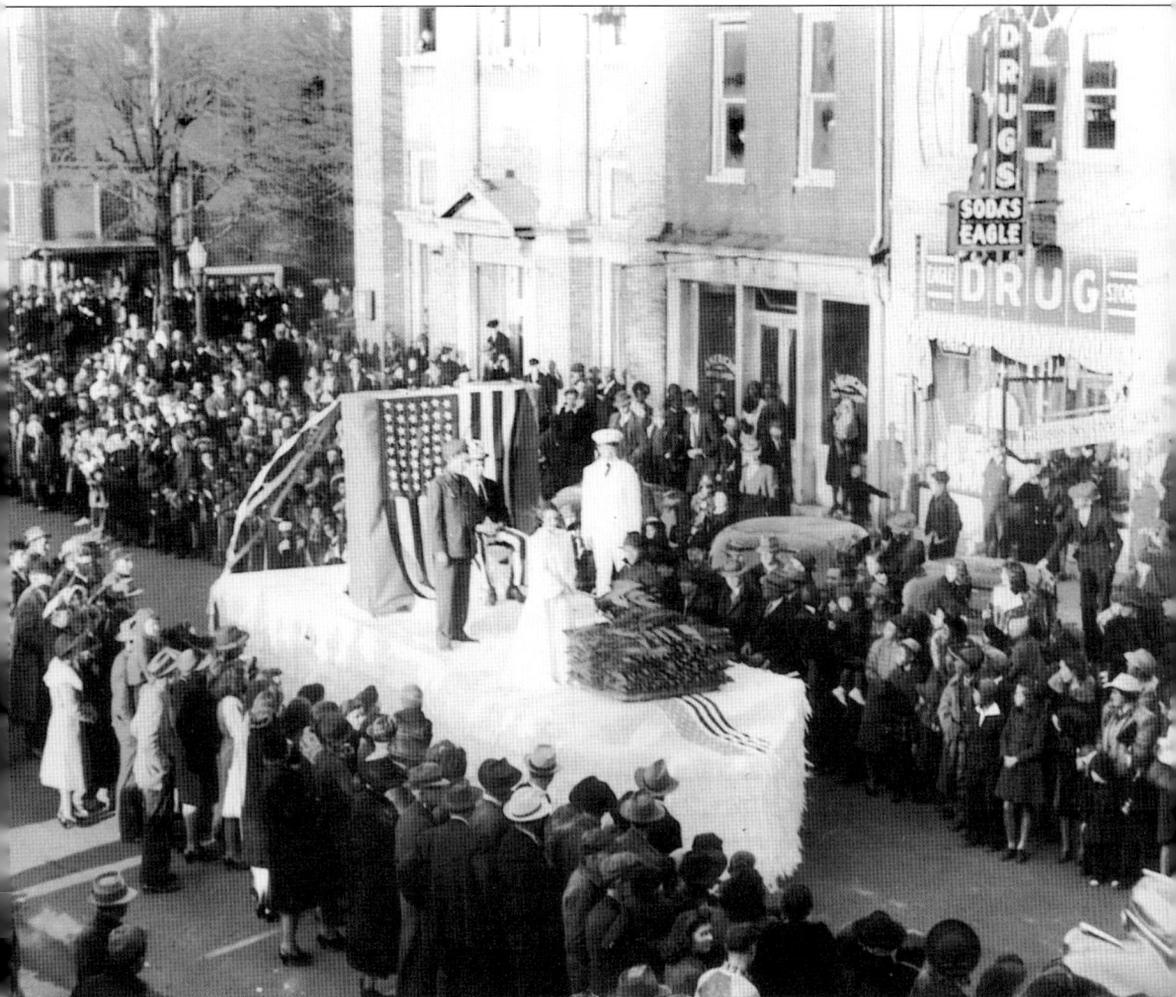

The best part about the tobacco season is the Tobacco Festival. The first parade was held November 25, 1941, in downtown Russellville.

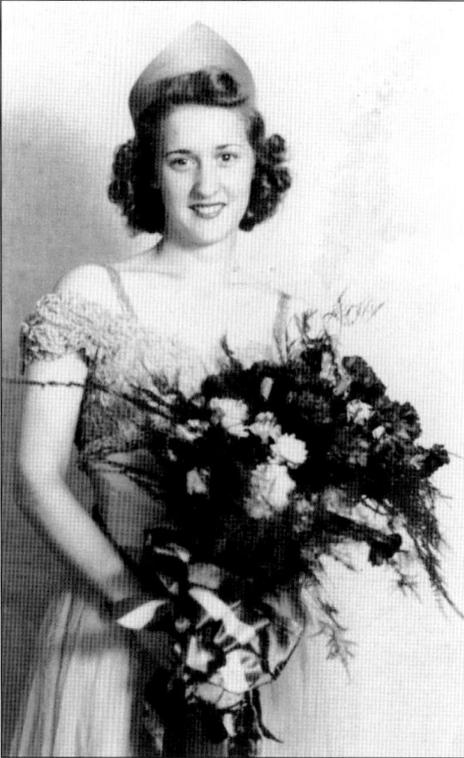

A festival is nothing without a beauty pageant. Tobacco Festival Queen for 1942 was Jean Young of Adairville (at left). In 1958 (below), the queen was Anne McCutchen. In her court, from left to right, are Sue Williams (1957 queen), Marylyne Welker, Mary Page Clark, and an unidentified man. (Bottom photograph courtesy of Sue Williams Spurlock.)

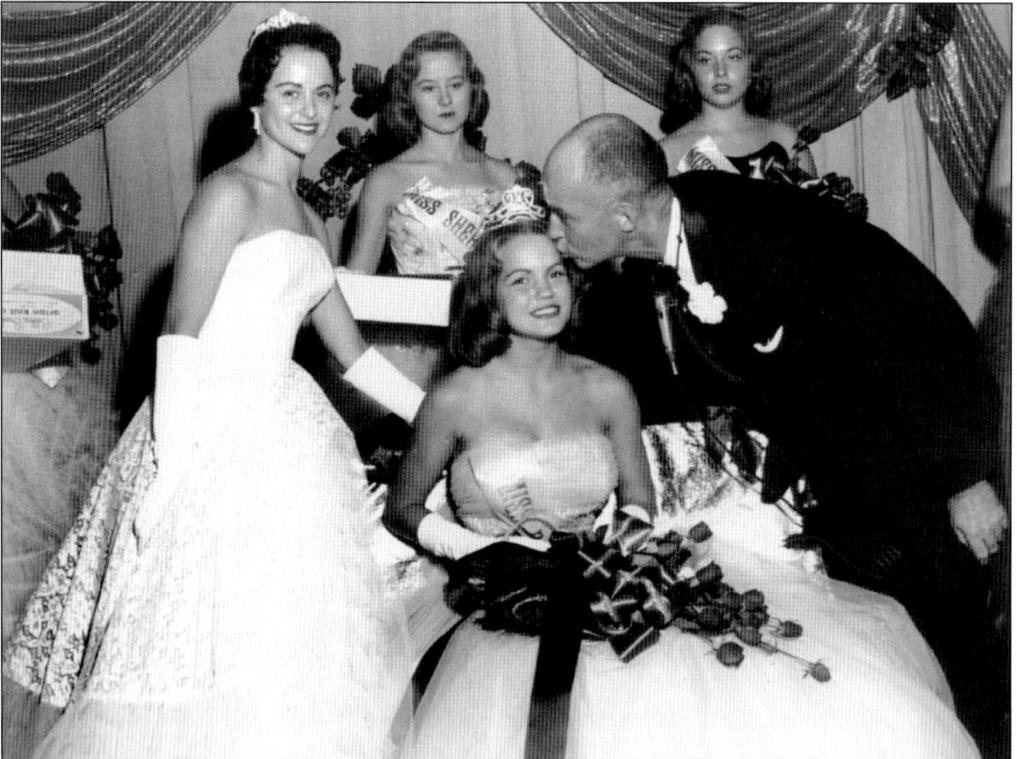

Every Tobacco Festival, a bank robbery by Jesse James (portrayed by Edward Taylor, at right) is reenacted. On March 20, 1868, Jesse James and his gang robbed a bank on Main Street owned by Nimrod Long. Approximately $14,000 in currency and coins was taken. Where they headed after the robbery (below) is uncertain. Stories are told across the county of Jesse James stopping at a farmer's house for a meal and leaving a gold coin under the plate. Historians dispute whether Jesse James actually robbed the bank, saying it may have just been his gang. Jesse James did have family living in Logan County. Nimrod Long knew Jesse James's father, Robert, and even educated him. (Top photograph by Mark Griffin.)

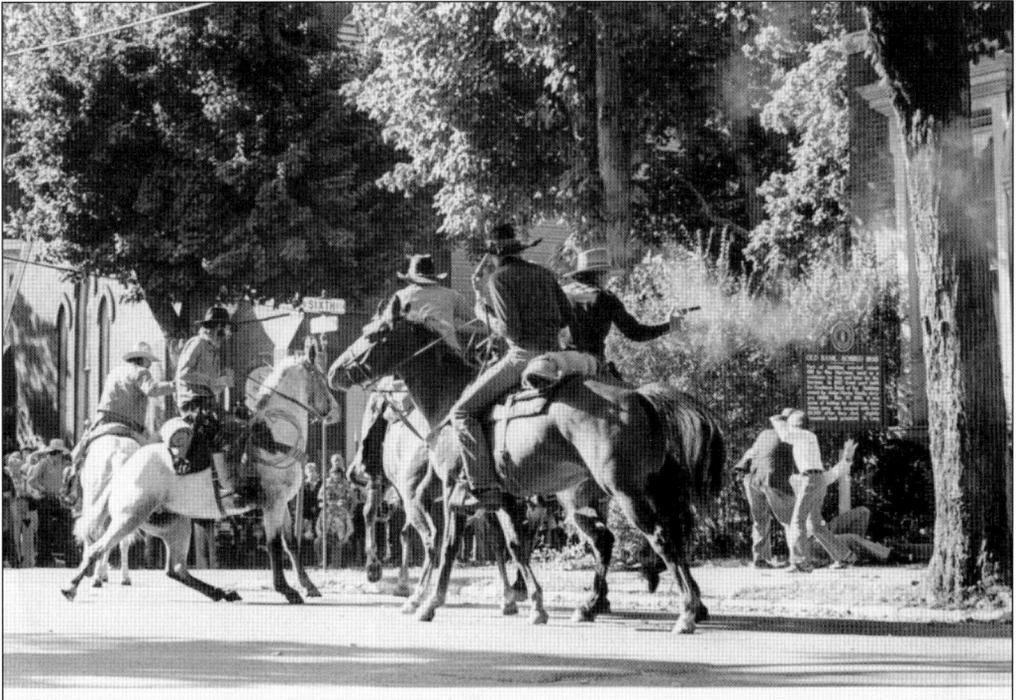

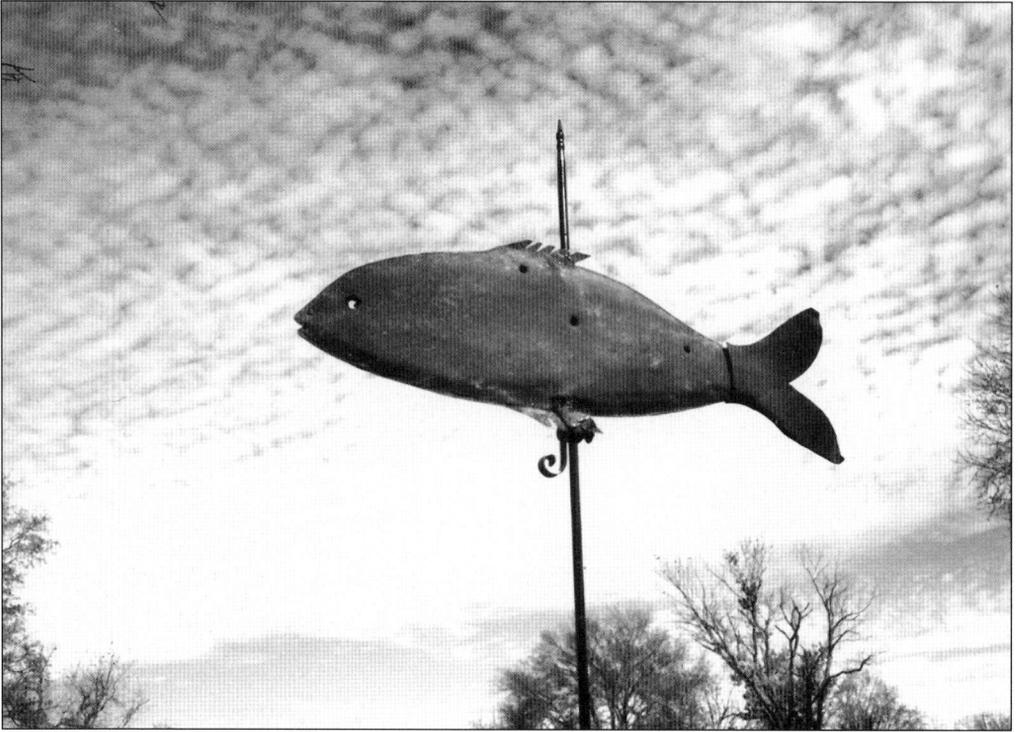

After robbing the bank, Jesse James's brother, Frank, is believed to have fired holes into the fish weather vane set on top of the courthouse. A Confederate solider and a drunk have also been accused of this misdeed. It is believed the unusual weather vane was used to symbolize Christianity. The actual weather vane (above and below) is now displayed in the Saddle Factory Museum. A faux fish weathervane was created to sit on top of the courthouse. Three bullet holes were shot in it for authenticity. (Top photograph by Mark Griffin.)

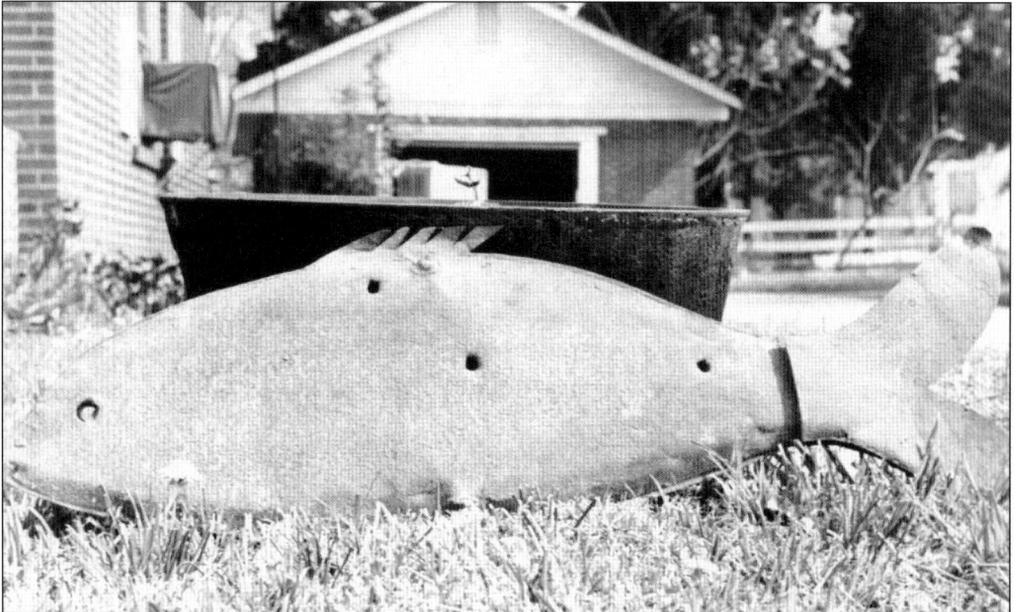

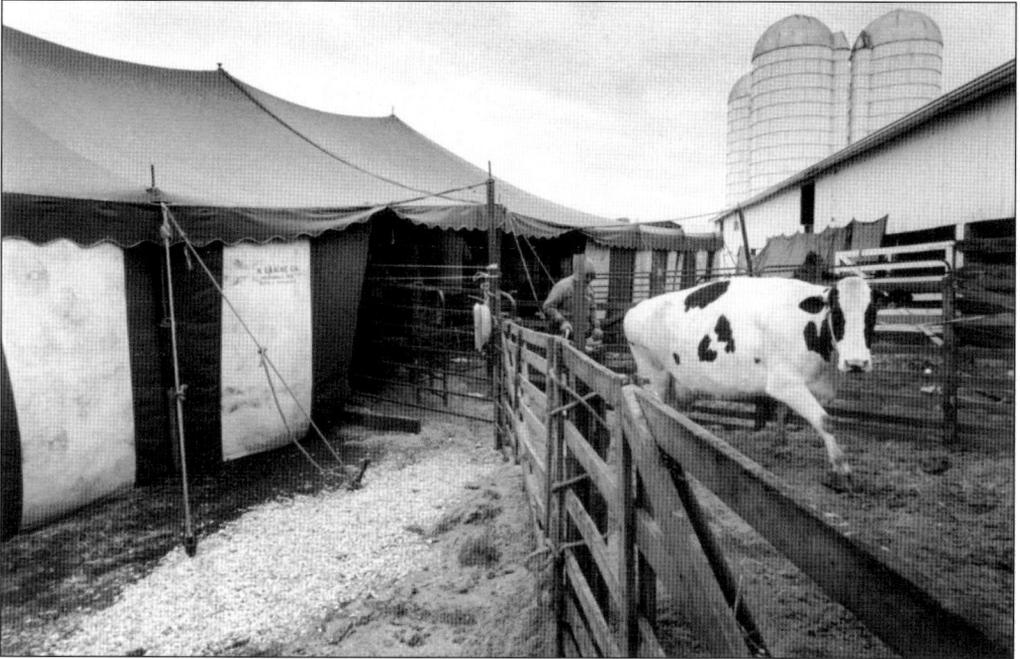

Livestock such as cattle are raised here mostly for beef, though the Robeys (above) have a large dairy. They are sold at cattle auctions (below), such as the feeder calf sale at Russellville Livestock Market.

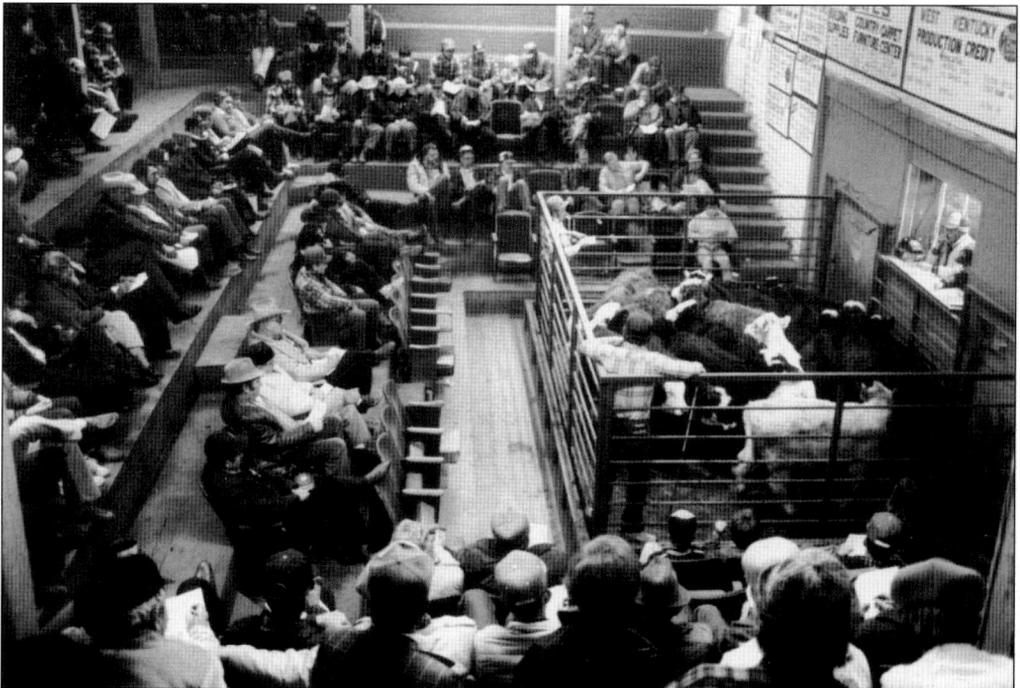

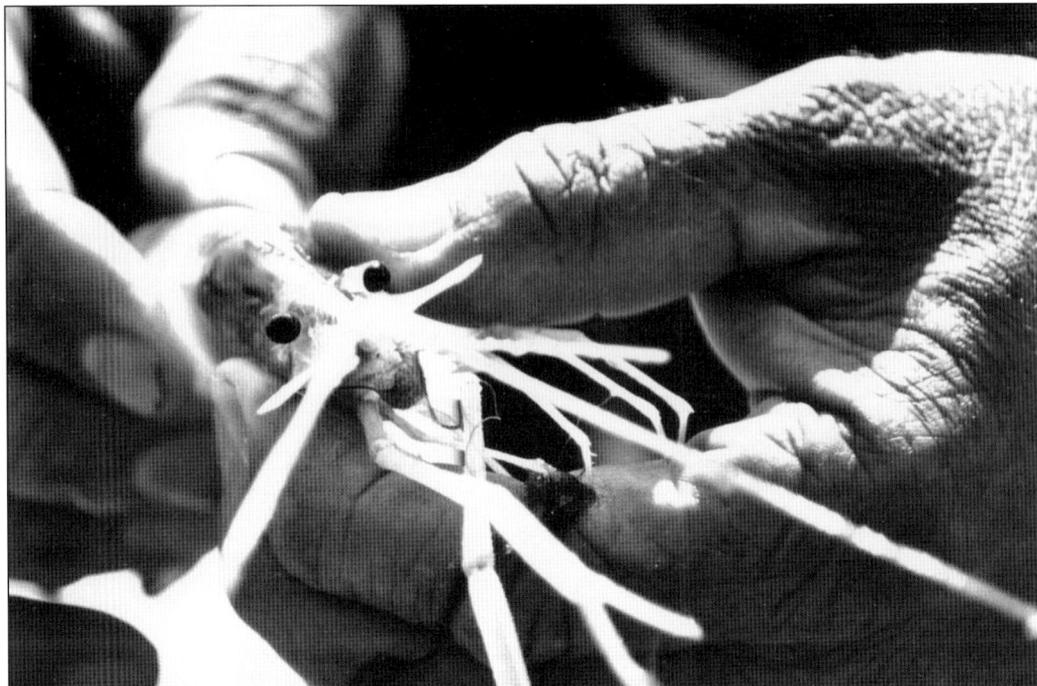

Farmers have been looking for other crops or livestock to replace tobacco. A few farmers have tried their hand at raising shrimp (above). Shrimp cannot live here naturally because saltwater is needed for the eggs, but once matured, they can live in fresh water. Century House Vineyard (below) started a winery. (Photographs by Mark Griffin.)

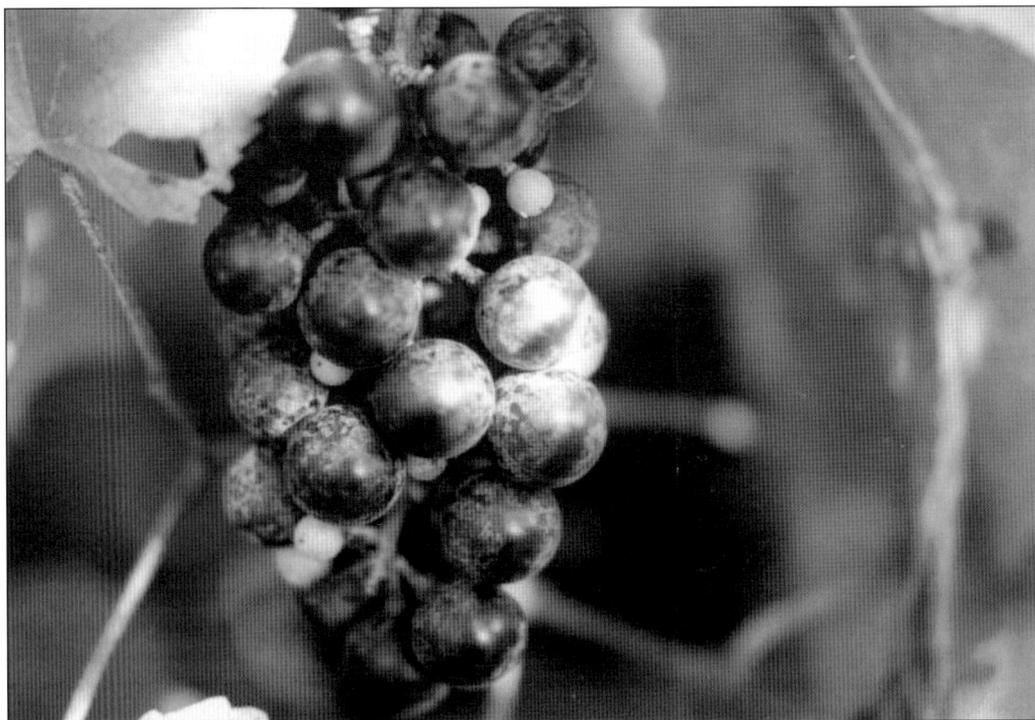

Two

COMMUNITIES

NASHVILLE, October 20
 It is with extreme regret
we have to record the mel-
ancholy death of his ex-
cellency MERRIWE-
THER LEWIS, Govern-
or of Upper Louisiana, on
his way to the city of wash-
ington. The following par-
ticulars, are given us by a
gentleman who travelled
with him from the Chicka-
saw Bluffs:
 The governor had been

Farmers mostly lived in their isolated communities. One
of the ways they received information about the county
was through newspapers such as the *Farmer's Friend*. The
October 27, 1809, edition earned a spot in the history books
for being the first newspaper to report on the death of
Meriwether Lewis of Lewis and Clark fame. How and why
a newspaper in Logan County became the first is a mystery.
(Courtesy of Filson Historical Society, Louisville, Kentucky.)

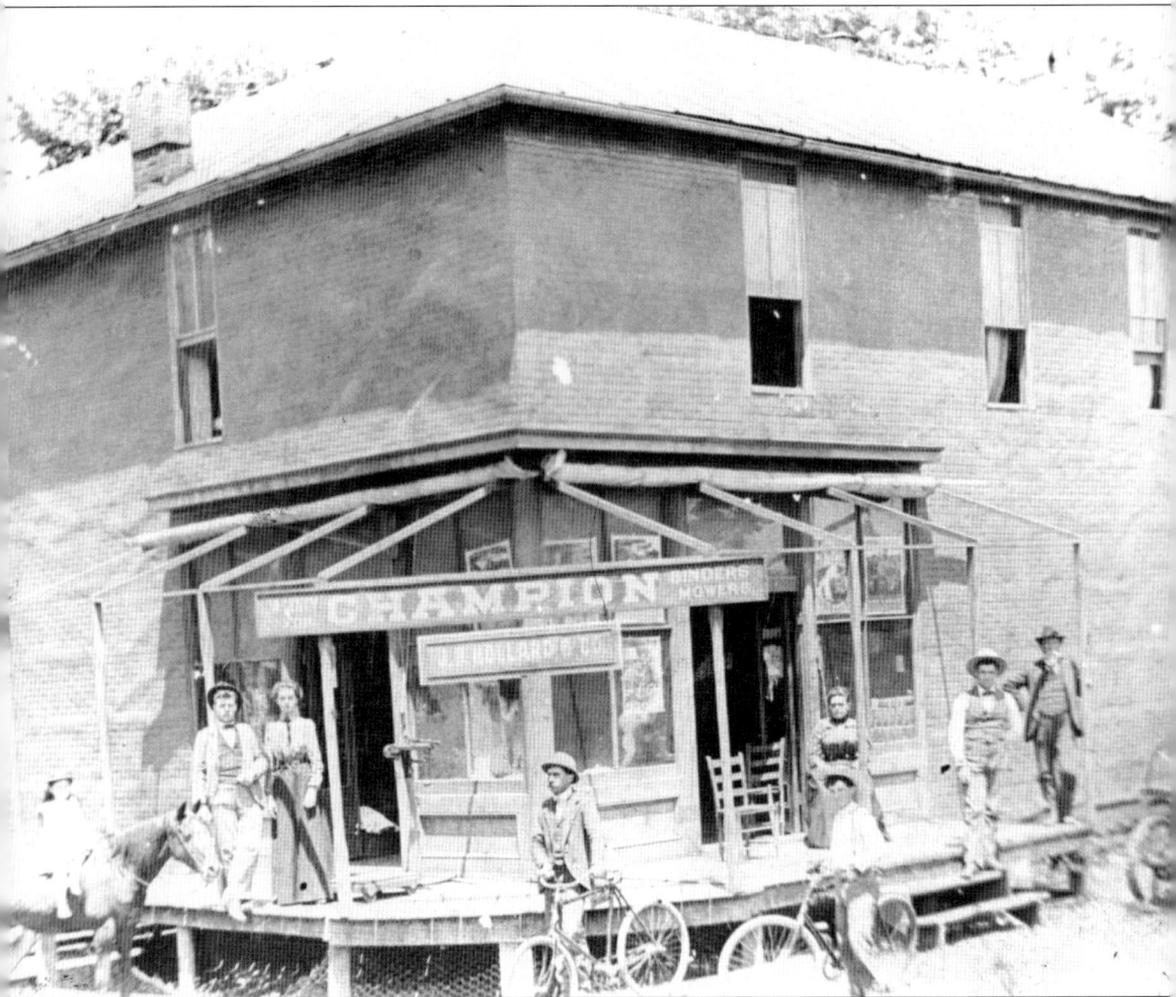

Logan County has hundreds of small communities, such as Ferguson. J. H. Holland Store operated by the train tracks. The store was later bought by Alonzo Stratton, who was considered the second most intelligent man in Ferguson because he had a ninth-grade education. Residents came to him for help in filling out Sears and Roebuck catalog orders. In the 1930s, Stratton bought a radio, and residents would listen to the Grand Ole Opry, or they would tell ghost stories about the headless woman. Pictured from left to right are Inez Holland Parrish on the horse, Palmer Lowe and his wife, two unidentified men with bicycles, Nobie Holland, Jesse Holland, and John Holland.

Many of these communities formed after the Civil War with the advent of the train. Residents (such as those unidentified people pictured above from Wolf Lick) settled close to the depots and depended upon the train for the transportation of goods and people to the bigger cities of Adairville, Auburn, Lewisburg, and Russellville. Oakville (below with unidentified residents on a train car) was a midpoint between Russellville and Adairville. The "Adairville Dinky" was the name residents gave to the train, which passed through the community. After the Dinky had been discontinued, residents reported of an eerie light that ran along the tracks, which a few called the Ghost Train.

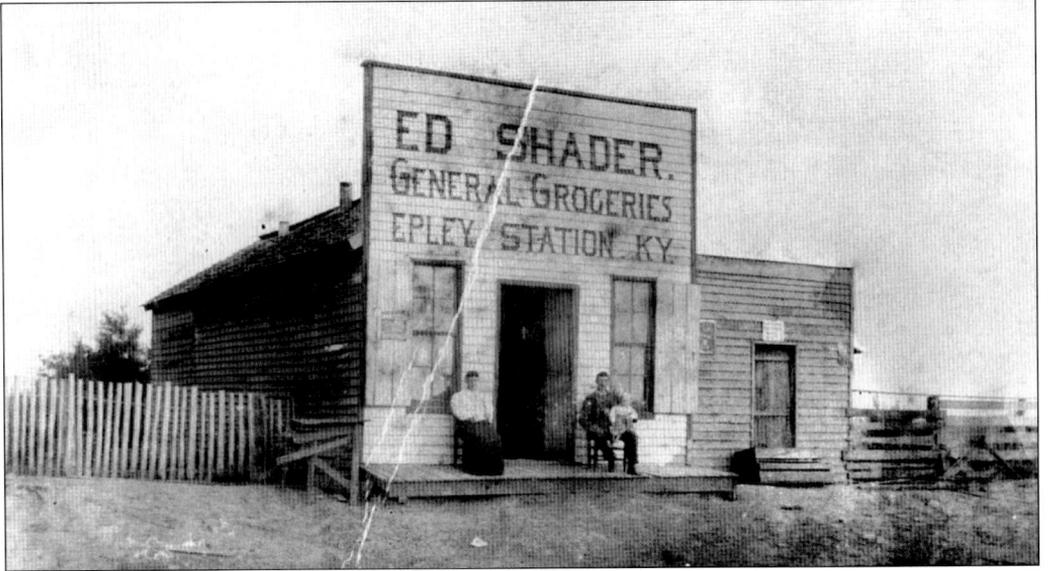

The trains brought supplies and materials for the general stores, such as the Shader Store in Epley Station (above). People, mostly men, would gather at the general store at Chandler's Chapel (below) to chat or loaf.

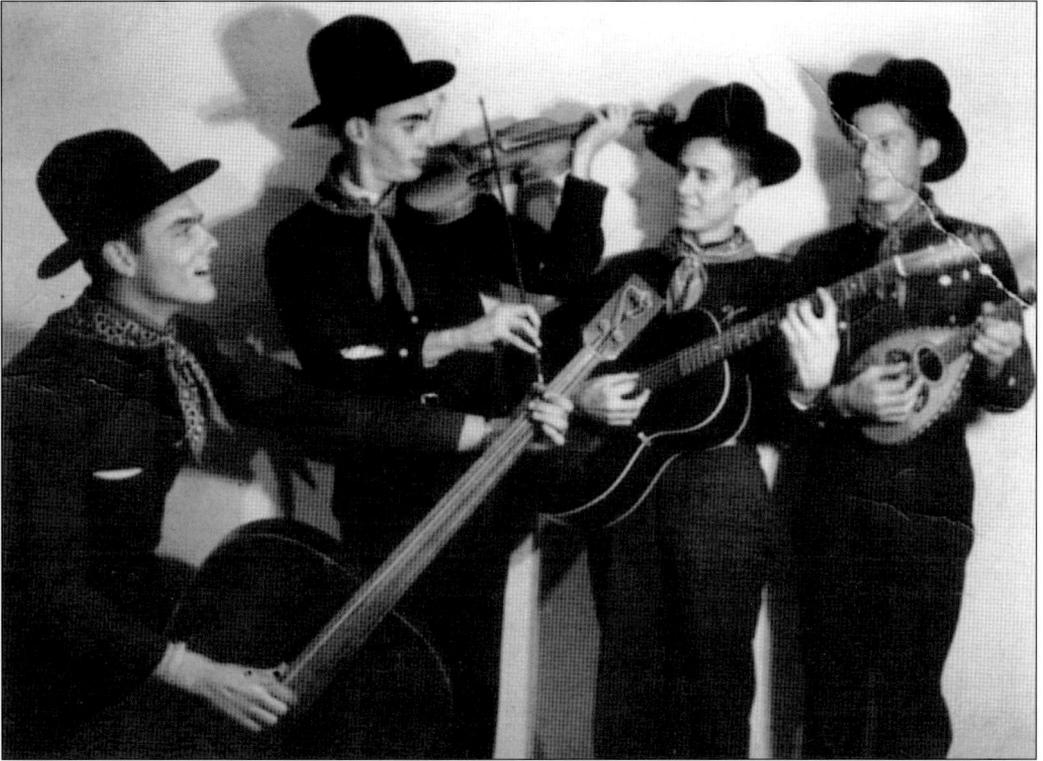

Residents would bring their musical instruments to the general store to play a few songs. A few of these people, such as the Coonrange Drifters (above) and Velma Williams (right), were able to make a career from music. Velma Williams of Epley Station was a member of country music legend Roy Acuff's band. She and her sister, Mildred, originally formed a singing duet called the Williams Sisters and performed on the Grand Ole Opry in Nashville during the 1940s. Mildred gave up the music career to become a mother while Velma continued on.

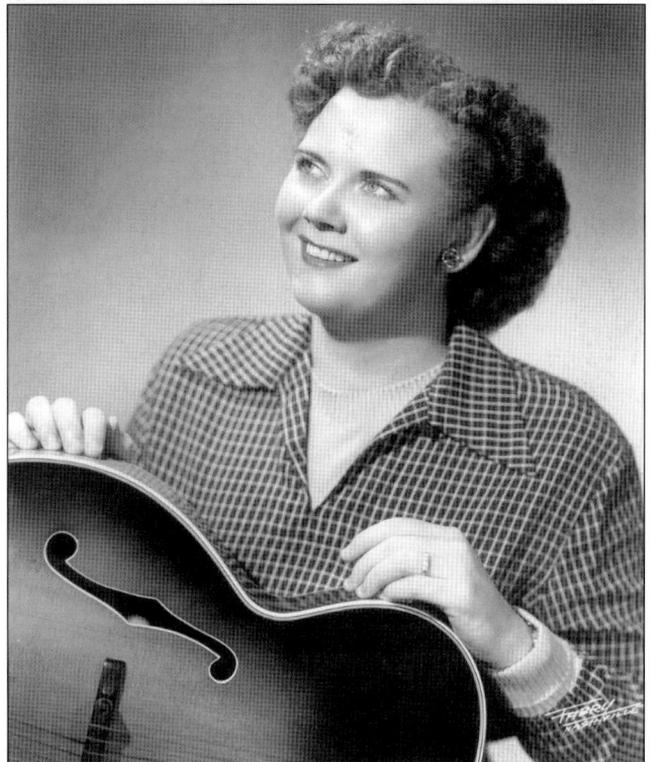

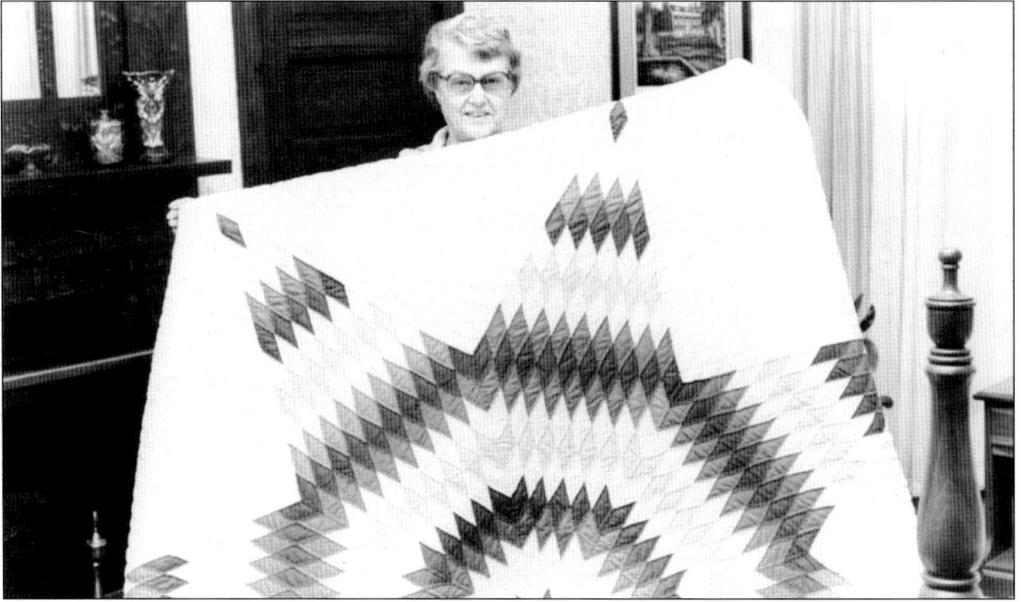

The women of these communities were mostly homemakers. One of the few social activities strictly for woman was quilting bees, where women would gather at a home to all work on a quilt. Louise Wren (above) shows off a starburst quilt made by the women of Red Oak Methodist Church. Weddings were another big activity for women. Luan Barclay (below) wears her mother's wedding dress.

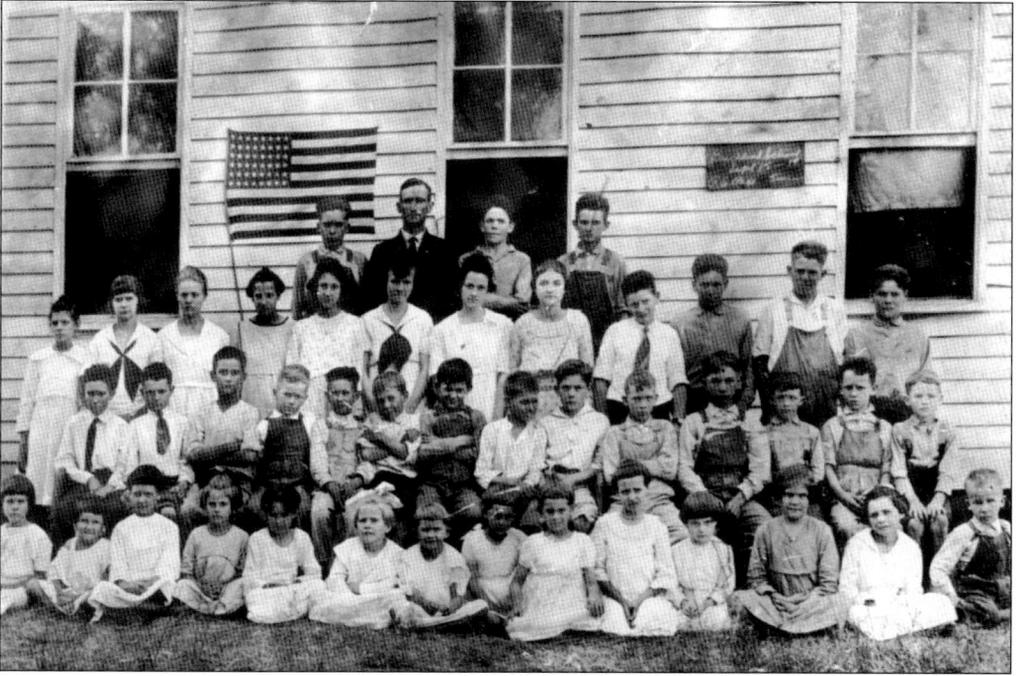

Families in the communities were big. One-room schools were built to educate the children. Above is the Beechland School. As people moved away from communities to make a living elsewhere, family reunions served as an excuse for people to come back to visit. The Banton family (below) held a reunion in the community of Dot at the Burchett House in 1922.

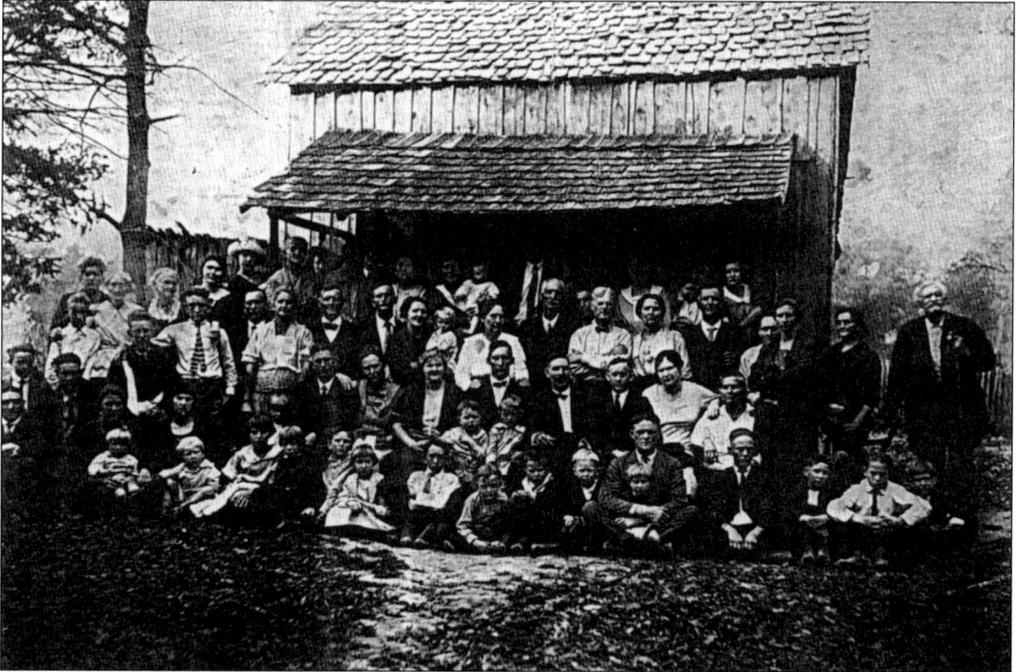

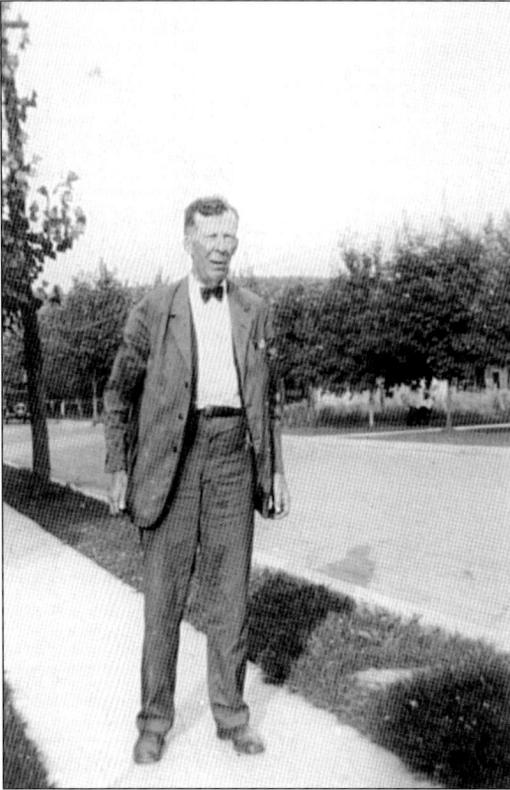

Country doctors were a necessity. The most beloved doctor from Gordonsville was Dr. J. R. Crittenden (left), who earned his medical degree at University of Nashville. Dr. Crittenden carried red, white, or pink pills in his coat pocket. When someone was sick, he would pull out a pill, blow the tobacco crumbs away, and give it to the person. He was usually paid $1 or a chicken for his services. Alice Morehead (also know as Aunt Alice) of Greenridge assisted Dr. Crittenden as a midwife. Her great-nephew was boxing legend Muhammad Ali. Dr. Crittenden's horse Old Nick (below) helped reach the homes.

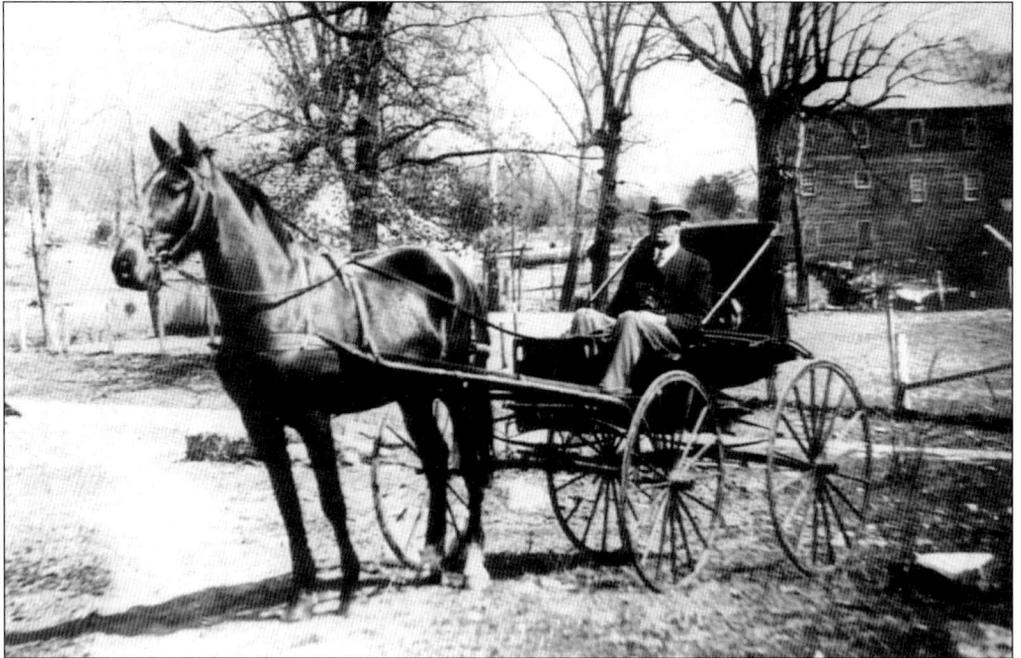

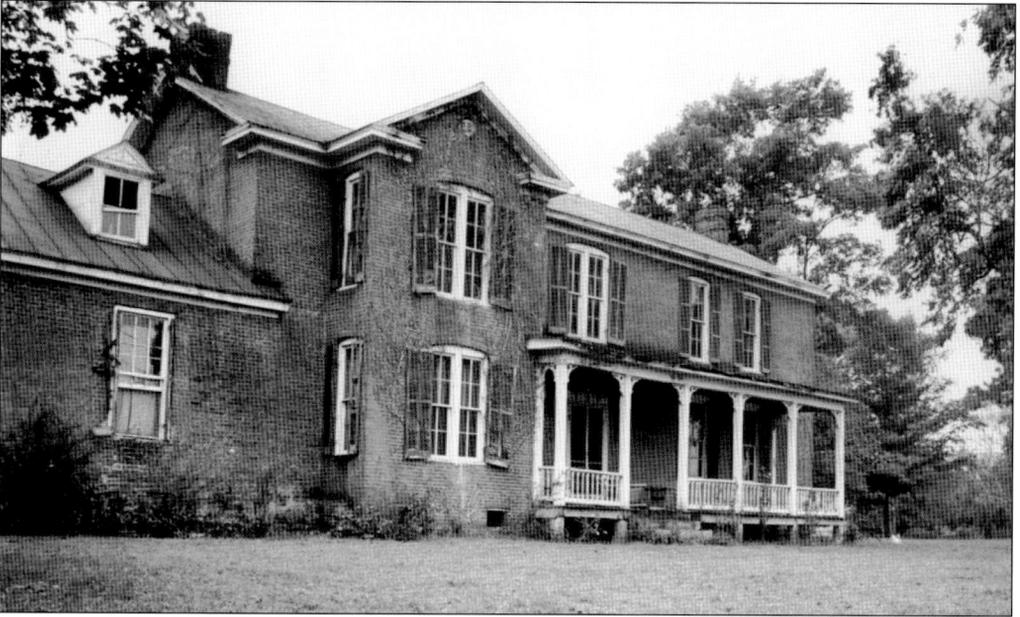

Described as one of the loveliest homes in Logan, Flint Ridge was built in 1805 by Robert Baylor using bricks made on the site of the 800-acre farm. When the New Madrid Earthquake of 1805 rocked this area, a wall in the was mansion cracked. The ghost of Mr. Baylor's wife, Frances, presumably haunts the home.

Harmony Hall was built by Benjamin Keene Tully, who hailed from a family of musicians in the Cave Spring community. The home received its name because of the acoustics. During the Civil War, Union soldiers tried to steal horses kept Mr. and Mrs. Henry Tully, which were hidden in a nearby cave. The soldiers kept Mrs. Tully and her children captive in hopes she would reveal the location of the horses. When all the soldiers slept, they escaped by climbing down the veranda.

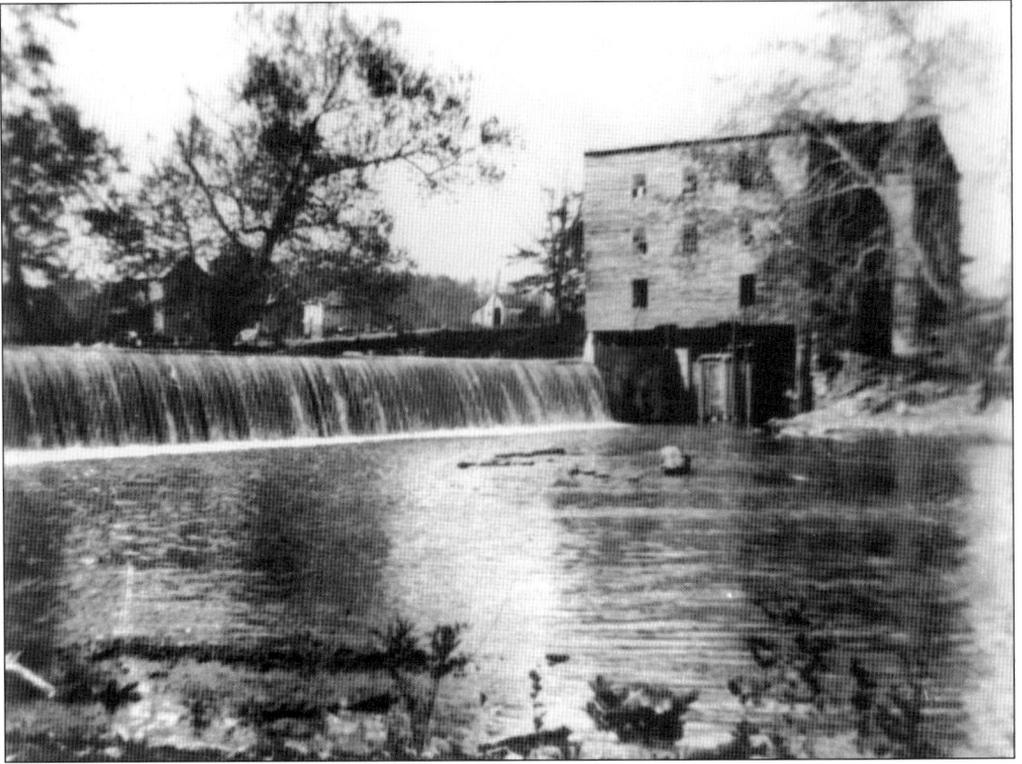

The community of Schley had a gristmill on the Red River. Christian Orndorff (the son of a Revolutionary War soldier) built the mill around 1820. His son, Eli, expanded the mill to include a sawmill. Eli's son, Hummer, built a concrete dam that still stands today. The mill itself burned down in 1927. Schley is named in honor of Rear Adm. Winfield Scott Schley, who fought during the Battle of Santiago Bay in Chile. Coleman Dowell (left, 1925–1985) was born here. He is the author of *Island People* and *One of the Children Is Crying*. (Bottom photograph by Carl Van Vechten, courtesy of the Library of Congress.)

Schley was a spot where people went to relax, and there were other places for Logan Countians to visit for relaxation, such as Diamond Springs Hotel (shown in both pictures). Diamond Springs, built in the 1890s, had different pools of iron and sulfur water that were believed to rejuvenate a person. For $3, a person could stay all day.

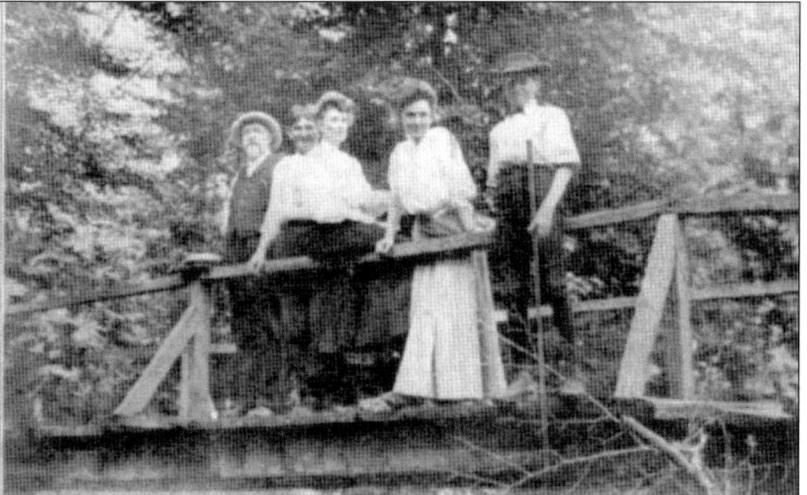

JOYOUS YOUTH AND AGE.

On Rawhide Creek Bridge in front of Diamond Springs Hotel.

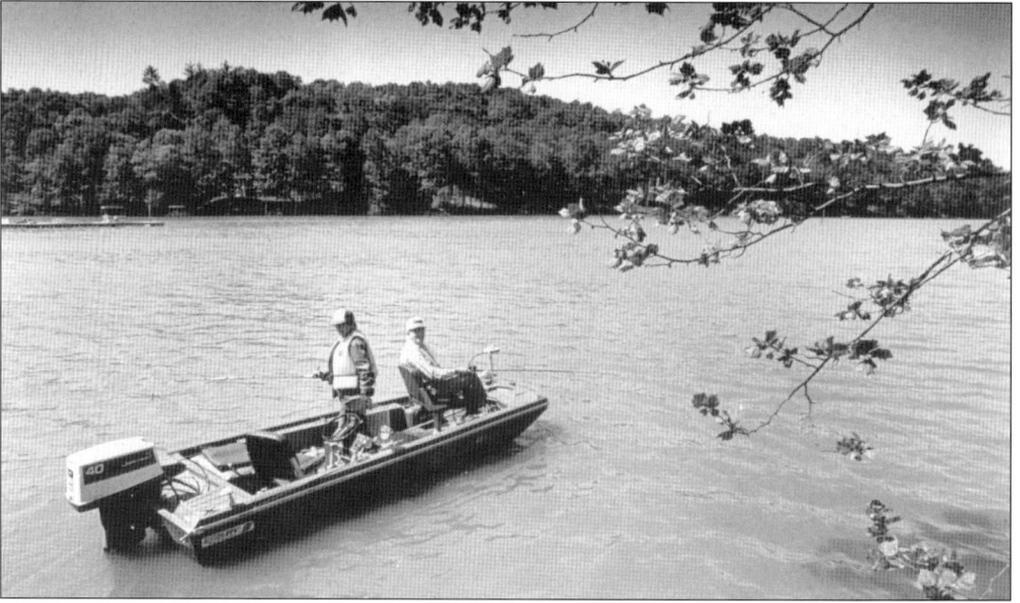

Logan County, as well as the rest of Kentucky, has no natural lakes. Two of the man-made lakes here are Lake Malone State Park (above) and Coonrange Lake (below). Lake Malone was created in 1960 by the damming of two creeks. It was named in honor of W. C. Malone, who donated land for the lake. Coonrange Lake was created in 1948 by the Coonrange Fish and Game Club as a way to conserve, restore, and manage wildlife in the Lewisburg area.

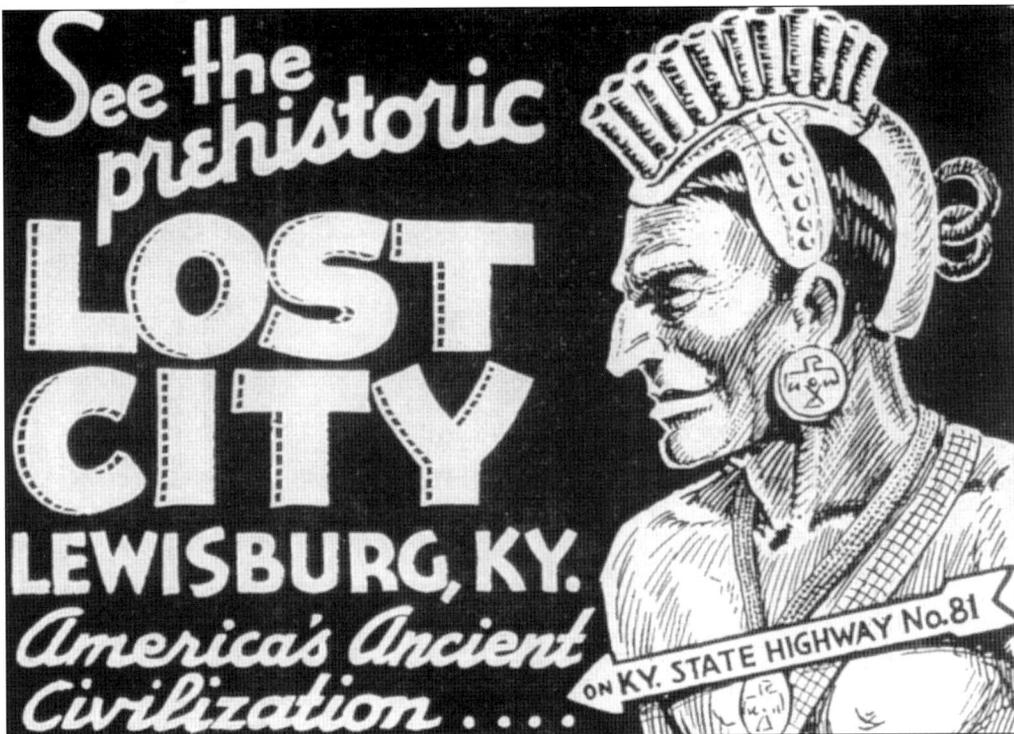

See the prehistoric LOST CITY

LEWISBURG, KY. America's Ancient Civilization

ON KY. STATE HIGHWAY No.81

Ancient Native Americans settled Logan County in such spots now known as Lost City (above) and Savage Cave. The 80 burial mounds of Lost City, located in North Logan, were excavated in 1929 by an archaeology team from the University of Kentucky. Three distinct cultures that settled here used crematories for the dead. In 1936, Lost City was opened as a museum and closed in 1941, not long after Pearl Harbor was bombed. Savage Cave was championed by Genevieve Savage, who studied the artifacts of the Clovis people. They settled in the cave during the Ice Age because of its warm environment. Savage opened her home as a museum for students such as Lori Smith and Teresa Wood (below from left to right with Savage). (Bottom photograph by Robert Stuart.)

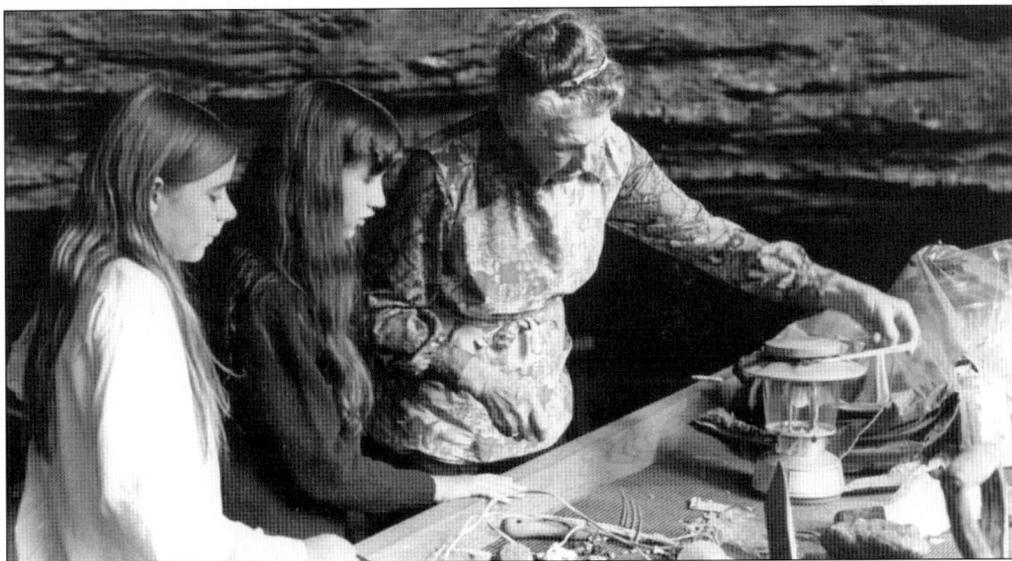

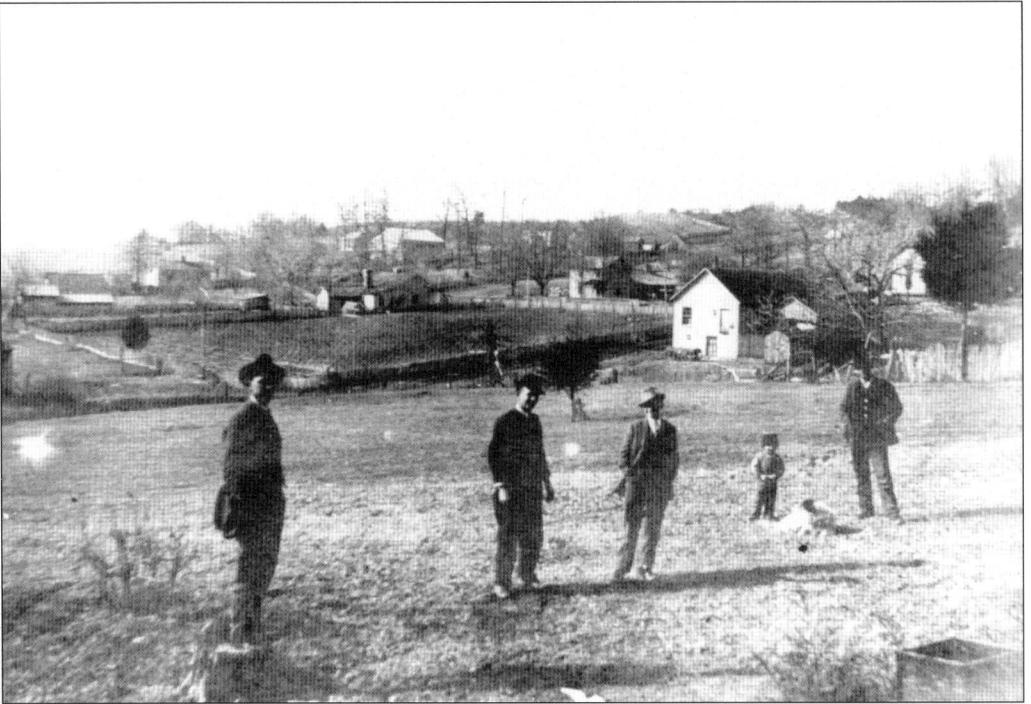

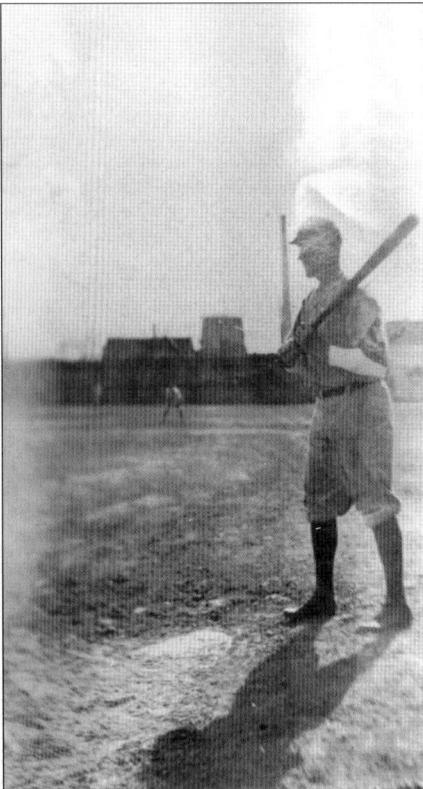

When whites settled Logan, all Native American tribes had moved on. The Native Americans had slashed and burned the land to grazing fields for buffalo. The southern end has the richest farmland of the county, while the rocky north end made for poor farming. The community of Homer (as pictured above in 1912 from left to right with Dolf Turner, Delbert Turner, Otis J. Ashby, Weaver B. Ashby, and John Ashby) is in the north end of the county. Regardless of where anyone lived, baseball was the popular sport, and each community had its own team. Hulon James of Adairville (left) was good enough to play professional baseball for the Texas League.

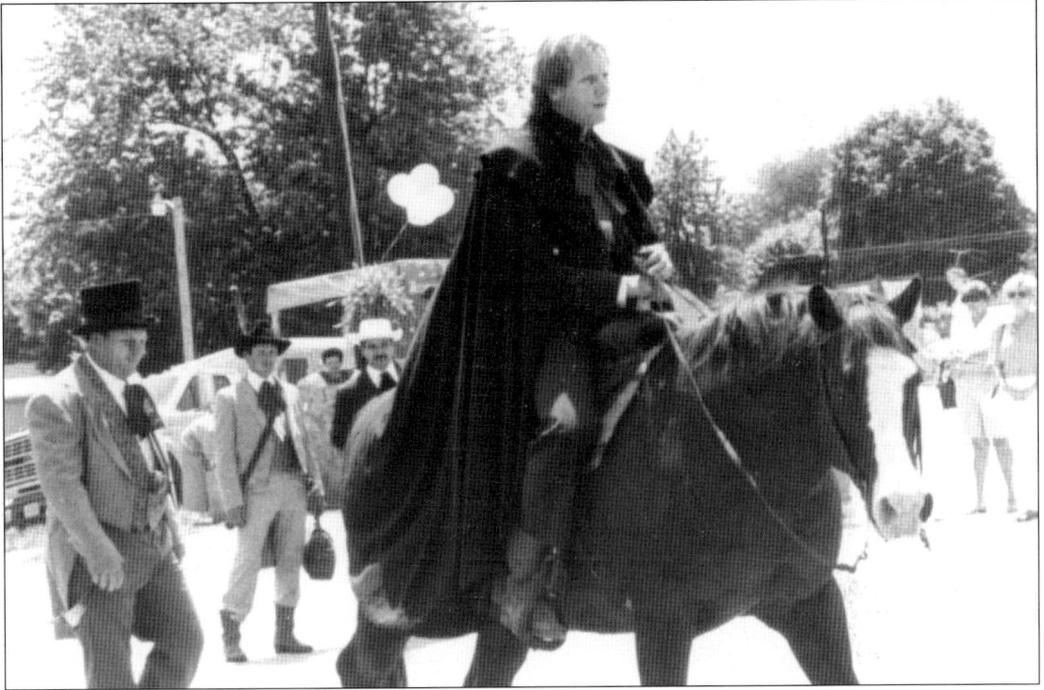

Andrew Jackson (portrayed by Dave Dockins, above on horseback) met with Charles S. Dickinson at Harrison's Mills, near Adairville, on May 30, 1806, for a duel. Dickinson had insulted Jackson's wife and refused to apologize. The Tennesseans crossed over the state line into Logan, where dueling had not been outlawed yet. Dickinson had first shot, but the future president wore an ill-fitting coat that deceived Dickinson as to where Jackson's heart was located. Jackson acted as if the shot missed him and fired his weapon. Dickinson died in the house below.

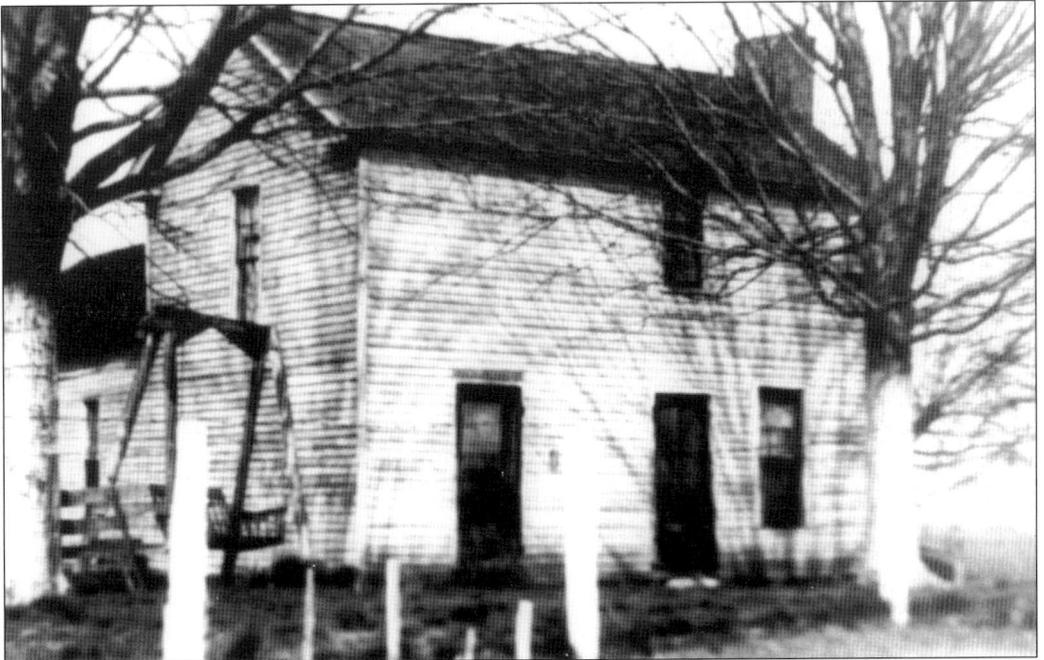

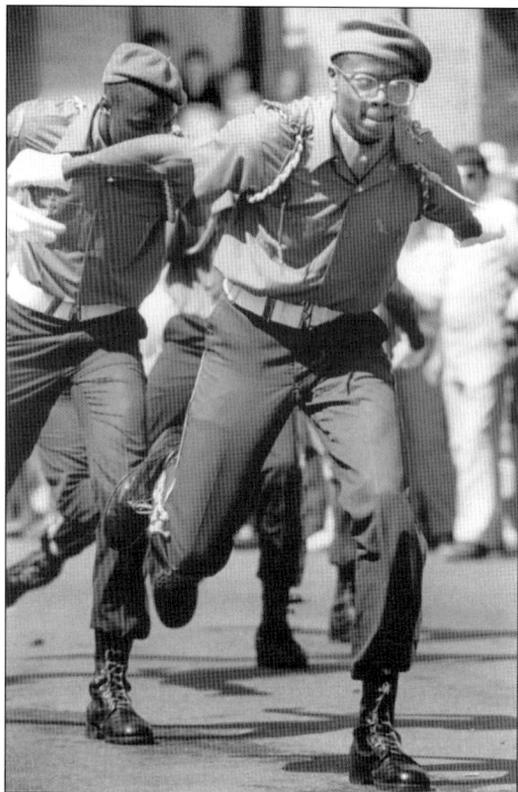

The duel is reenacted annually at the Strawberry Festival in Adairville, one of the four incorporated cities. Once strawberries were raised here, but they proved to be unprofitable. Yet the festival continues on every spring. The parade brings floats and drill teams (at left) as well as carnival rides and a womanless beauty pageant (below).

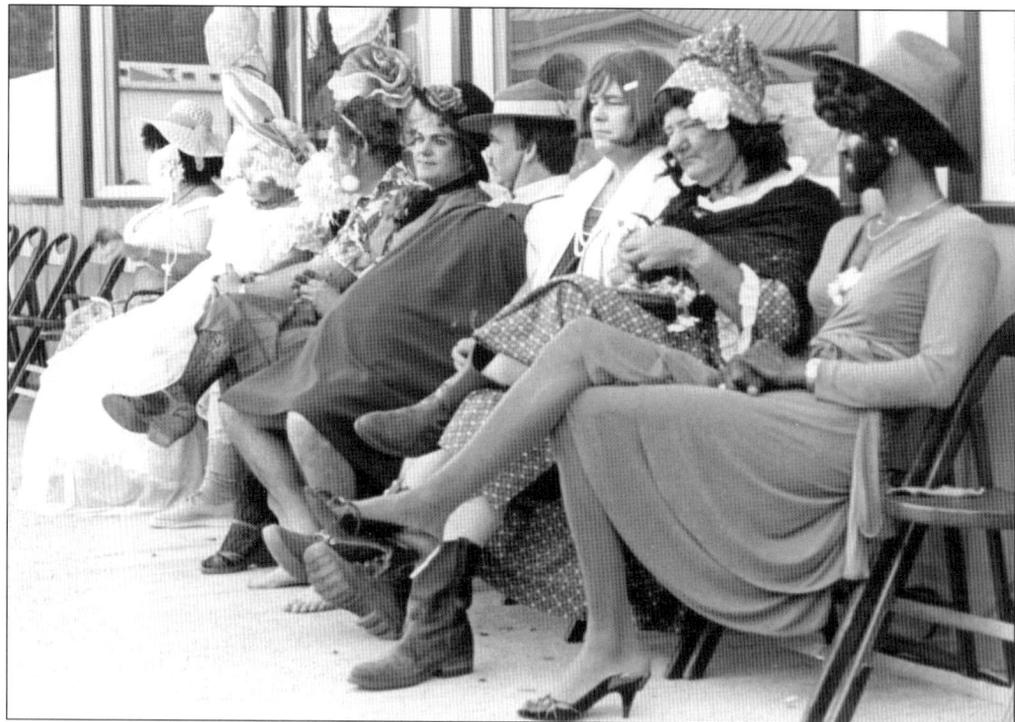

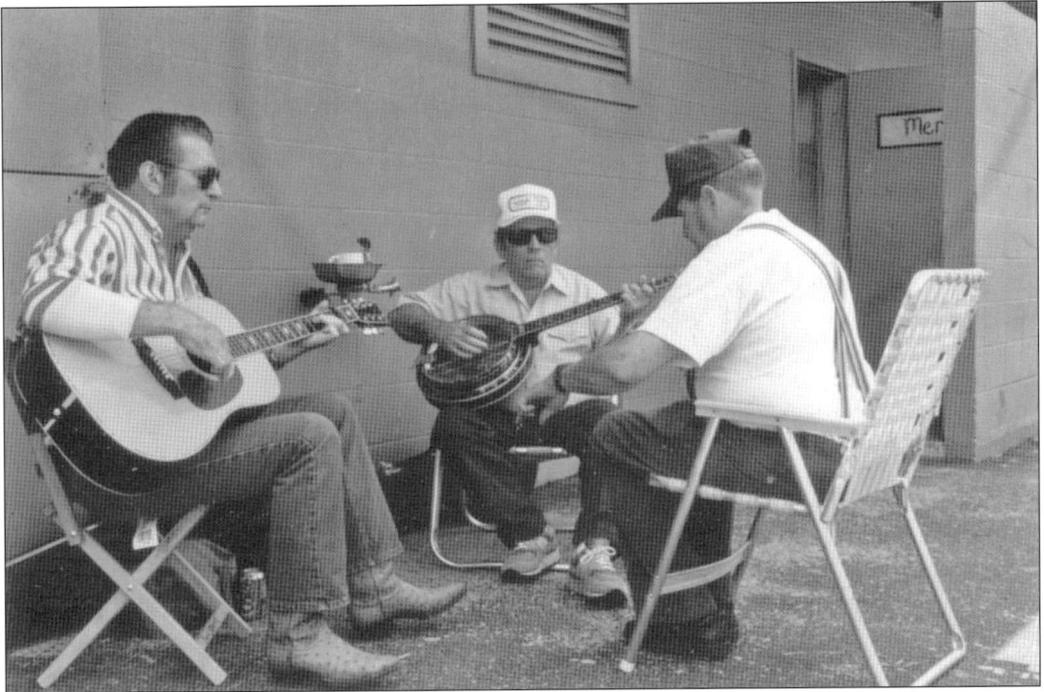

Auburn and Lewisburg are two other incorporated cities. Every year, Auburn has the Autumn Days Festival and a Bluegrass Jam (above). Lewisburg is the purple martin capital of Kentucky, and a parade is held every year. Another parade happens during Christmas: Alice Lynn Forgy Kerr, a Lewisburg native and a former state senator, waves from a car (below). (Top photograph by Mark Griffin.)

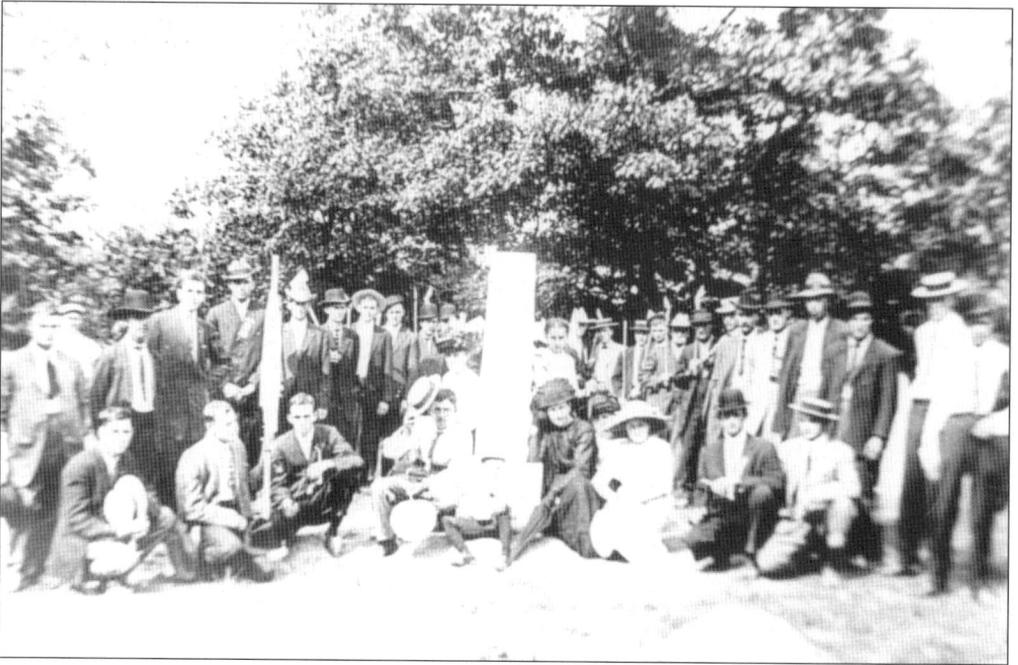

Death affected every community. The Woodmen of the World (above) erected a tombstone for a fallen member, Vernon Hollins, around the 1920s at New Friendship Cemetery near Auburn. The community of Schochoh had its own funeral home in its general store. J. H. Harper (below with driver Church Herndon) owned Harper Funeral Home. They are taking the body of Ulys Carmack to be buried at nearby Red River Cemetery.

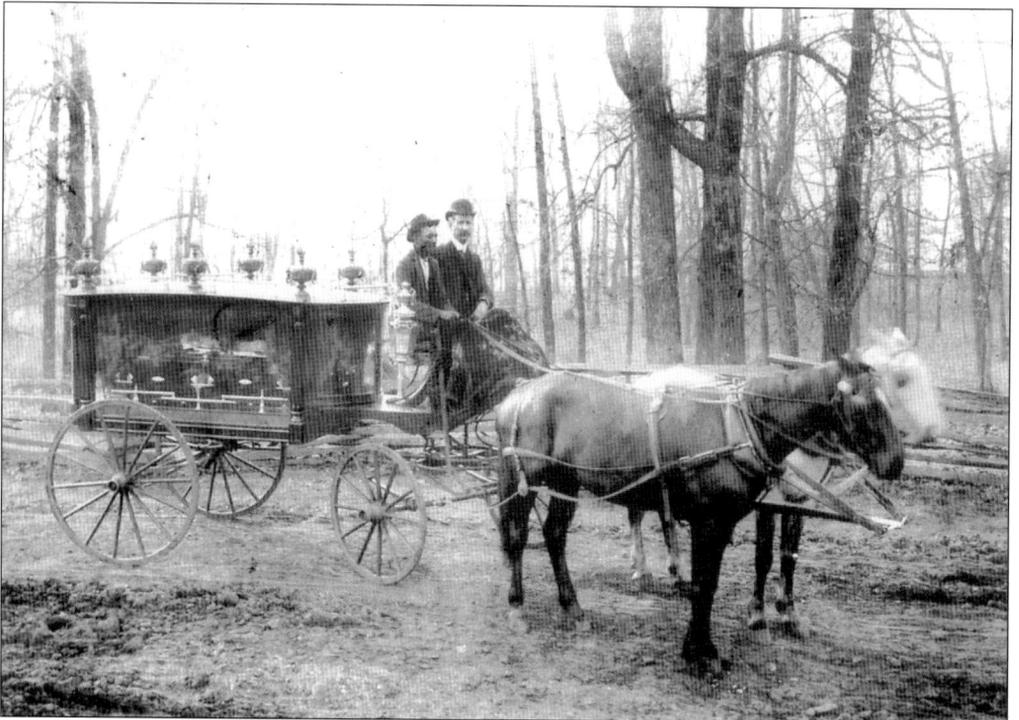

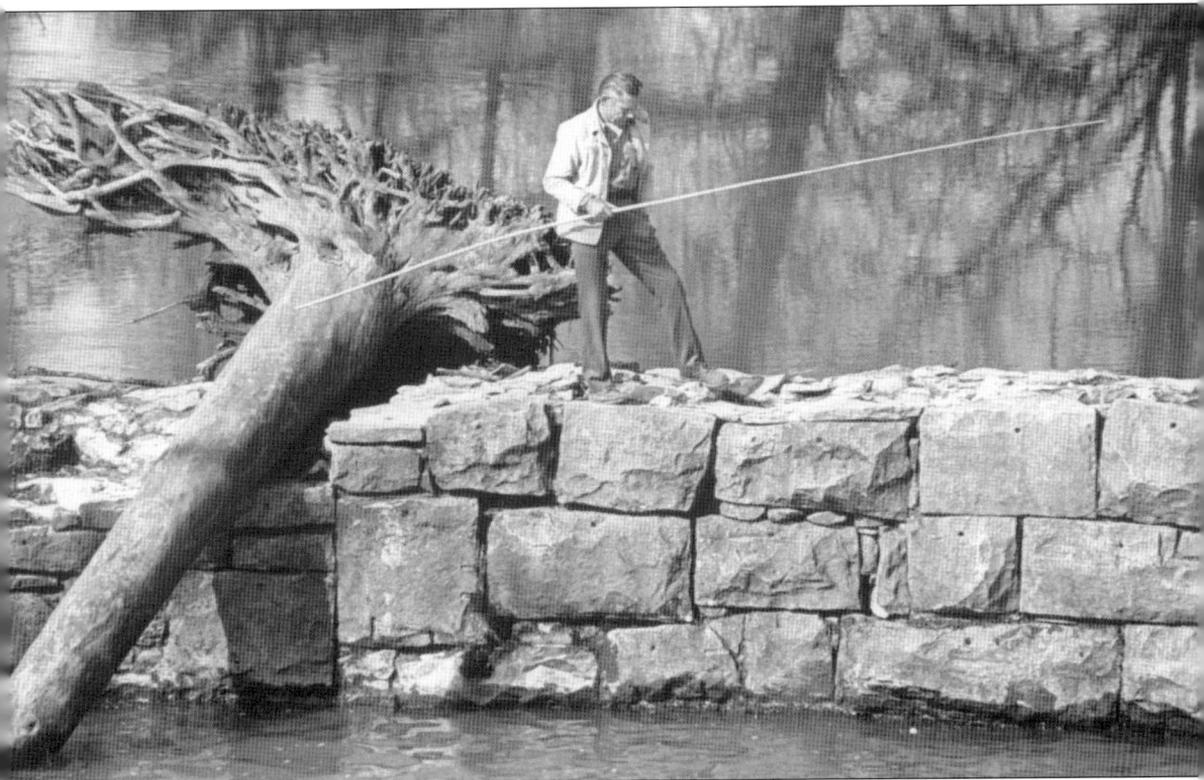

Many of the communities have vanished. Lickskillet once had a thriving mill but is now a good spot for fishing (as Daniel Moore shows) and swimming. The name comes from a spot near the mill where deer and other wild animals came to use a salt lick, which eventually resembled a skillet. (Photograph by Leslie Page.)

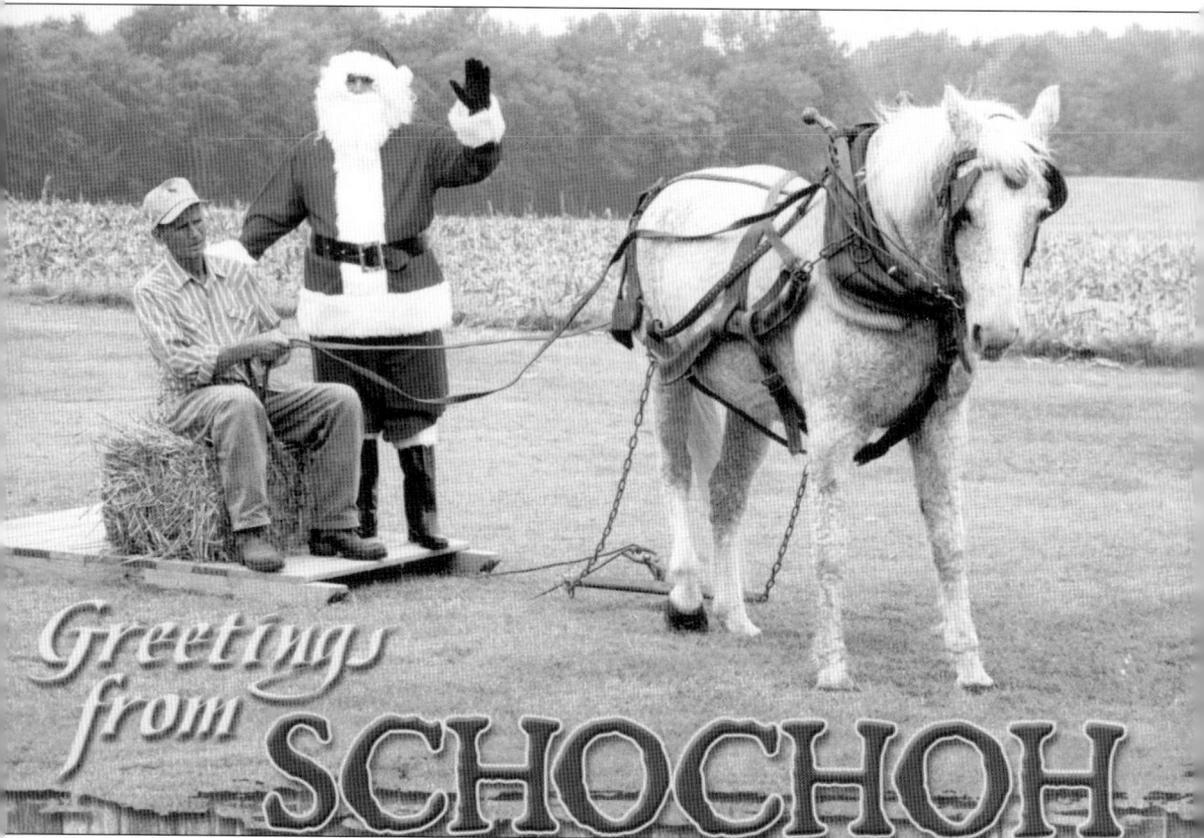

Greetings from SCHOCHOH

Schochoh is one of the few communities still a community. Every first Sunday of December, its Christmas parade draws approximately 900 people. It is the only time a person will see a traffic jam here. It started as a joke when James Harve Smith rode a ground slide with Santa Claus hitched to a mare, Snowball, through the community of Schochoh in 1990. Someone in a car asked them what they were doing. "We're having the Schochoh Christmas Parade," Smith replied. Thus was born a new event in Logan. (Photograph by Jessica Moore.)

Three

RUSSELLVILLE

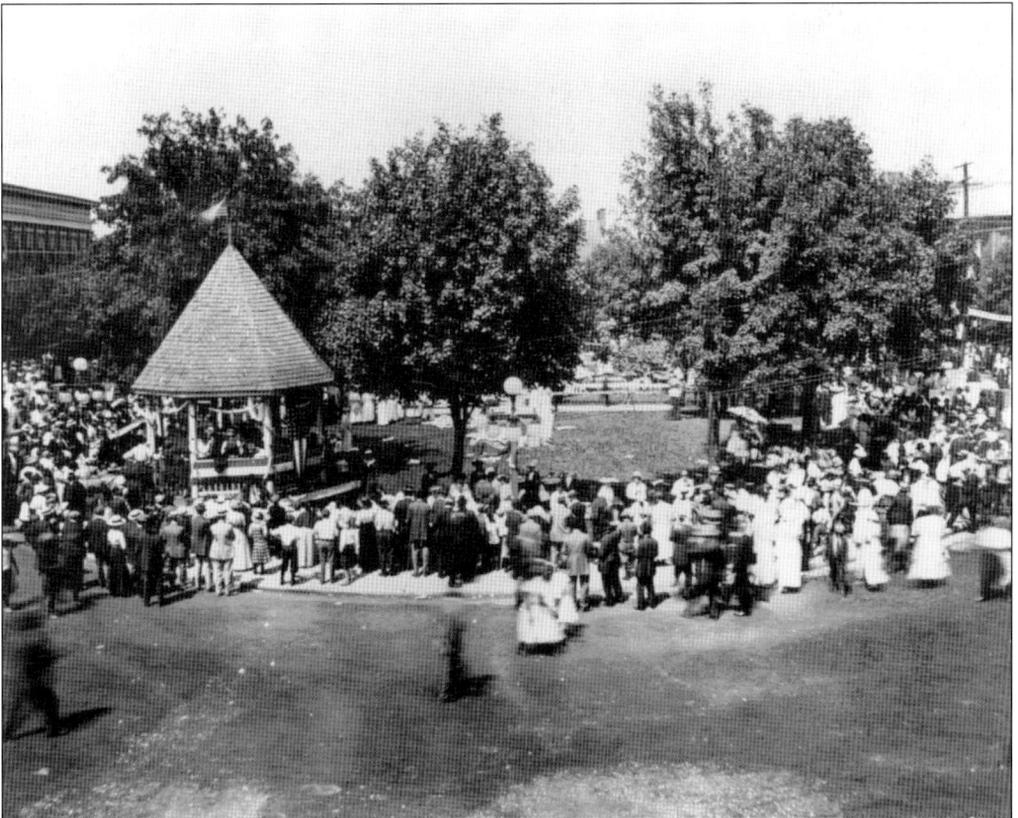

Farmers would come to the county seat of Russellville. In the early 20th century, they came on the first Monday of the month for court matters or to trade or swindle. In the summer of 1915 (above), they gathered at the square for a Dixie Highway Barbecue.

When farmers came to Russellville, they did business with Gaines Cooksey (left, 1868–1948). At his grocery store (below), simply called Cooksey's, he bought their livestock, eggs, and produce. Residents also called him Judge Cooksey because he served as a police judge. Newspaper readers across the county would read his advertisements, and not just for the specials.

The Meanest Woman in the World!

You will wonder just who she is. Possibly she is your wife and you do not know it.

Now we will tell you who she is. Your wife loves you, she loves her children, she loves her home. She has just one hobby. She thinks she is the best cook in the world. Then when you come to town and buy a common cheap brand of lard. Then, when she comes from the kitchen with a plate of biscuits, and looks at you and her children, and gets a whiff of the odor of mean lard from the plate of biscuits, she forgets husband, children and home and becomes the meanest woman in the world

We are selling Old Hickory Lard this week for 50 lb. for $6.50 to advertise this noted brand and to save your family from being broken up by a mean wife.

Cooksey was known for expressing his views and thoughts on the topics of the time. He expressed his disapproval of Kentucky governor A. B. "Happy" Chandler, recommended who to vote for, encouraged support for Tom Rhea and Pres. Franklin Roosevelt, or engaged in a grocery war with a fellow grocer. In a 1937 advertisement, Cooksey warns what happens when a husband buys the wrong product.

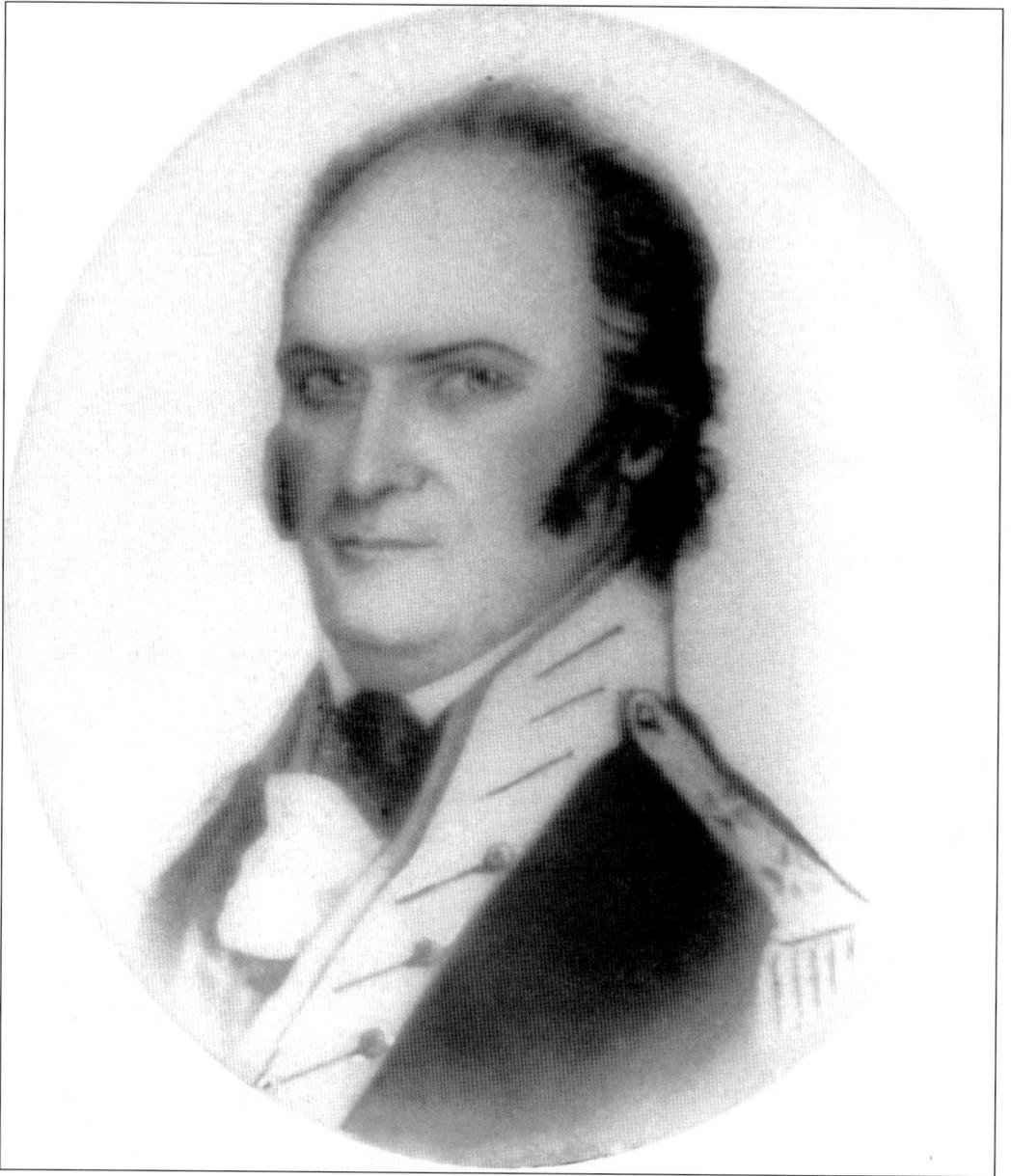

Maj. Richard Bibb (1752–1839) intended to be a minister but instead joined the Revolutionary War. He was one of the wealthiest men in Logan and owned many slaves, but he grew to detest slavery. In 1829, he freed 52 of them and sent them to Liberia. After his death, the remaining slaves were freed and lived on settlements each called Bibbtown. His son, John, invented and cultivated Bibb lettuce.

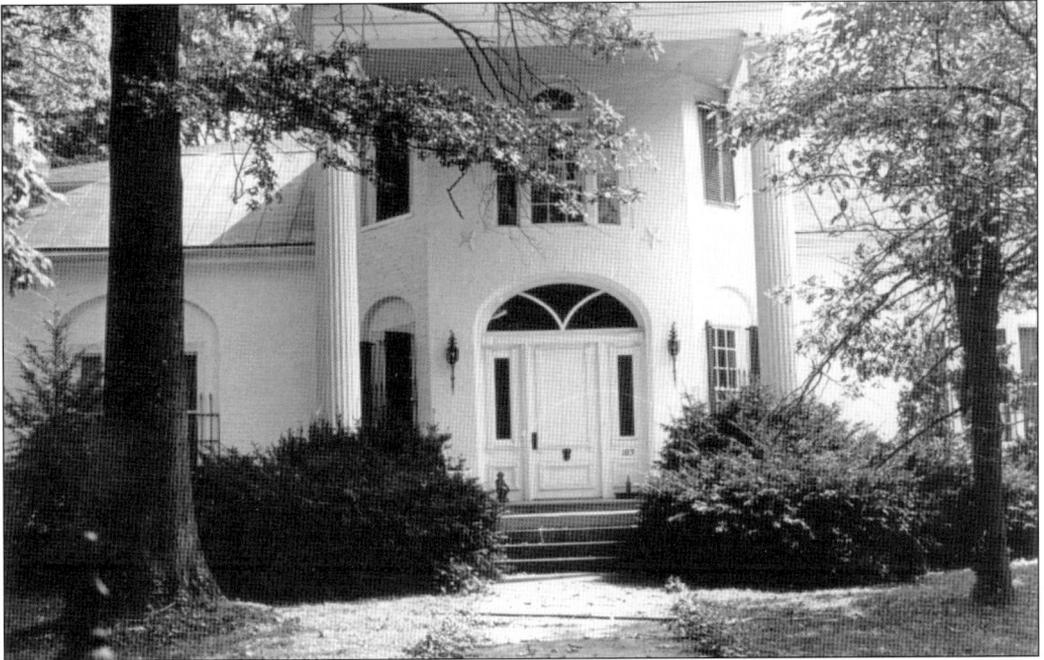

The Bibb House is where Major Bibb freed his slaves in 1829. Fifty-two of them gathered in the backyard. Bibb stood before a barrel with a Bible and hymnbook resting on top. He bid farewell and shook the hands of each slave before they rode off in wagons to Clarksville, Tennessee, where they took a boat to New Orleans.

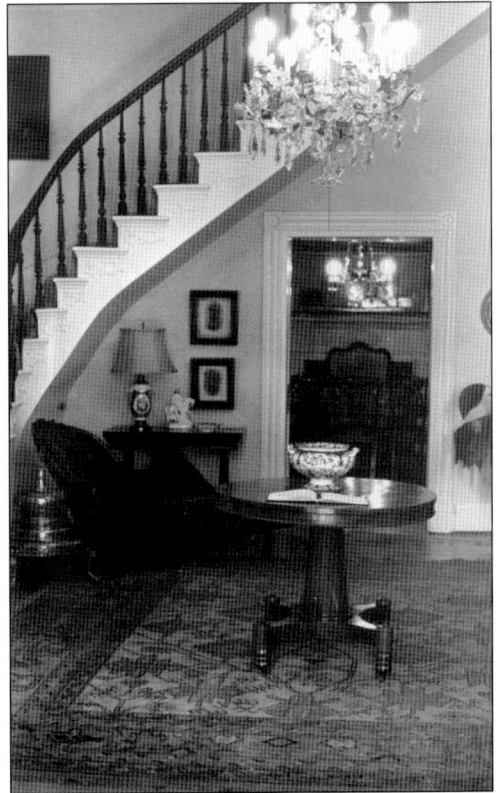

Alberta Foulkes claims her great-great-grandmother, Catherine Bibb, was a daughter of Major Bibb. She lives in one of the Bibbtown settlements and has written a historical sketch about the community. She is the author of a book of poems and claims the church at Bibbtown has three and a half members. "I'm the half-member," Foulkes says. (Photograph by Mark Griffin.)

One of the last private owners of the Bibb House was Agnes Davis, known as the Lady in Red. She received a compliment once that she looked good in red and chose to always dress completely in that color, even down to her undergarments. The Bibb House's interior was even decorated in red. She ran her own fertilizer business on the square. During Christmastime, she set up a Christmas tree decorated with ornaments from the farmers' sons who were serving overseas in the military. Her home was opened for children to visit during Halloween. Her main hobby was collecting crocks.

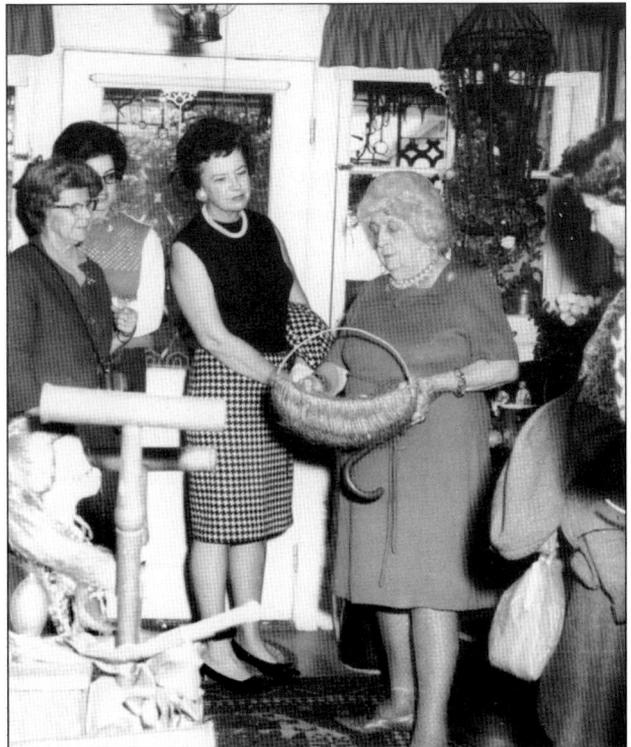

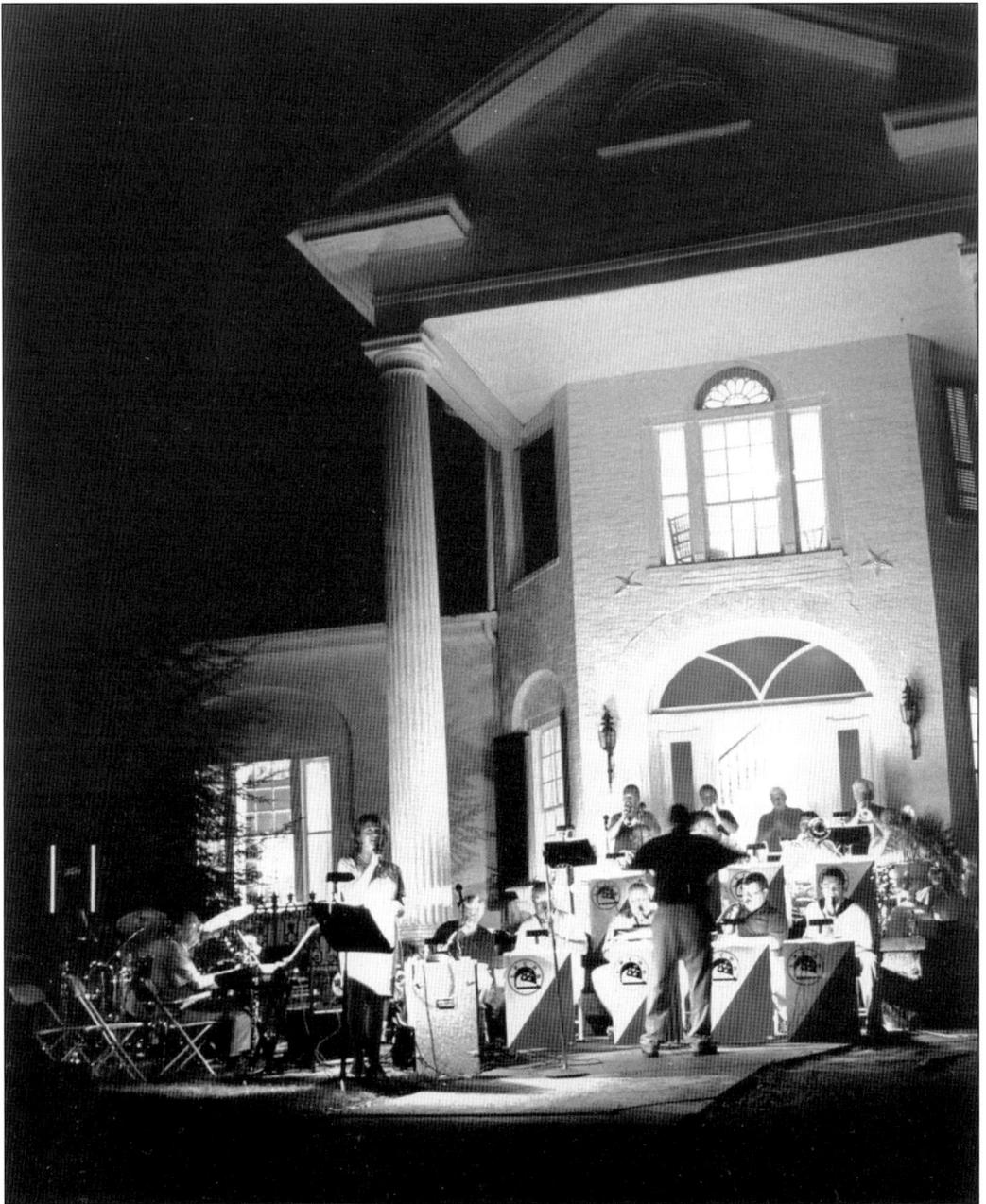

When Agnes Davis died, she requested that the Bibb House be made into a museum. Today the public is invited to browse the historic home or to rent the banquet hall for receptions. Once a year, concerts are held on the front lawn by such performers as the Lost River Cave Big Band (Photograph by Mark Griffin.)

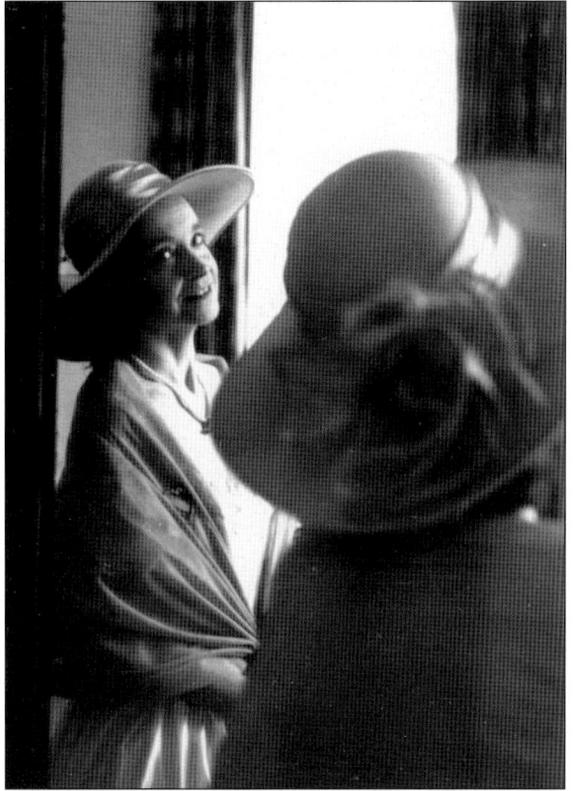

Debbie Grise (at right), as a child, knew Agnes Davis and has portrayed her at the Bibb House. Grise also dresses in antebellum gowns to participate in Civil War events. When Dorian Walker came to Logan County to audition roles for extras for his Civil War drama, *The Greatest Adventure of My Life*, Grise came already in costume. Walker was so impressed he immediately asked her to be in the movie. Grise is a member of the Agnes Davis Red Hat Society (below). Only members age 50 and over are allowed to wear red hats; Grise hasn't reached that age yet, so she wears a pink hat. (Photographs by Mark Griffin.)

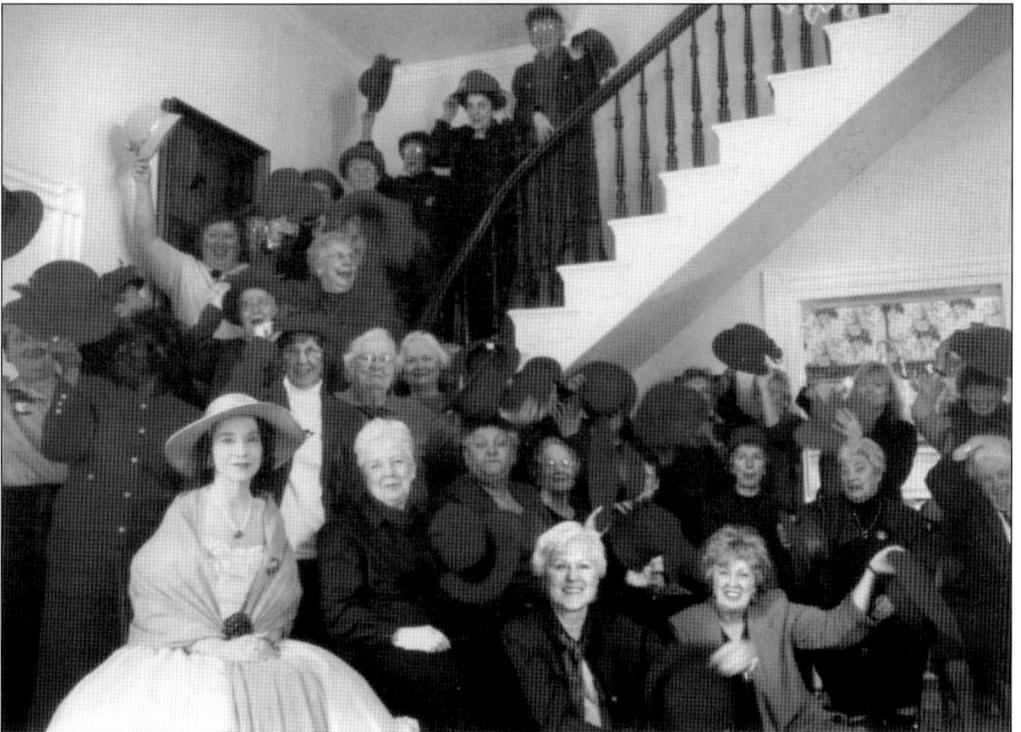

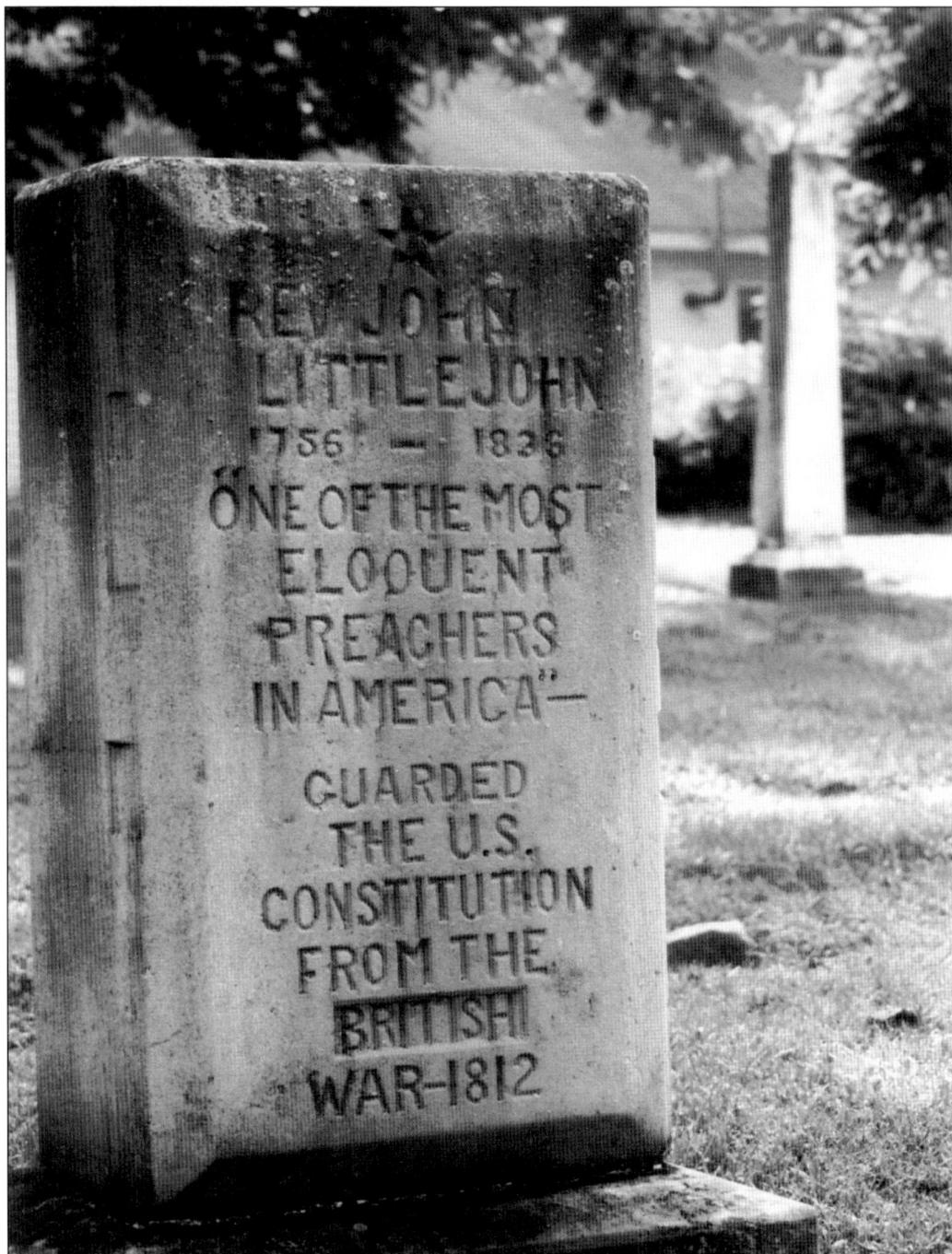

REV JOHN
LITTLEJOHN
1756 — 1836
ONE OF THE MOST
ELOQUENT
PREACHERS
IN AMERICA"—

GUARDED
THE U.S.
CONSTITUTION
FROM THE
BRITISH
WAR-1812

John Littlejohn, a Methodist circuit rider, is another local hero. Born in England, he lived in Leesburg, Virginia, when his country needed his services. During the War of 1812, the Declaration of Independence and other government documents were removed from Washington, D.C., for safekeeping from the British and taken to Leesburg. Littlejohn was entrusted with those documents. Littlejohn moved to a farm near the Red River in 1821 from his home in Leesburg. He died in 1836 and is buried here. (Photograph by Mark Griffin.)

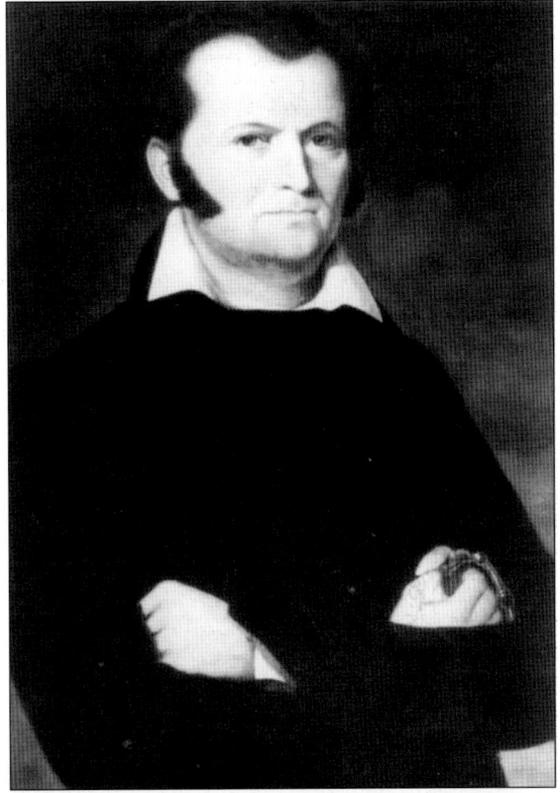

Jim Bowie (right) is claimed by both Logan and Simpson Counties as their native son. At the time he was born, the county was called Logan, but today his birth site is located in Simpson. Bowie is famous for two things. He invented a 15-inch hunting knife, believed to have been made from a meteorite that has his name (as shown below by an unidentified man). He also died at the Alamo in San Antonio, Texas, on March 6, 1863, during its famous moment in history.

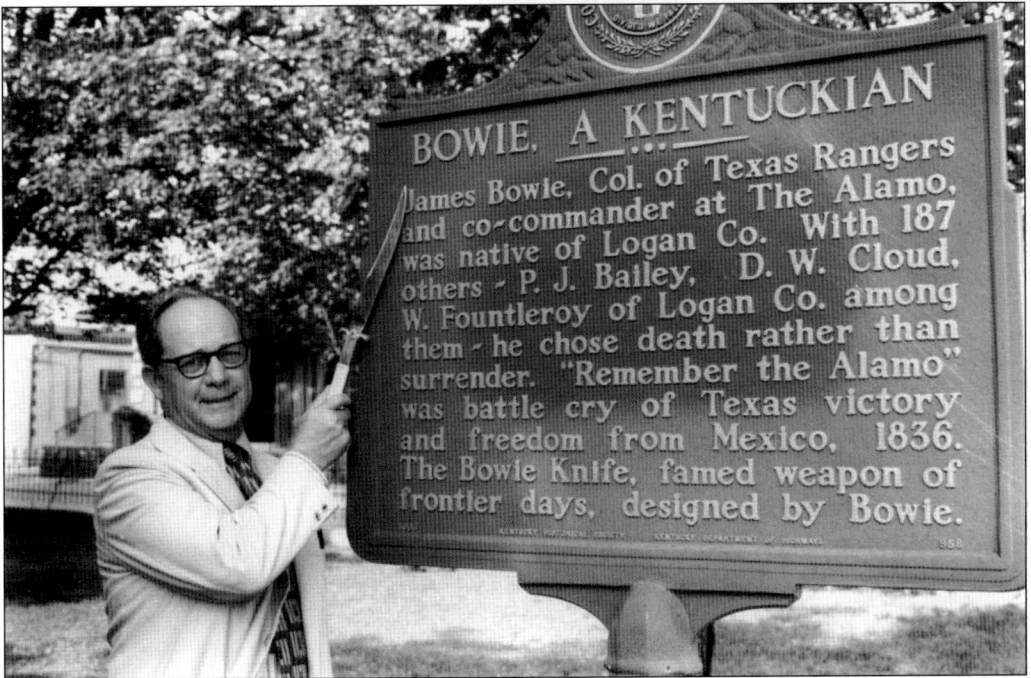

BOWIE, A KENTUCKIAN

James Bowie, Col. of Texas Rangers and co-commander at The Alamo, was native of Logan Co. With 187 others - P. J. Bailey, D. W. Cloud, W. Fountleroy of Logan Co. among them - he chose death rather than surrender. "Remember the Alamo" was battle cry of Texas victory and freedom from Mexico, 1836. The Bowie Knife, famed weapon of frontier days, designed by Bowie.

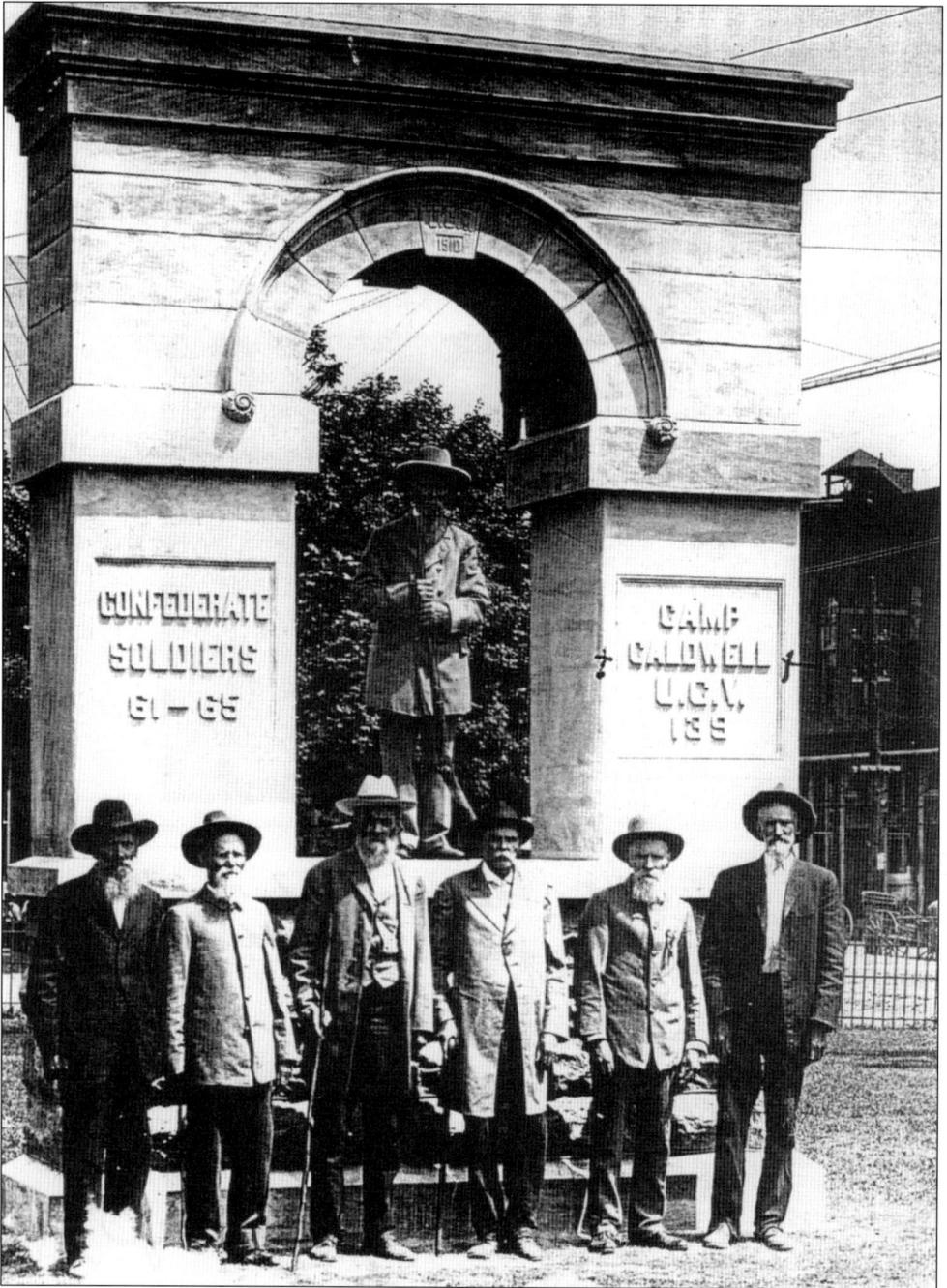

Logan Countians participated in other wars, including the Civil War. Kentucky was seized by the Union before it could secede. On November 18–20, 1861, delegates from across Kentucky came to Russellville at the Clark Building to discuss forming a provisional Confederate government in Kentucky. Some citizens joined the Union army while others sided with the Confederates. The most famous were the soldiers of the Orphan Brigade (pictured in the Square of Russellville at a 1920s reunion). These soldiers from various parts of the state earned their name because once they left Kentucky, they had no way of coming back. (Courtesy of Regina Phillips.)

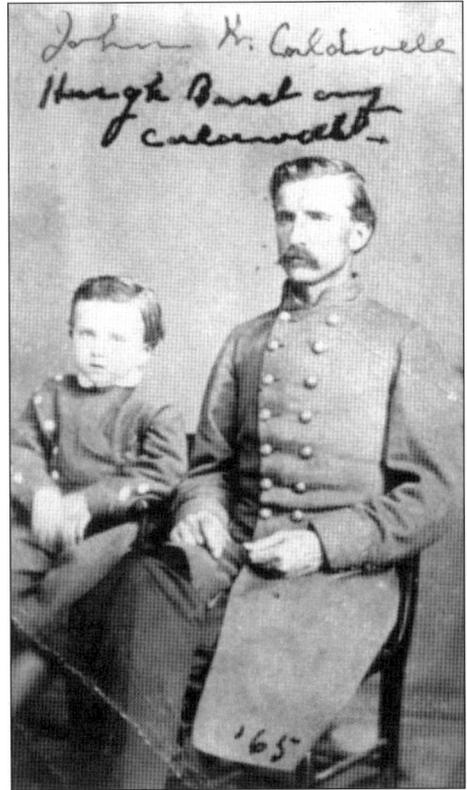

Col. John W. Caldwell's action in the Civil War earned him a statue in the square. When the war started, he (pictured right in 1865 with his son, Hugh Barclay Caldwell) commanded the Logan Grays at the Battle of Shiloh, where 20 were killed and 29 wounded, including himself, out of 64 men. He was wounded again at Chicamauga but continued fighting through the war until he surrendered at Washington, Georgia. John Caldwell Browder (below) was named after the hero. A lawyer and author of the humorous legal novel *Nisi Prius*, he unexpectedly died in 1913 and was mourned by the community.

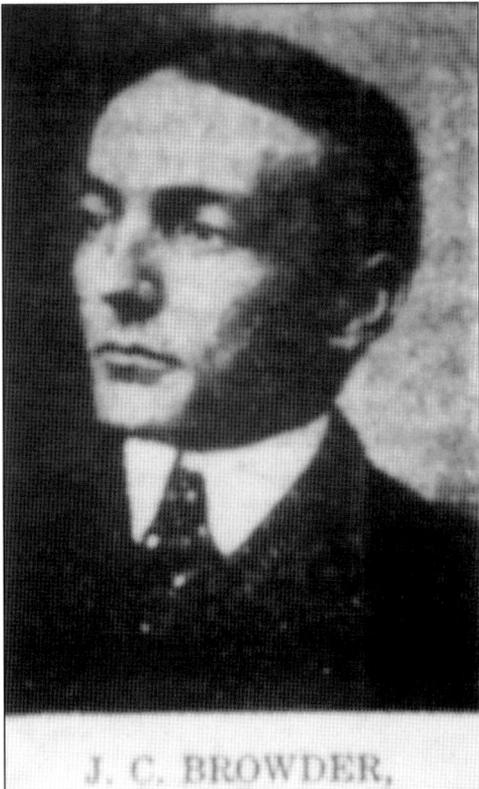

J. C. BROWDER,

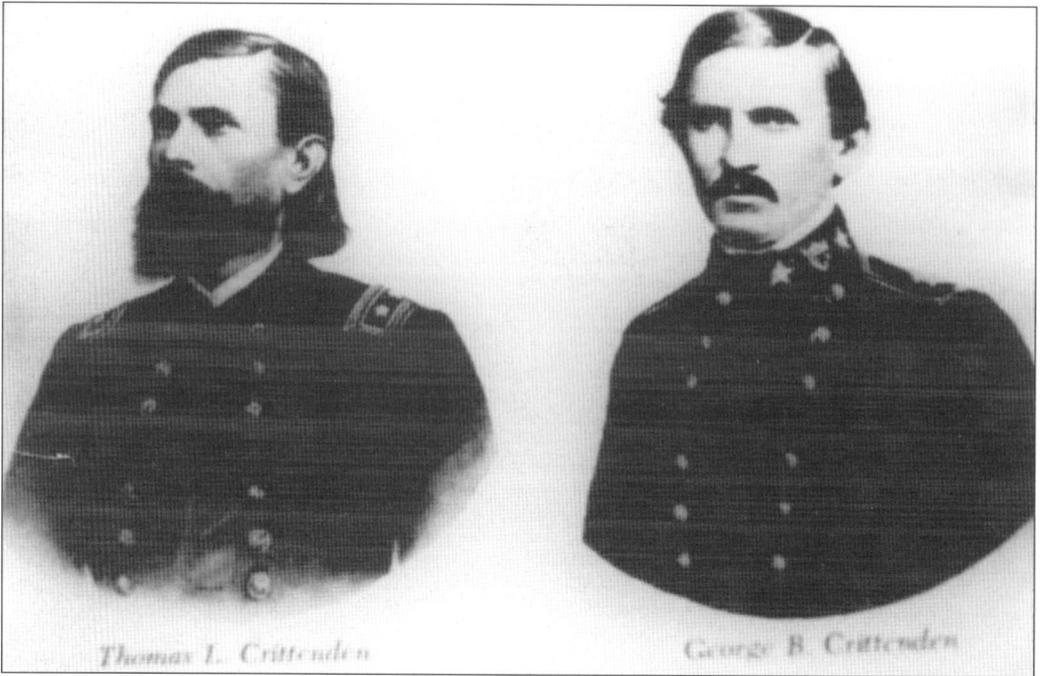

Thomas L. Crittenden George B. Crittenden

U.S. senator John J. Crittenden of Russellville (his home is shown below) tried in December 1860, to create a compromise between the North and the South in hopes of preserving the Union. The Crittenden Compromise failed, and two of his sons, Thomas L. Crittenden and George B. Crittenden (above) fought on opposite sides of the Civil War, meeting each other at the Battle of Shiloh.

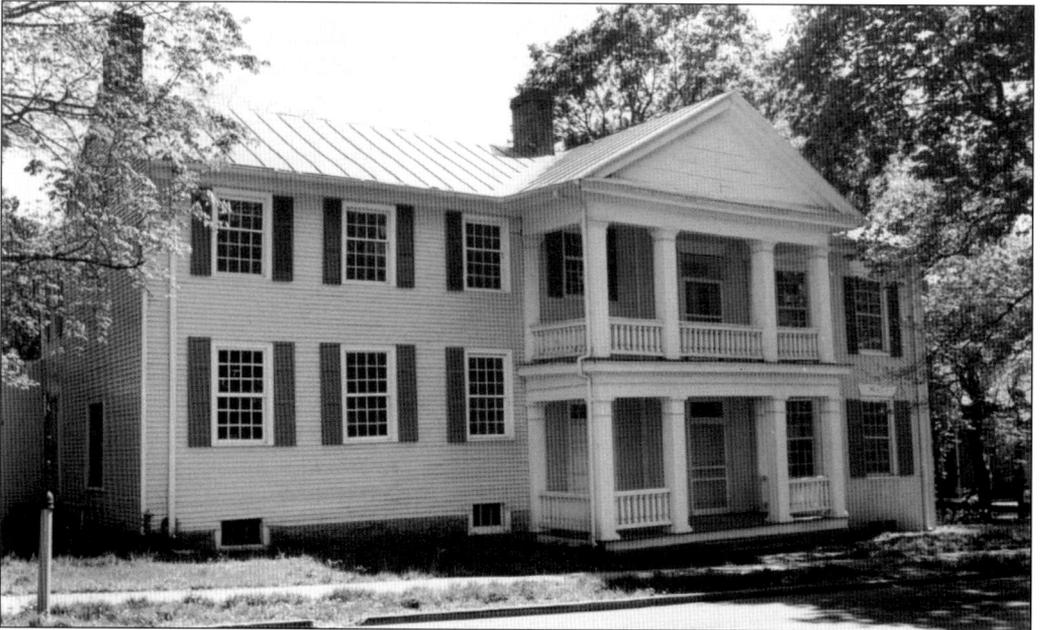

John J. Crittenden served as governor of Kentucky from 1848 to 1850. Other Logan Countians have served as governor: John Breathitt (1832–1834), James T. Morehead (1834–1836), and Charles S. Morehead (1855–1859). Historical markers (as pictured with unidentified people at top and bottom) were erected in June 1964, near Breathitt's home to honor these four men. Another Logan Countian, Tom Rhea, who lived in the Breathitt House almost became the fifth governor from the county. (Photographs courtesy of Barrow-Skaggs Studios.)

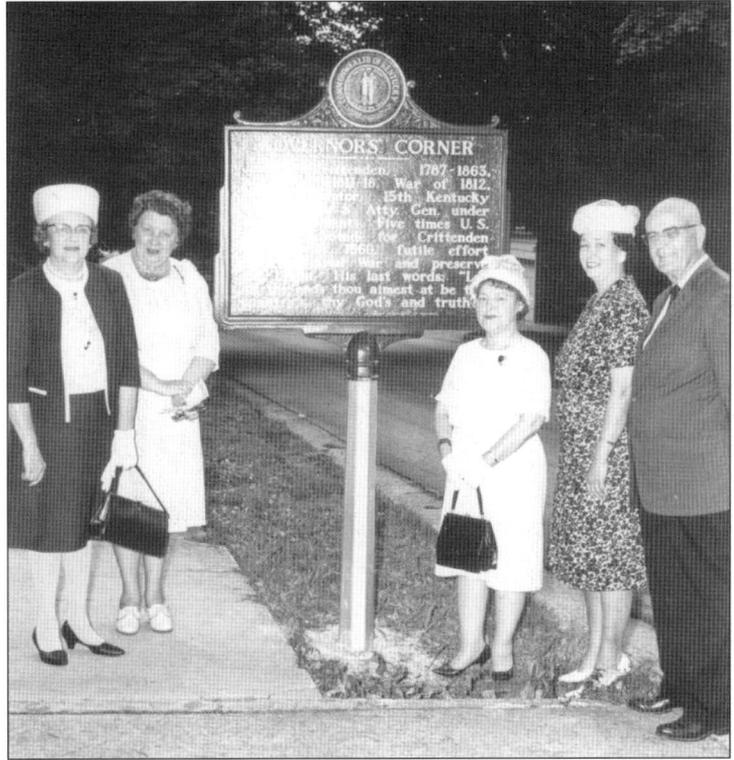

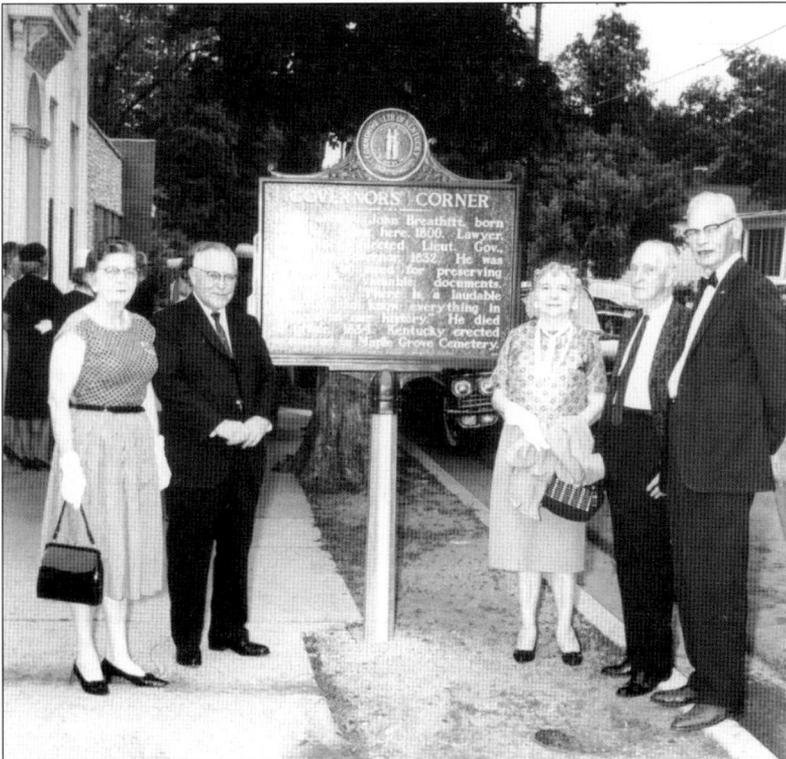

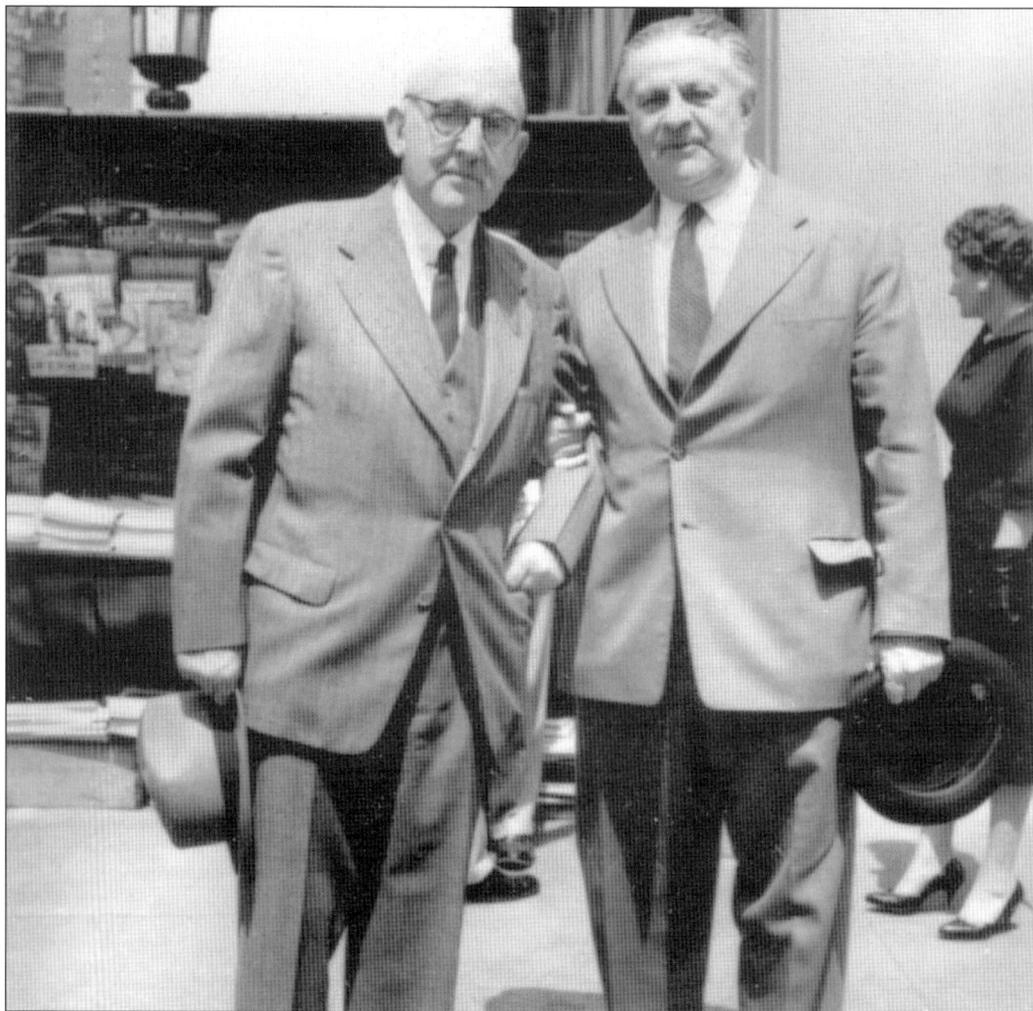

One Logan Countian left here but never forgot the county. Thomas Pritchett deGraffenried Jr. (1881–1961) practiced law in New York after leaving Russellville. As a counsel member of Cunard Steamship, he had a successful practice. When deGraffenried (pictured on the left with an unidentified gentleman) died, he bequeathed approximately $1 million to Russellville for the education of its citizens.

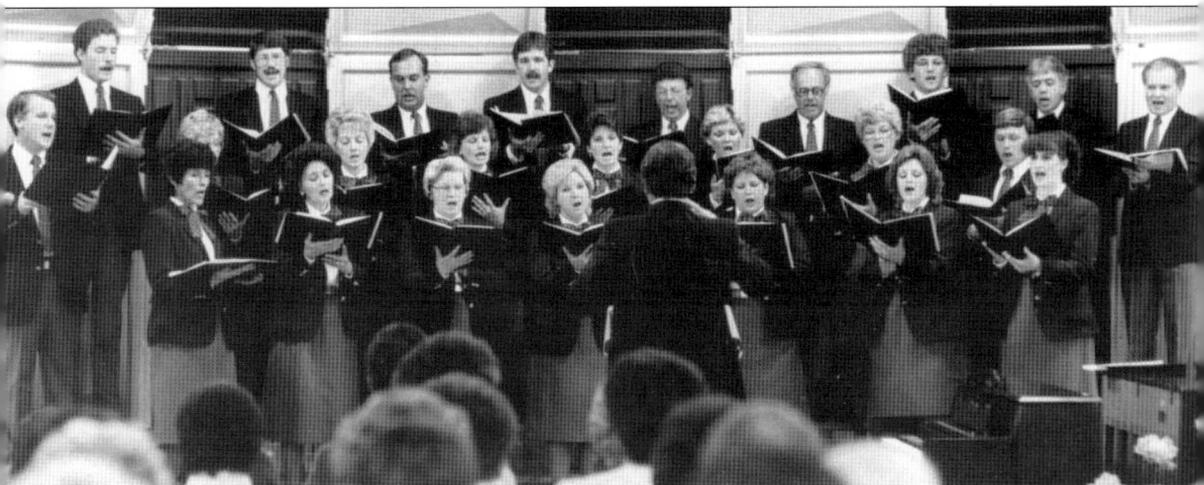

DeGraffenried's bequest led to the creation of the Logan County Public Library, Russellville Area Vocational School, the deGraffenried scholarship grant and loan fund, the deGraffenried Auditorium, and the deGraffenried Chorale (above). The chorale was organized in 1978 by Hazel Carver, who also served as its first director.

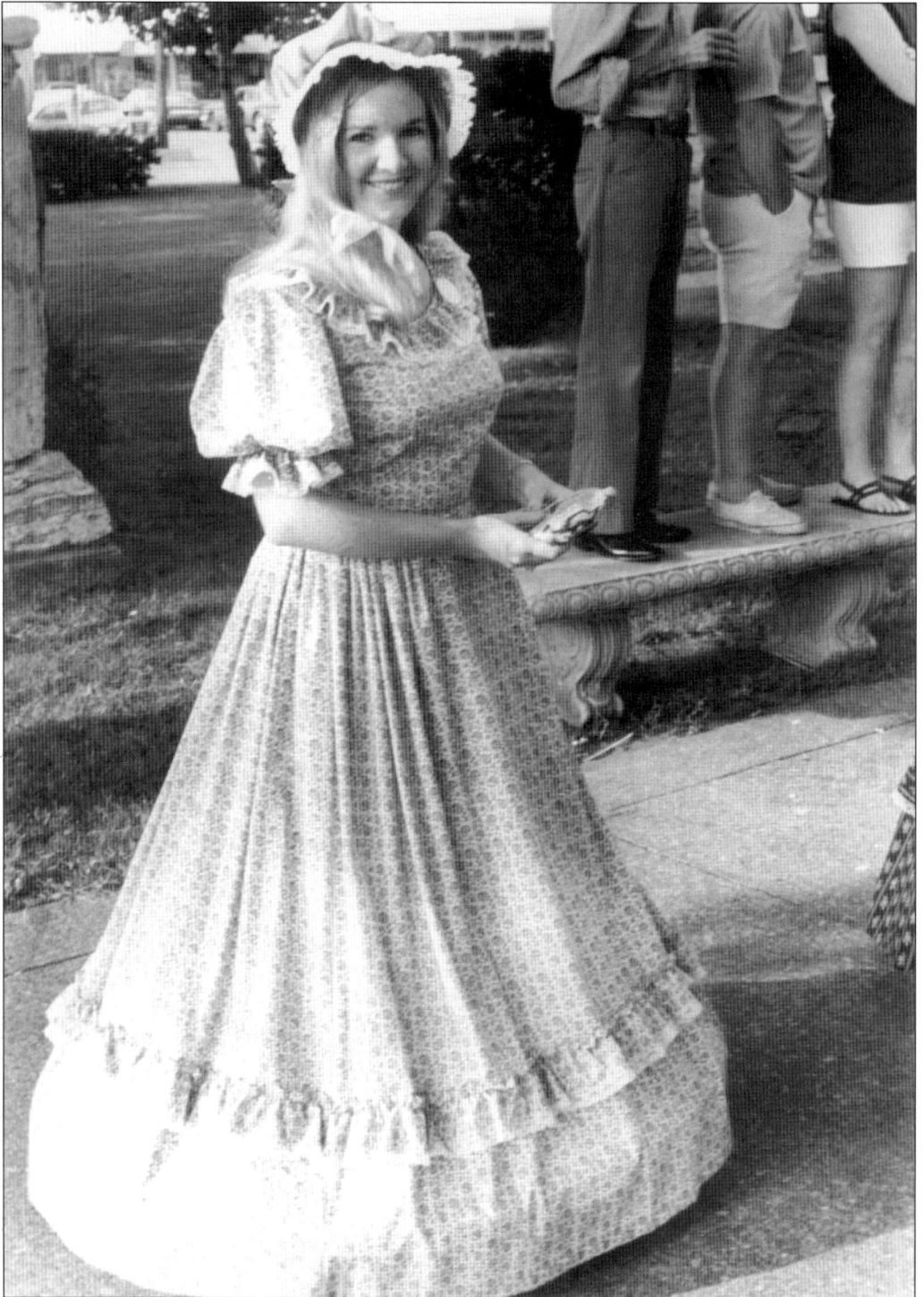

Mary Beth Dowden sings in the deGraffenried Chorale as well as assisting in other musical performances and being a former music teacher at the elementary school. In the picture above, she is dressed in period attire for Russellville's 175th anniversary.

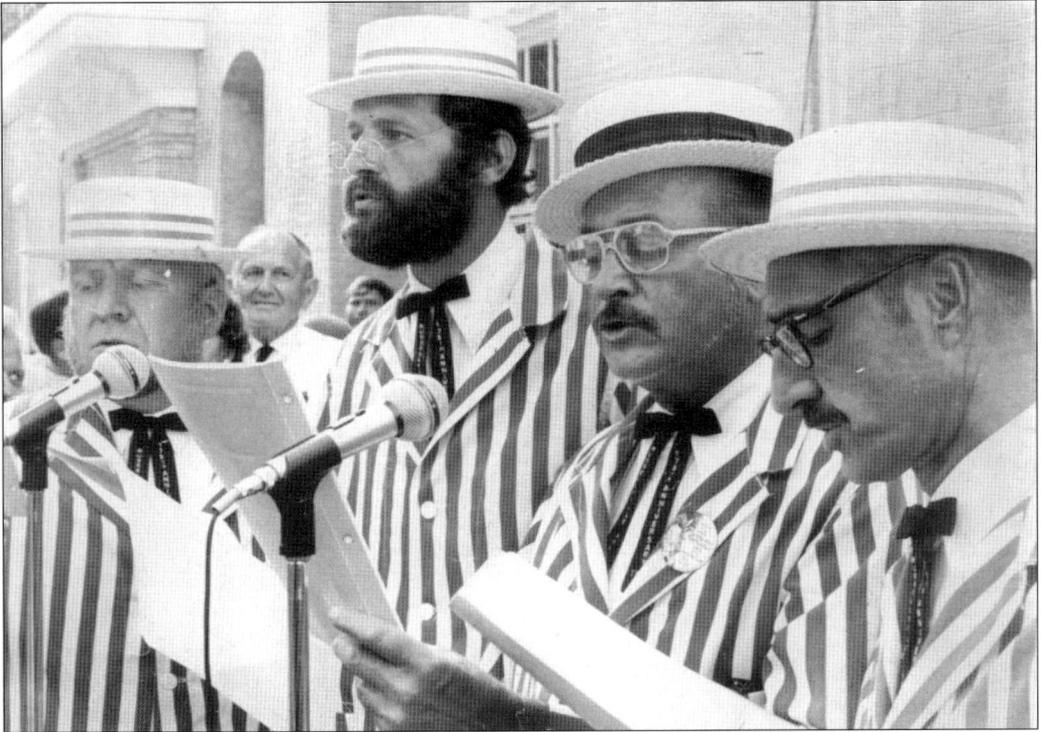

In the year 1973, Russellville celebrated its 175th anniversary. A patriotic parade (below) was held downtown, men grew beards, and women wore Colonial gowns. From left to right above, Joe Hardy, Bill Webb, Jim Lyne, and Joe Emberger sang in a barbershop quartet (above).

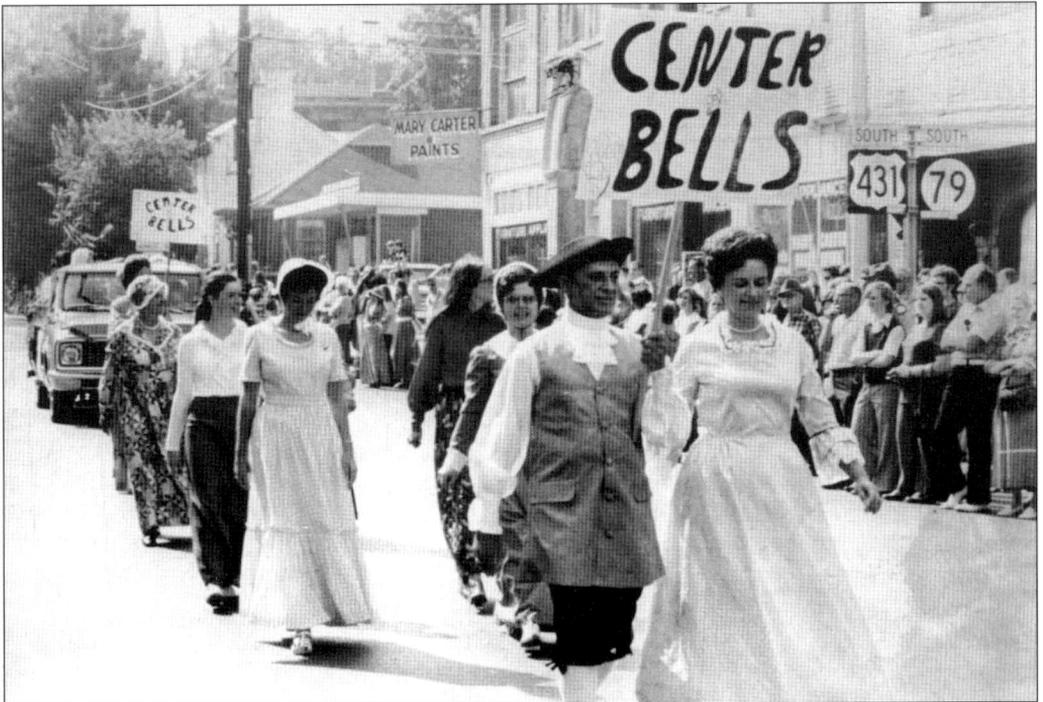

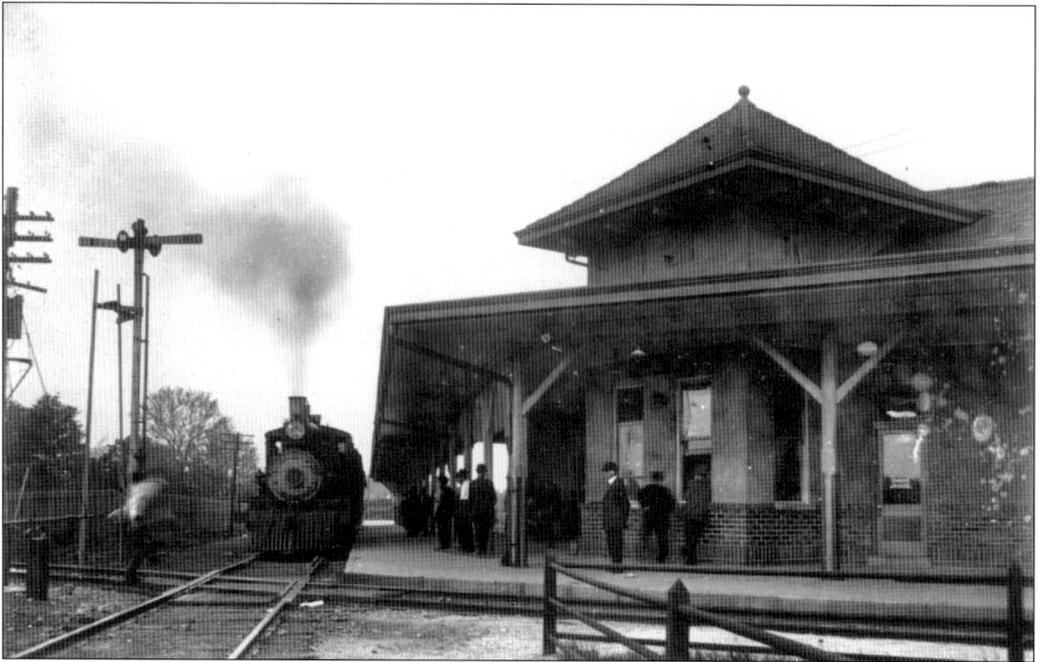

People who came to Russellville usually took the train. The Russellville Depot (above) became a popular hangout spot as residents went to see who would arrive. For visitors with luggage or packages for residents, H. Wade Hampton (below with his daughter, Meme, right, and Morgan Caldwell, left) ran an express service where he would pick up the items for them. Meme was called one of the most beautiful women of Russellville.

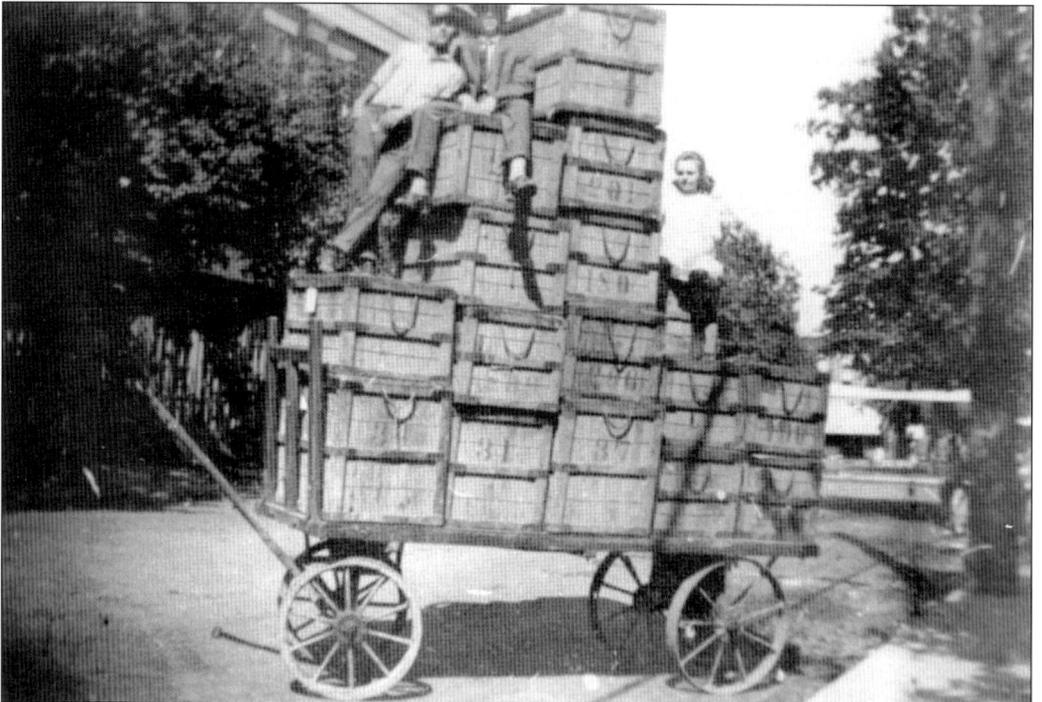

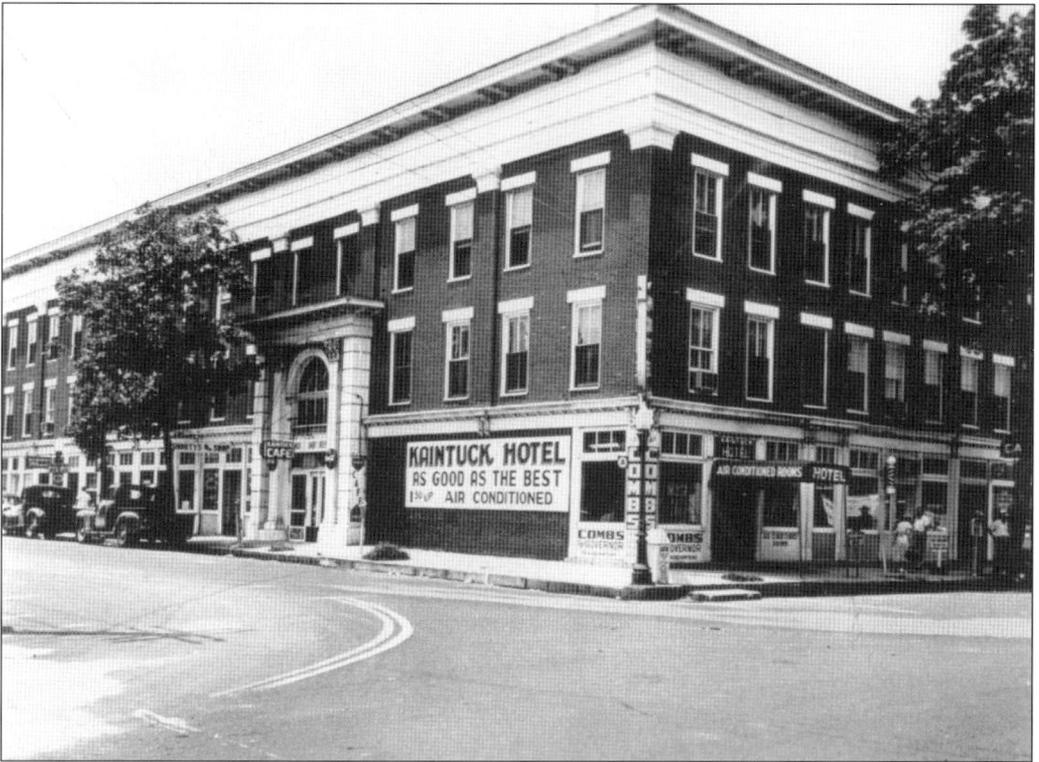

Hampton delivered the luggage to his office at the Kaintuck Hotel (above in 1956), where visitors also stayed. The grand three-story hotel, once known as the Forst House (shown below in 1900) had a barbershop, pool hall, tobacco office, laundry, post office, express office, doctor's office, and saloon. Cooksey's was originally located here. The hotel was torn down, and a large bank was built on the location.

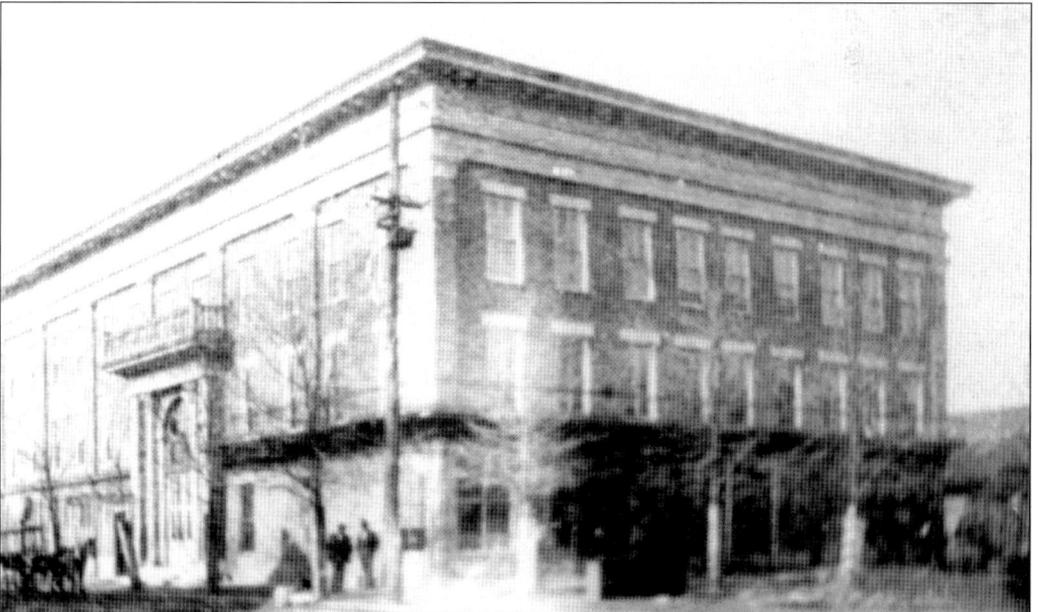

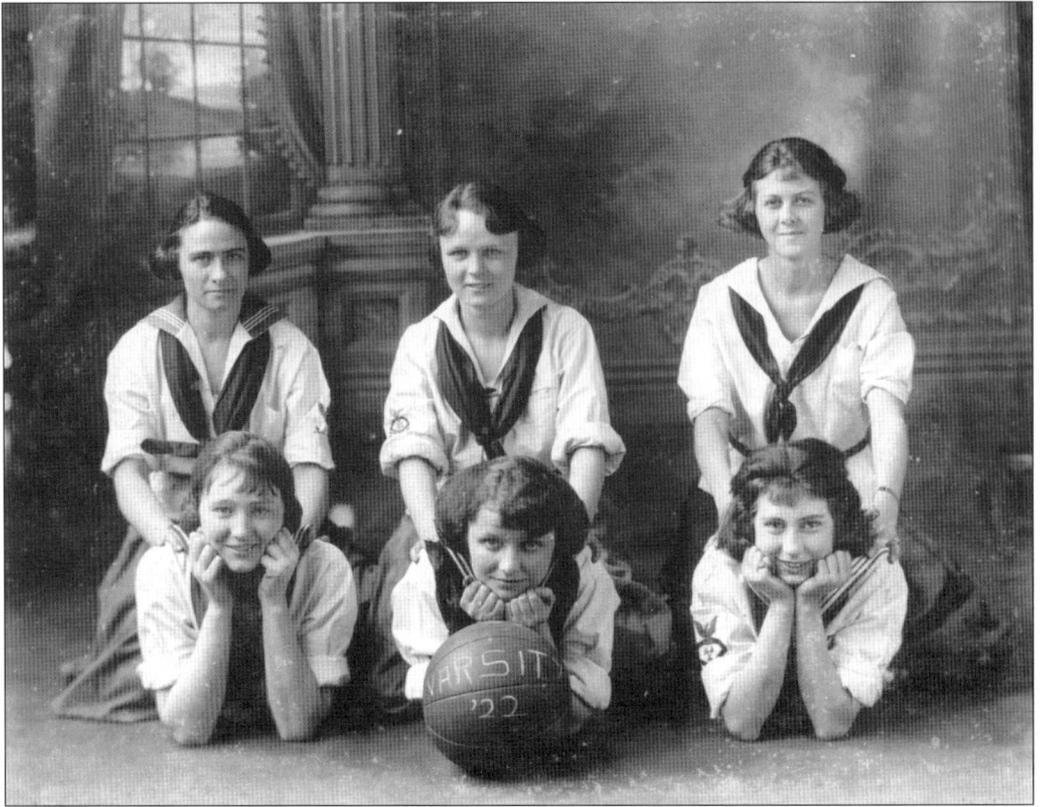

Young ladies came from various states to be educated at Logan Female College (shown below), which started in 1856. An ample gymnasium allowed for the creation of basketball teams (above), but they only played against themselves. The school closed in 1931 because of the Great Depression.

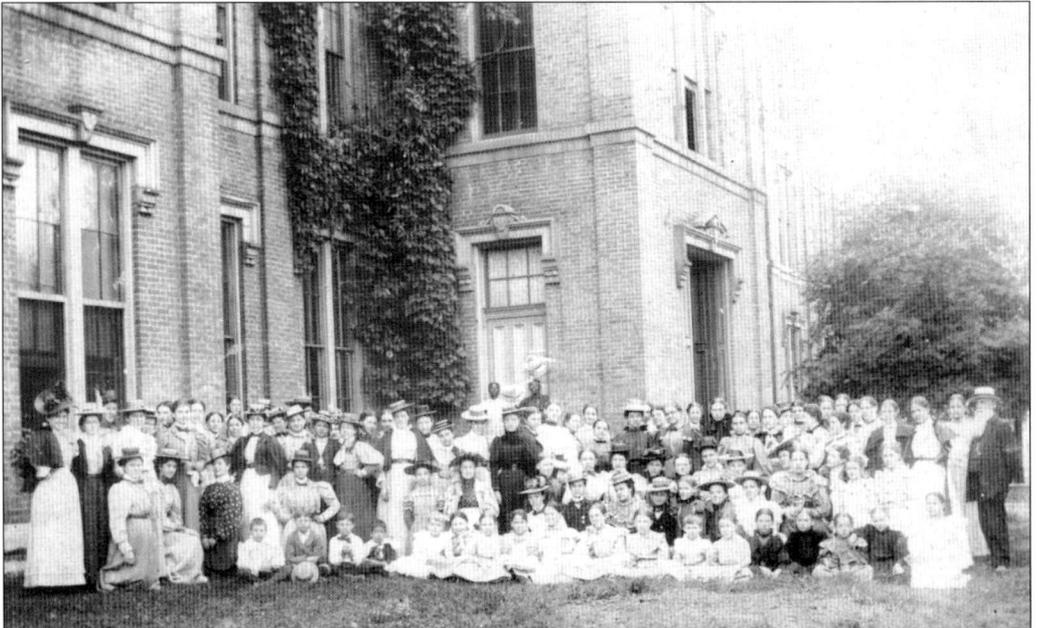

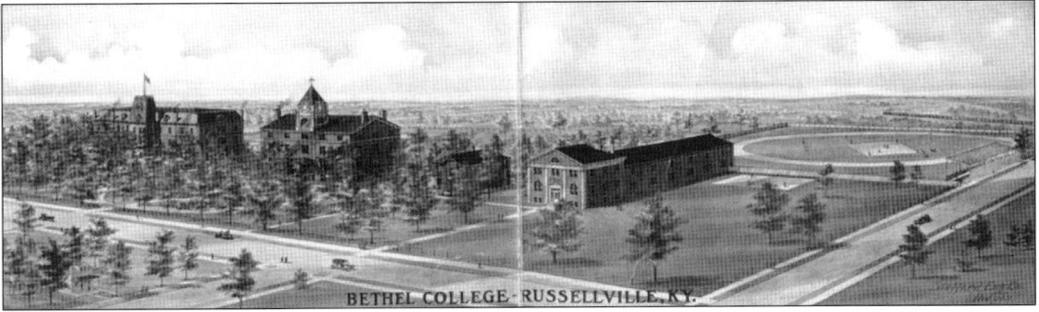

BETHEL COLLEGE · RUSSELLVILLE, KY.

For the young men, there was Bethel College (the campus is shown above and the professors below). Started on January 3, 1854, as a high school, the school's campus grew to where it had two dormitories, apartments for married couples, a library, athletic field, and more. Bethel closed on January 20, 1933, because of the Great Depression.

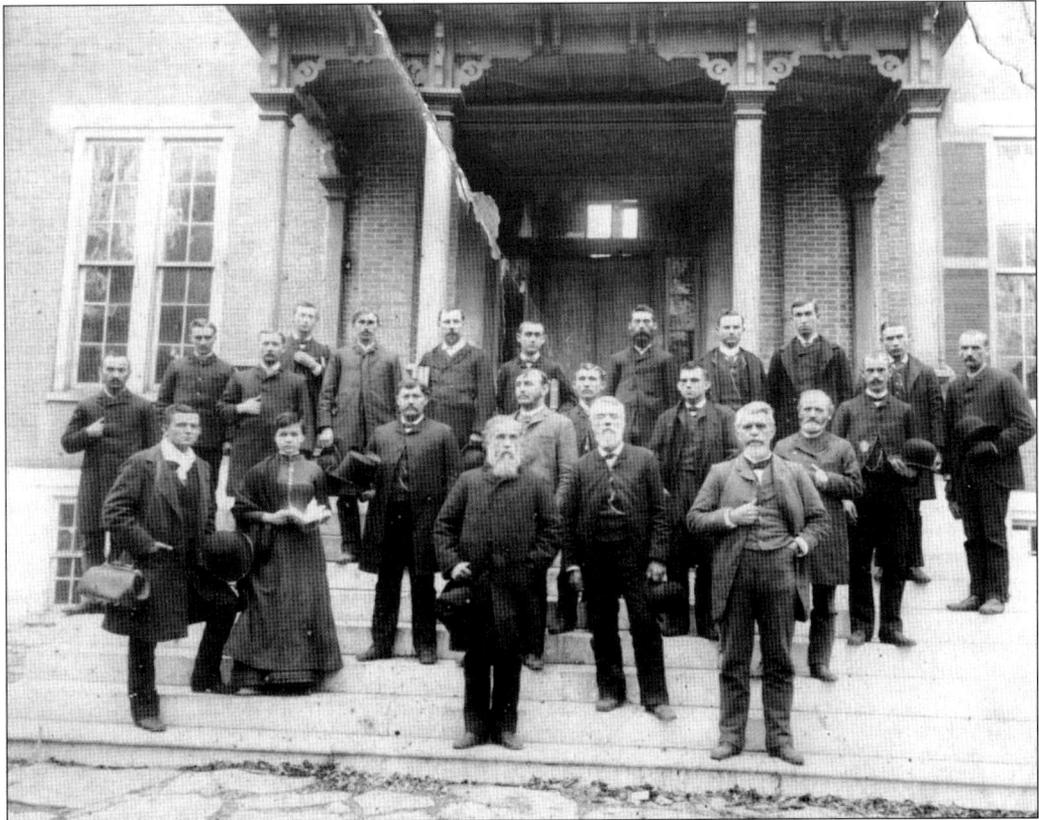

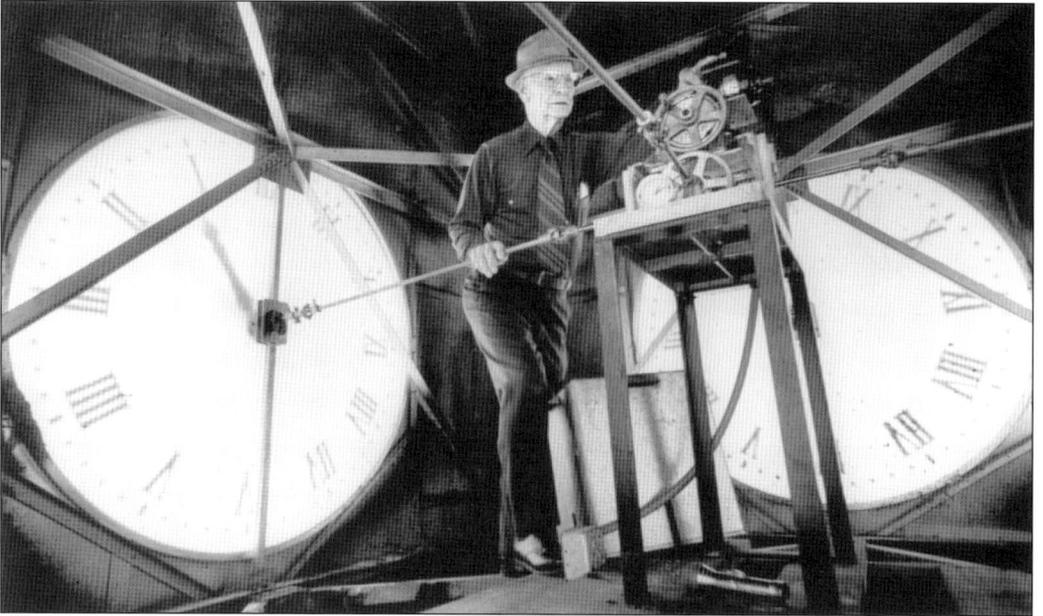

Logan Countians survived the Great Depression, and time marched on, just like the clock at the courthouse. The one responsible for the clock's maintenance was Elbridge W. Humphries (1904–1986).

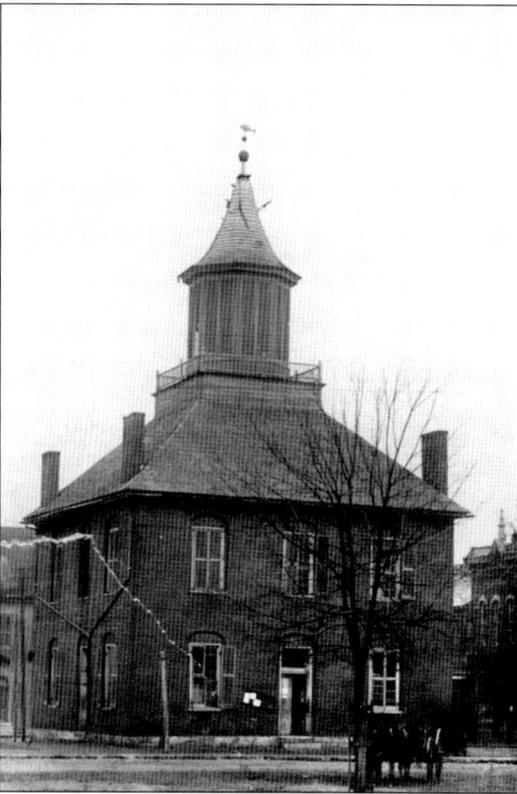

Four

POLITICS AND ELECTIONS

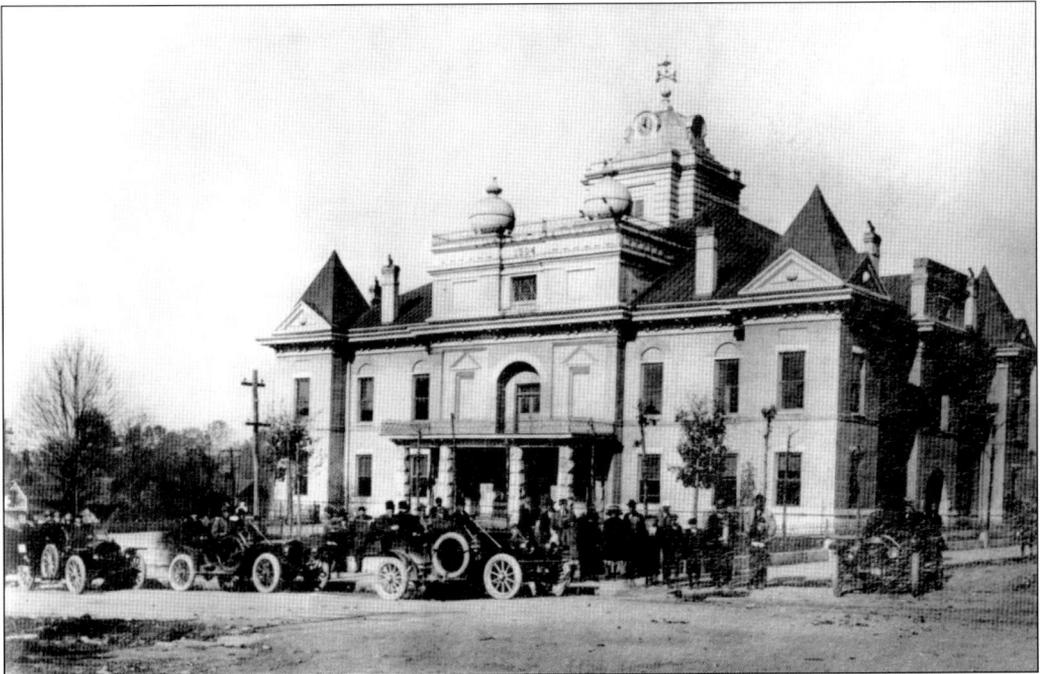

When the James Gang robbed the bank and Frank James shot at the fish weathervane, the courthouse was located on the square (opposite page). In 1904, it moved to its current location on Winter and Fourth Streets (above).

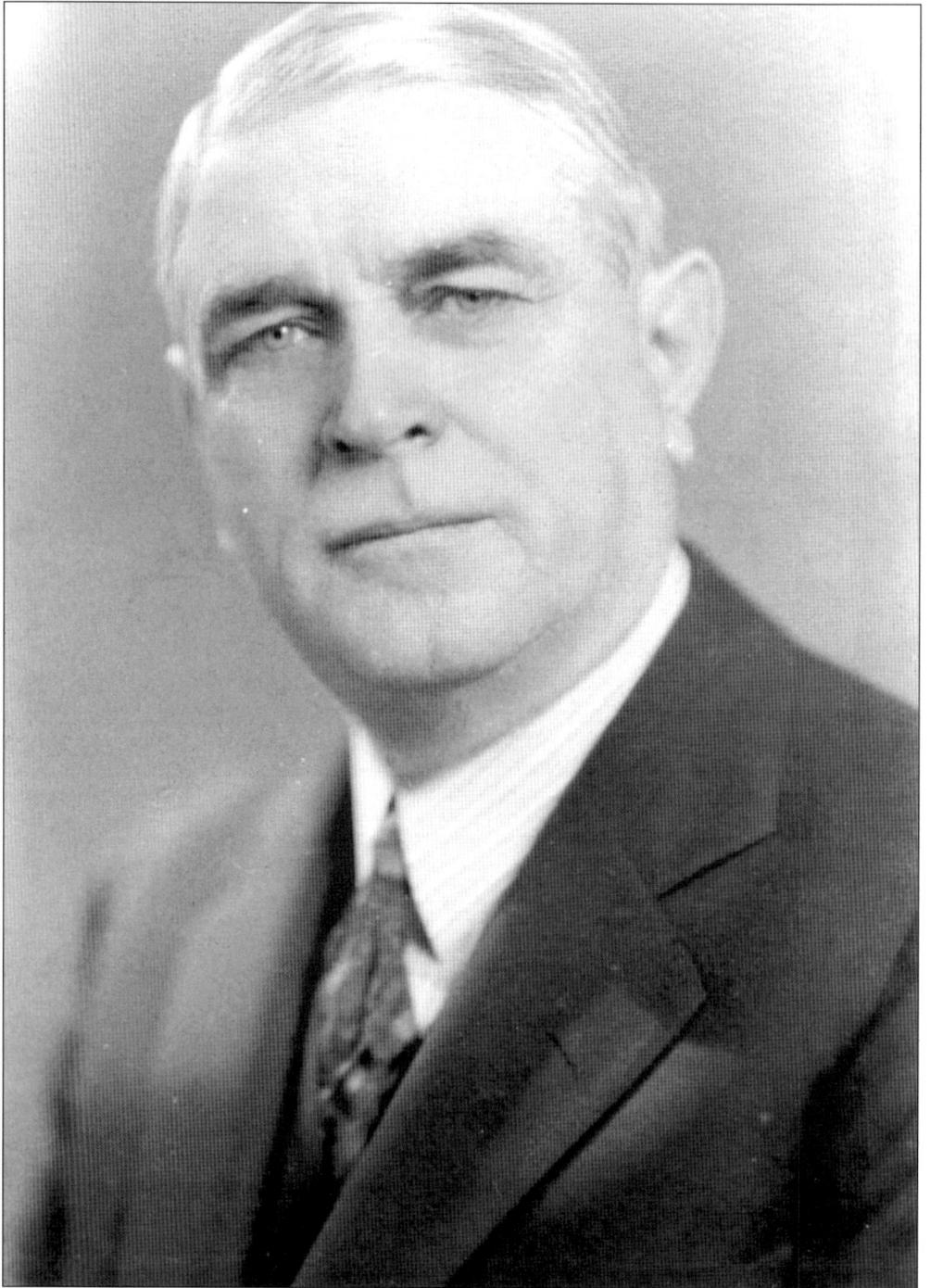

One cannot talk about Logan County without mentioning Thomas Stockdale Rhea (1871–1946). His political influence reached across western Kentucky, making him one of the most powerful political figures in Kentucky history. His only elected positions were sheriff and state treasurer, but he served on the Kentucky Highway Commission and as campaign manager for several successful candidates for governor. He was unsuccessful with his own.

Tom Rhea (shown in the second row, third from right) had become an early advocate of Franklin D. Roosevelt when he was campaigning for president. Rhea was impressed with Roosevelt's ideas. At the June 1932 Democratic convention in Chicago, Rhea lined up votes for Roosevelt so he would be the Democratic nominee. Rhea's efforts helped the New York liberal win in the conservative South. Roosevelt appreciated Rhea's help so much he made a surprise visit to Russellville on July 8, 1938, to express his gratitude. Family lore says Roosevelt offered Rhea a cabinet position, but Rhea wanted to become governor.

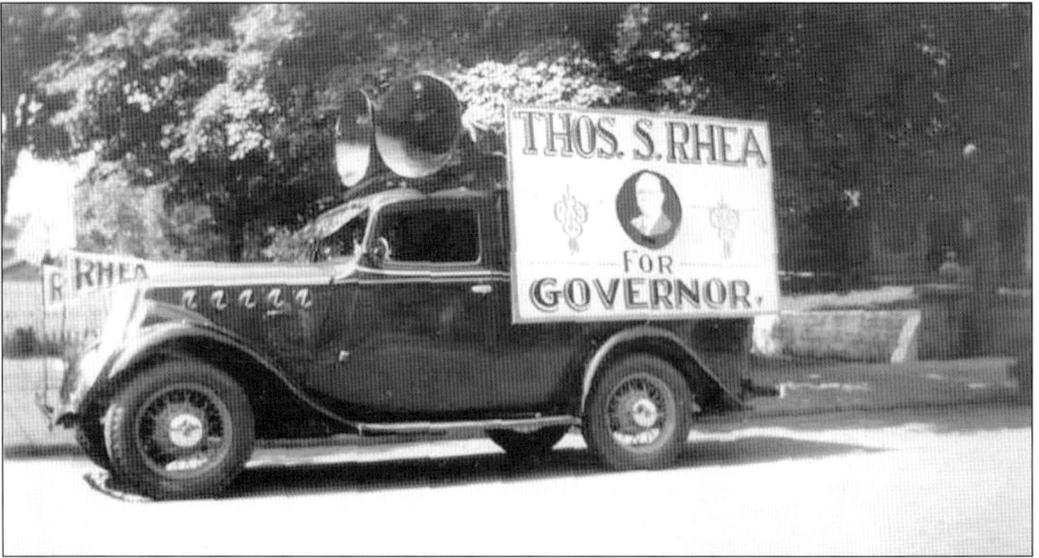

In 1935, Rhea ran for governor against A. B. "Happy" Chandler, the Boy Wonder. Chandler—a charismatic young politician who was serving as lieutenant governor—knew Gov. Ruby Laffoon preferred Rhea. When Laffoon and Rhea left for Washington to talk to Roosevelt for New Deal assistance, Chandler used the absence to call for a reform in state elections, wanting a primary system for political nominations instead of relying on conventions. Rhea and Laffoon returned to Kentucky. Rhea was concerned that Chandler would get enough votes in a primary system to beat him, so he suggested a double primary system, figuring he would get enough votes then to beat Chandler in the second term. His own idea would be his downfall.

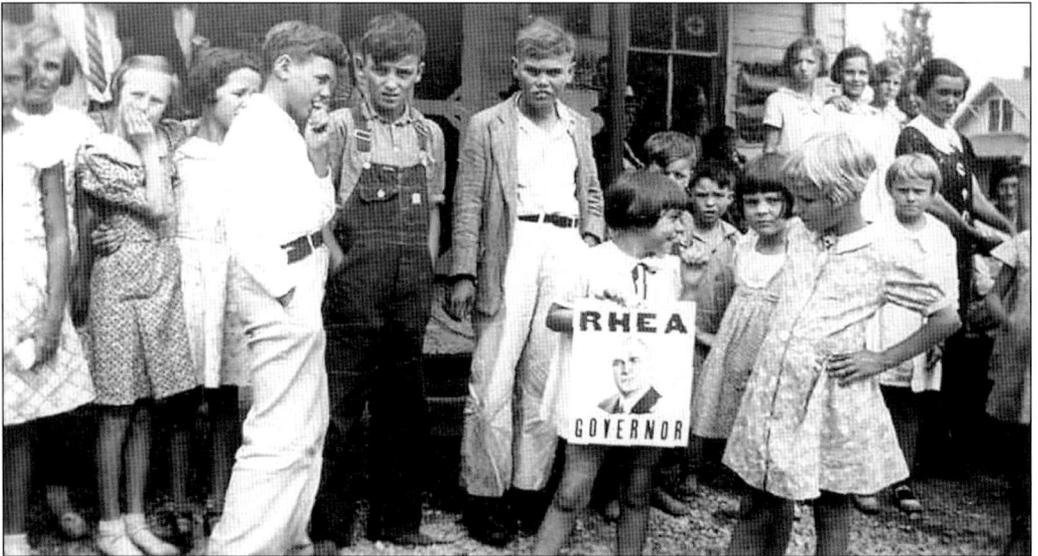

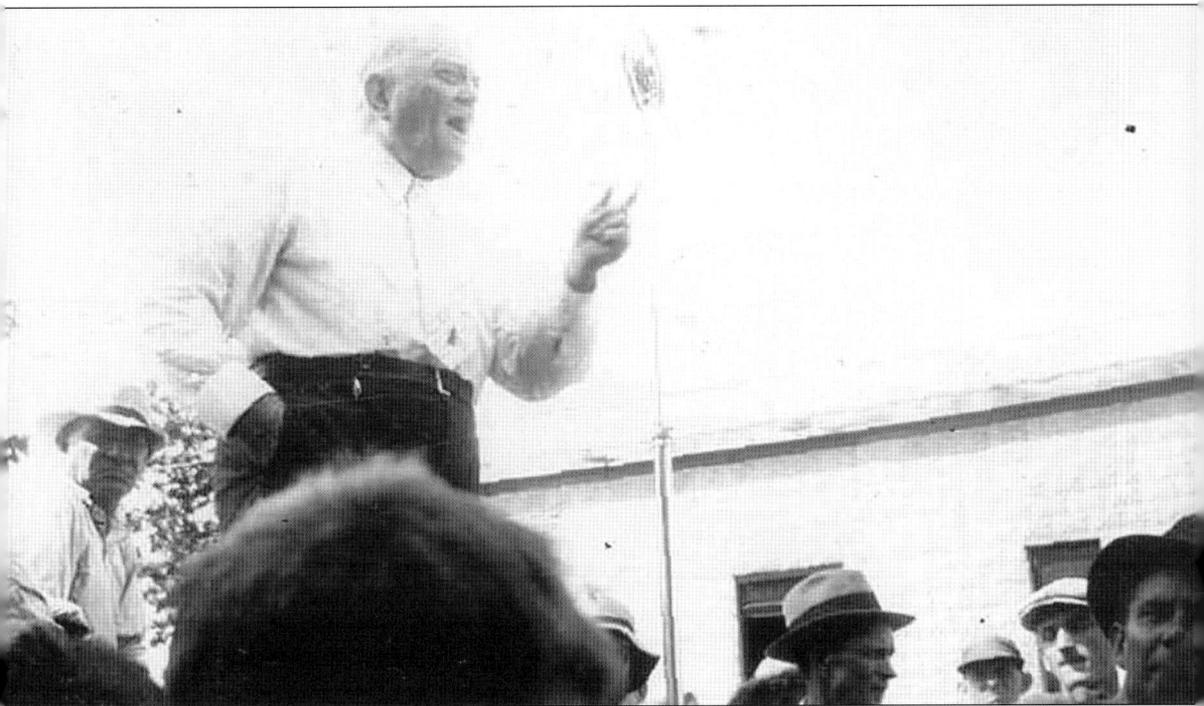

E. J. Felts, the commonwealth's attorney, drove the Rhea bandwagon across Kentucky. Rhea's brother, Albert Gallatin (above), spoke in Central City, Kentucky. A large picnic was held June 8, 1935, in Bowling Green, Kentucky, in honor of Rhea, and the day was declared Tom Rhea Day. All stores in Russellville closed so people could attend. A motorcade of 1,200 people from nearby Greenville drove to the picnic. Rhea's platform including supporting Roosevelt's New Deal, old age pension, and repealing the state tax on food items.

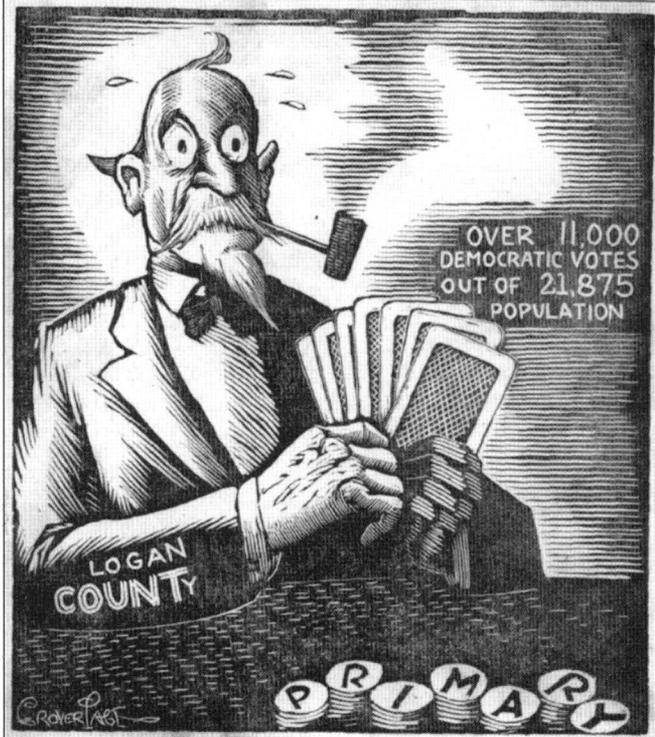

"But Colonel, Haven't You Too Many Cards?"

OVER 11,000 DEMOCRATIC VOTES OUT OF 21,875 POPULATION

LOGAN COUNTY

PRIMARY

The first primary was held August 1, 1935, and Rhea won. In Logan, Rhea received such a high number of votes that Chandler and the *Courier-Journal*, a statewide newspaper, claimed that was more people than were registered to vote. Political cartoons lampooned Rhea's victory in Logan. "Some of the press criticize our large majority," Gaines Cooksey retorted, "but they cannot, not being a Logan County citizen, realize just how solid we were behind Tom, regardless of our party affiliations." Rhea lost the second primary in September, and Chandler became governor.

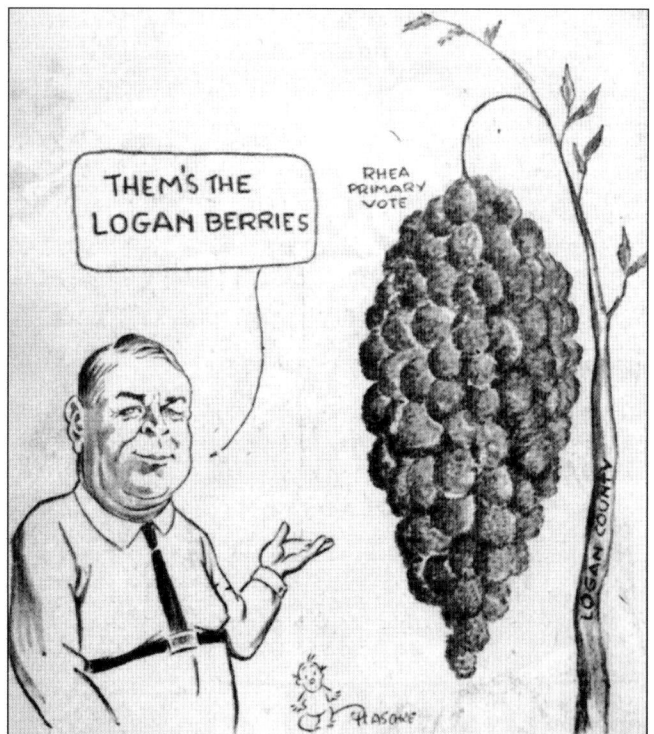

THEM'S THE LOGAN BERRIES

RHEA PRIMARY VOTE

LOGAN COUNTY

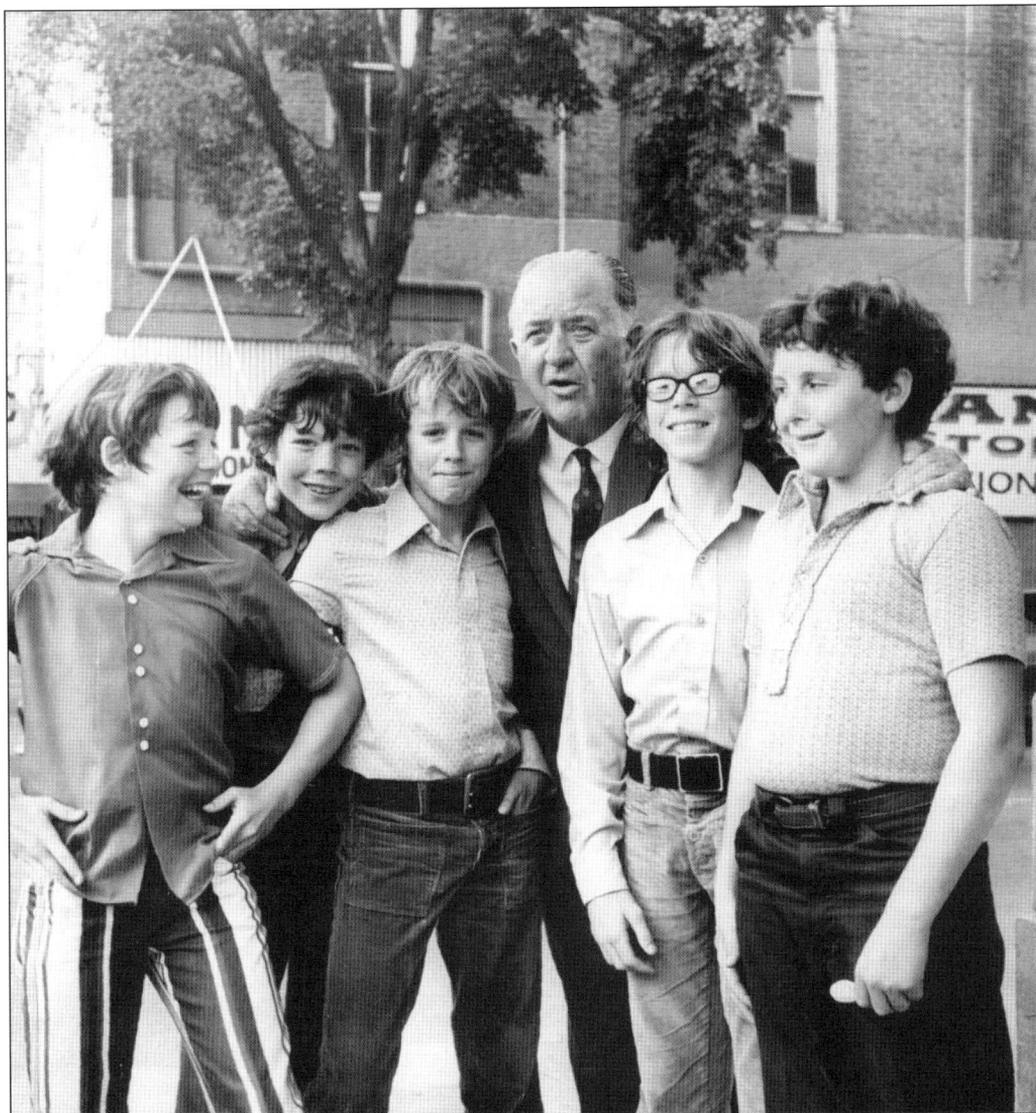

The 1935 election caused so much resentment between the two candidates that Rhea, a staunch Democrat, supported the Republican nominee for governor. Local lore says Chandler wanted to build a wall around Logan. As time passed, the hard feelings between Logan County and Chandler softened. Chandler came to Russellville in 1976 to ride in the Tobacco Festival Parade and have his picture taken with children. (From left to right, the children are Andy Humphries, Charles Mathis, Louis Kirkpatrick, Bob Hedges, and Wick Gorrell).

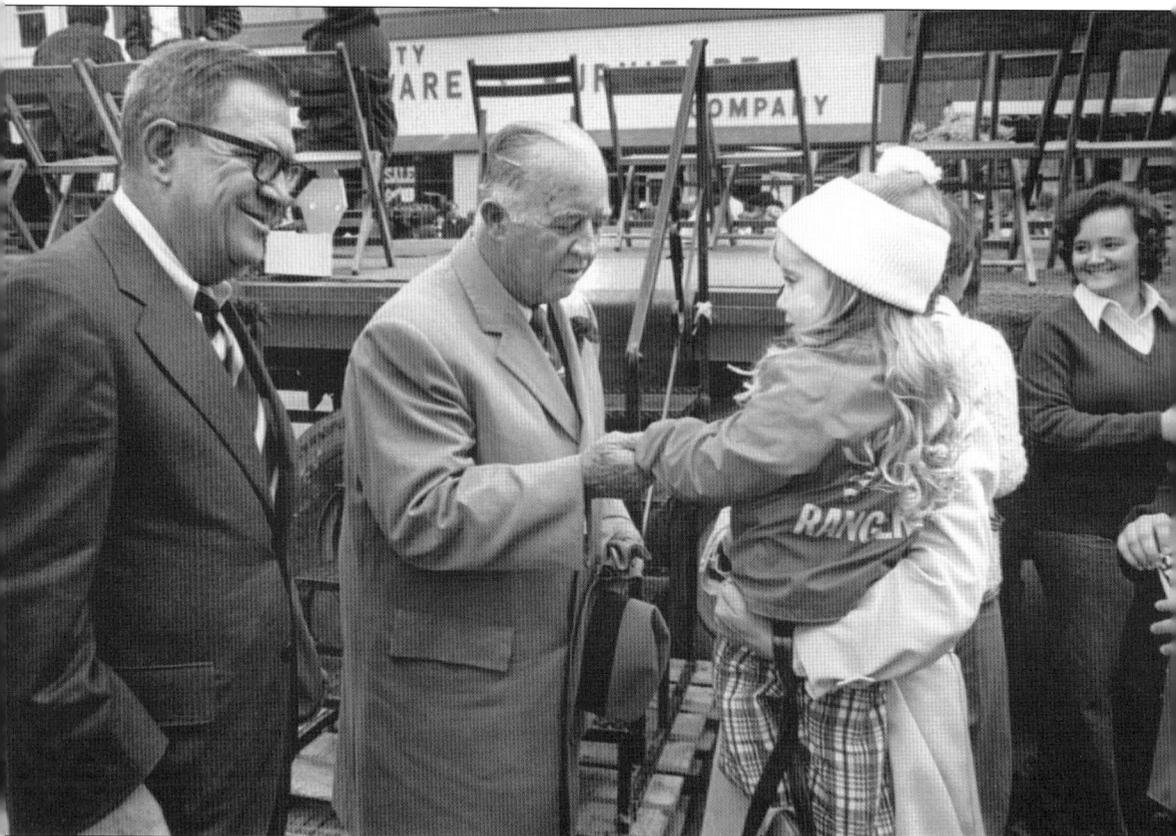

Chandler even made amends with the Rhea family. Tom Rhea's son, Albert Gallatin (at left), named after his uncle, served as a guide for Chandler, who is shaking hands with an unidentified girl, during his visit to Russellville and rode with him on a float in the Tobacco Festival.

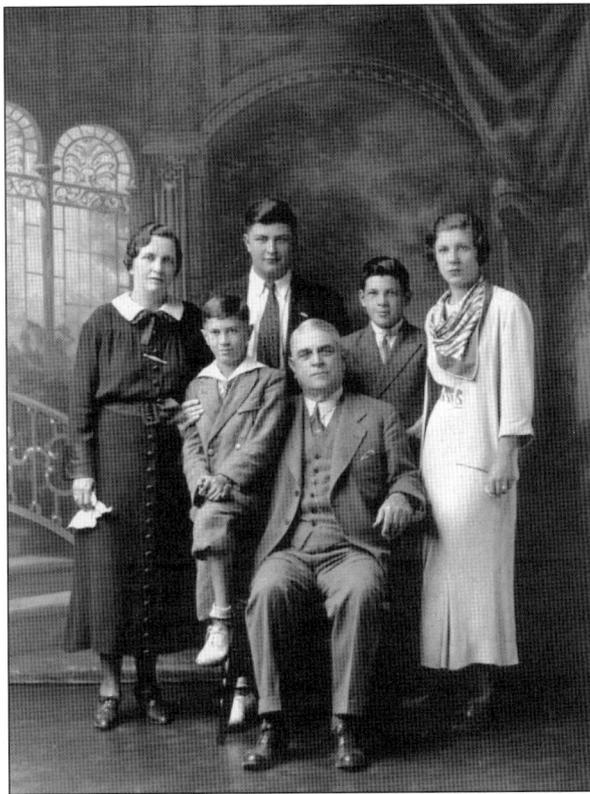

Albert G. "Ab" Rhea (1922–2002) followed the family tradition of being a lawyer and active in politics. He never held an office, but he was a legislative attorney for the office of the secretary of defense in Washington, D.C., until Pres. Dwight Eisenhower, a Republican, was elected into office. He returned to Russellville and practiced law up until he passed away. His family is pictured here: Lillian Rhea, mother; Roland Clark, brother; Tom Jr., brother; Tom Sr., father; A. G.; and Lillian, sister. Tom Rhea Jr. (1920–1995, below) was active in local politics, serving on the city council.

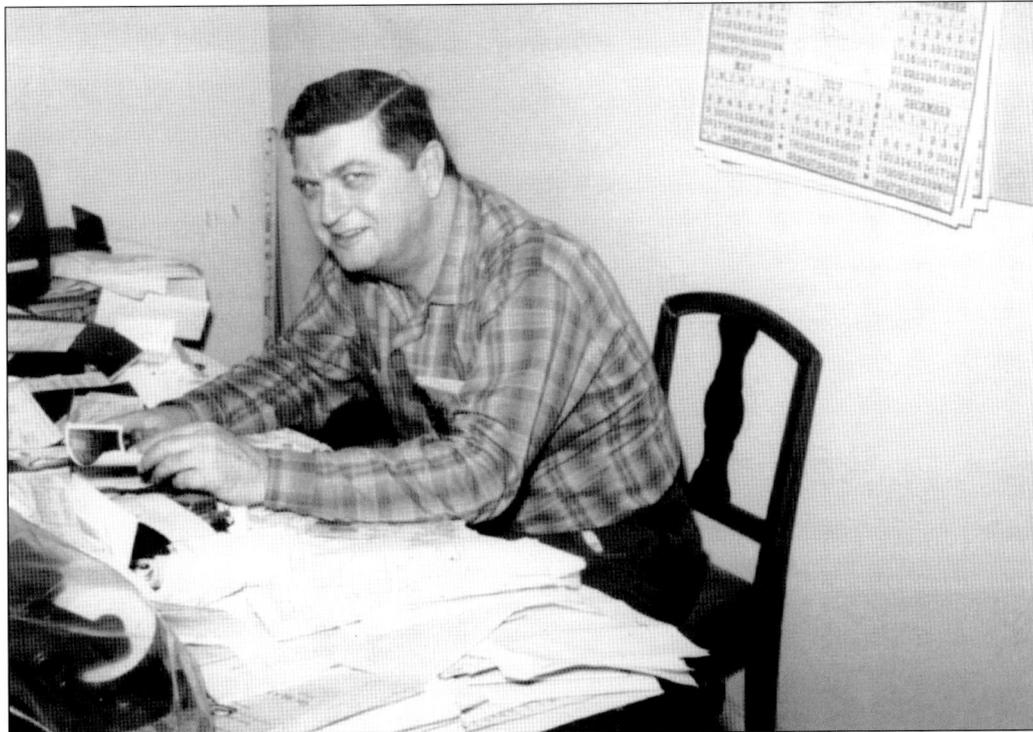

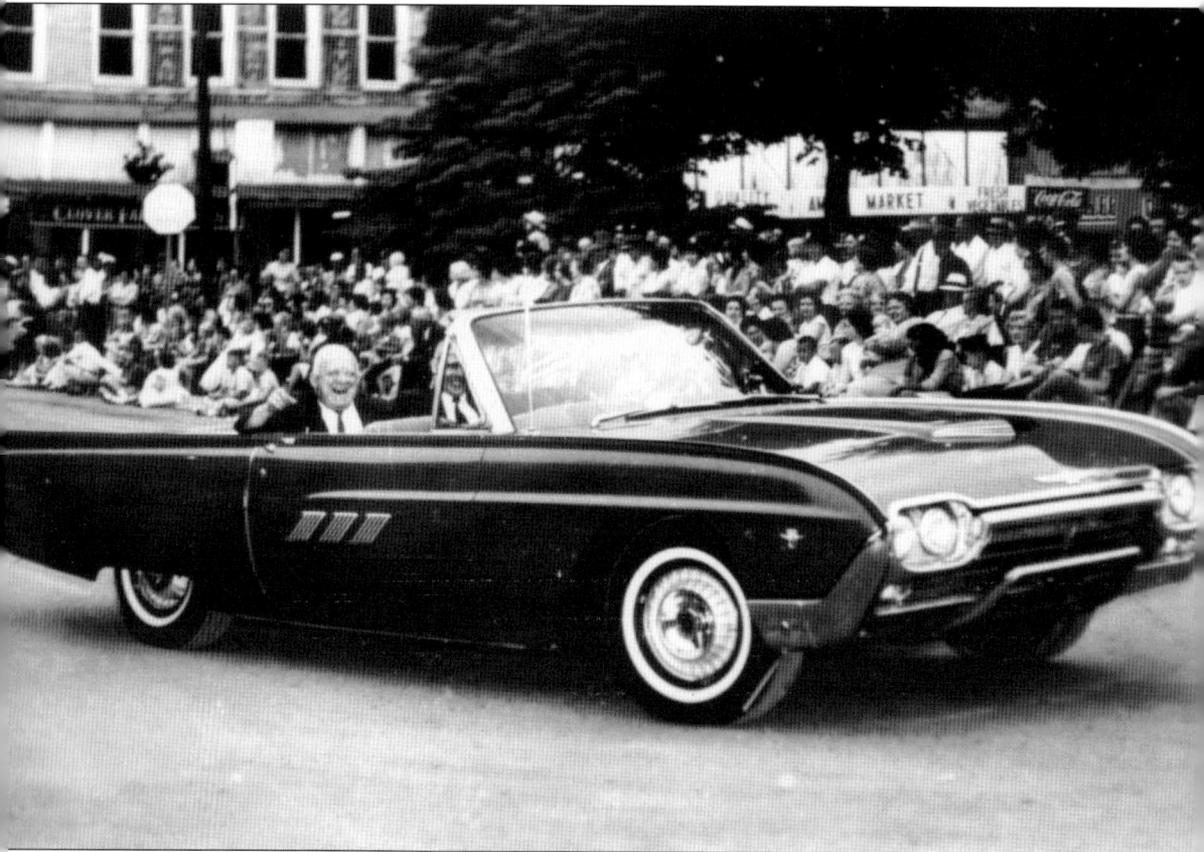

Tom Rhea's political successor was Emerson "Doc" Beauchamp (1899–1971), who is shown waving at Logan Countians at the Adairville Strawberry Festival. A jovial man, Beauchamp started in politics at the age of 13 as a page in the state legislature. Doc Beauchamp served two terms as county court clerk. He was later elected as state tax commissioner, sheriff, commissioner of agriculture, state treasurer, and clerk of the senate. The highest position he reached was lieutenant governor.

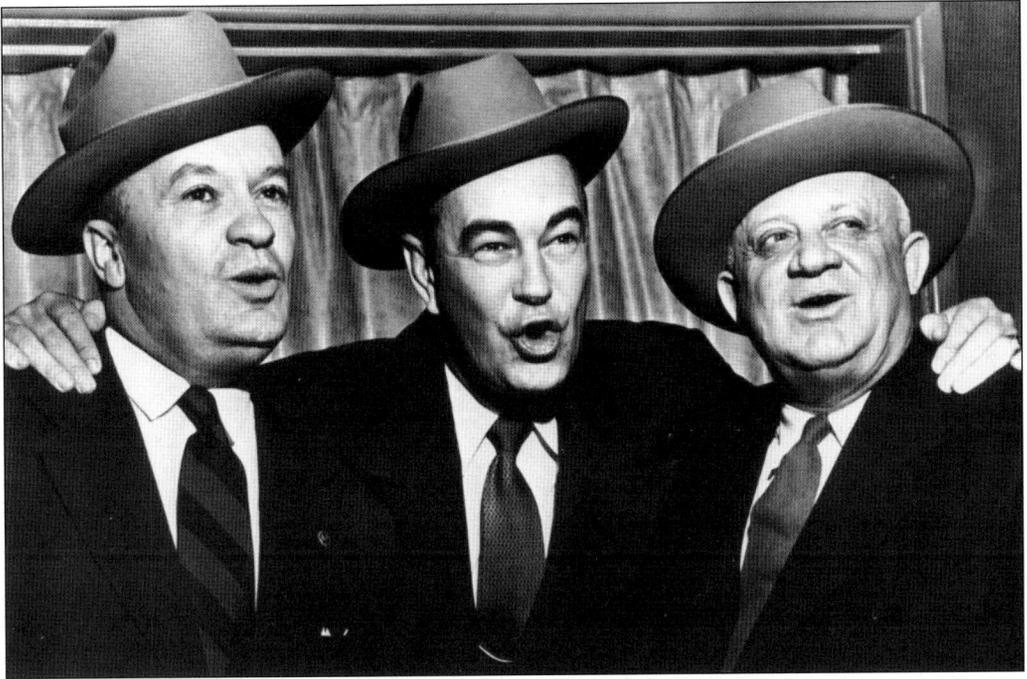

Doc Beauchamp (shown above on the right with Gov. Lawrence W. Wetherby in the middle and an unidentified man on the left and below with his right hand on the ballot box) never achieved the clout of Tom Rhea, but he had a personality that made him enduring and well liked. His father, Isaac Beauchamp, nicknamed him Doc in hopes he would grow up to become a physician. Both of Doc's grandfathers served in the Kentucky legislature, which exposed Beauchamp to politics at an early age. (Courtesy of *Courier Journal*.)

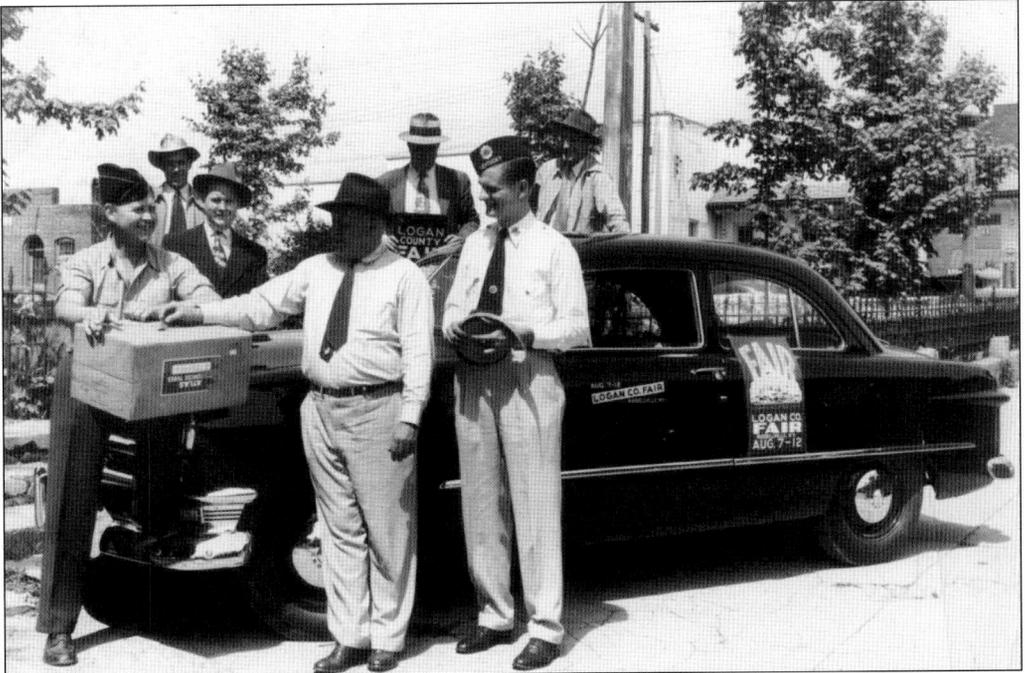

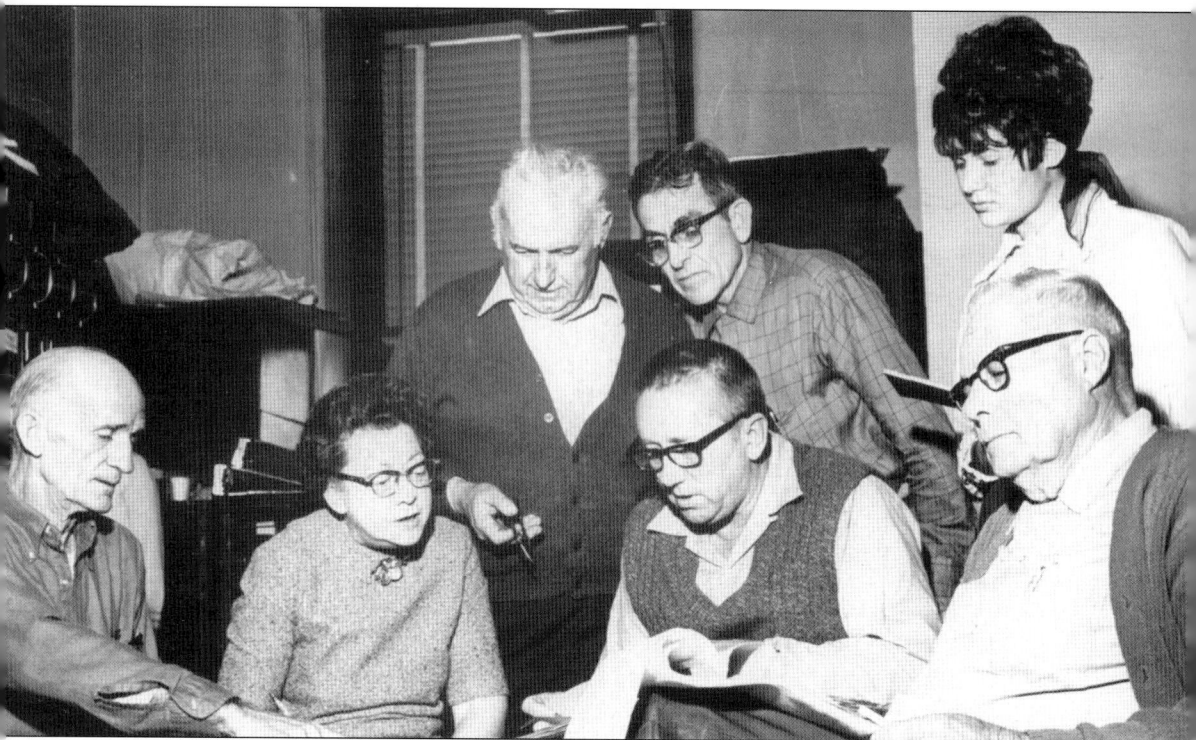

In 1959, Governor Chandler, serving his second term, ordered the voting records in Logan to be purged because deceased people were still voting, claiming the county had 22,000 voters out of a 22,335 population. The *Courier-Journal*'s publisher, Barry Bingham, condemned this voting practice. Kentucky writer Harry M. Caudill, for his book *Slender Is the Thread*, asked Beauchamp why so many dead people voted. Beauchamp replied in his usual wit, "What Mr. Bingham doesn't know is that we knew all those dead people the paper has written about. We know they were all good Democrats who would have liked to keep on voting for their friends if they could have. We were just carrying out their wishes, and if we had died first they would have done the same for us."

Elections have improved greatly since those days, but the tall tales are still told. One story goes that Doc Beauchamp himself and another man were at the cemetery of Schochoh collecting names for an upcoming election. They circled the entire cemetery and eventually came back to the first tombstone. "We can't write his name down twice," Beauchamp said. "That wouldn't be fair." (These buttons belong to Jim Nealy, former district and circuit clerk.)

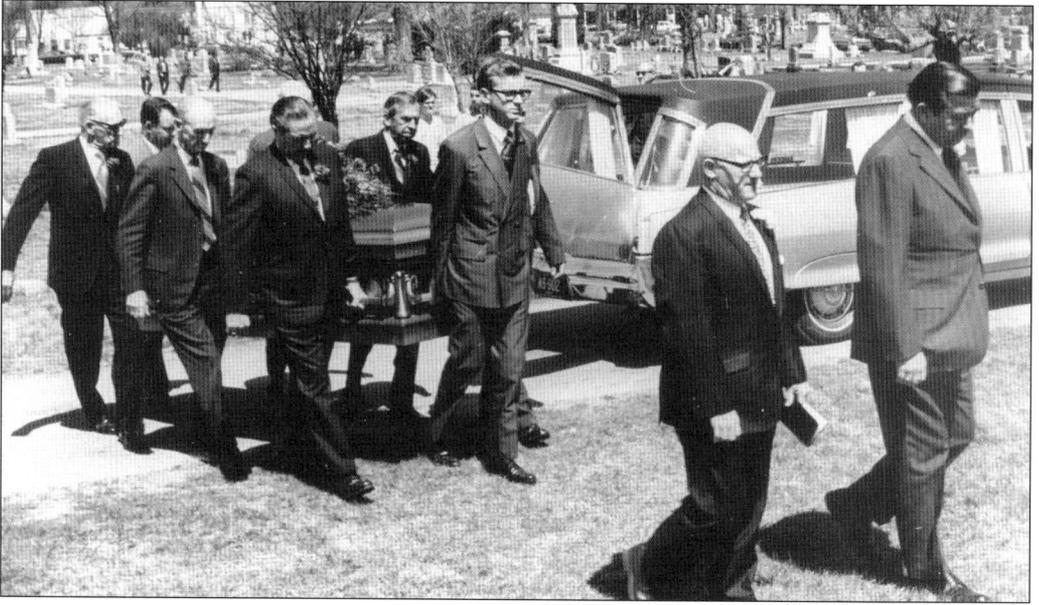

When Doc Beauchamp passed away on March 26, 1971, dignitaries from across the state came to Russellville to pay their respects, including Gov. Wendell Ford and "Happy" Chandler (shown on the opposite page talking to Beauchamp's wife).

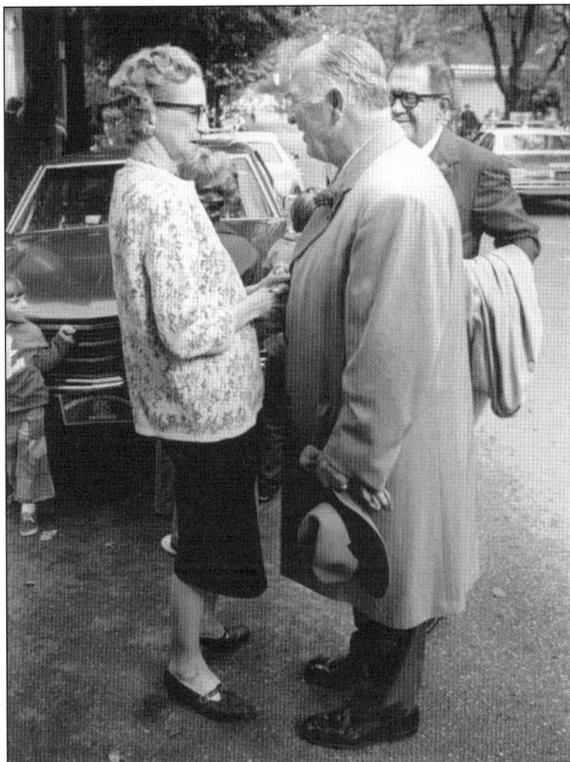

Elizabeth "Bob" Orndorff Beauchamp was the wife of Doc Beauchamp. She never cared for politics, preferring to live in Russellville while her husband worked at the state capital of Frankfort during the week and came home on weekends. She spoke of her husband after he died in the present tense. One of the qualities she loved most about Doc Beauchamp was, as she said, "His laugh is so full." Her unusual nickname came from when, as an infant, she was mistaken for her cousin Bob. The mistaken identity was so humorous to the family, she was stuck with that nickname. She died August 17, 2002, at the age of 101. (Bottom photograph courtesy of the *Courier-Journal*.)

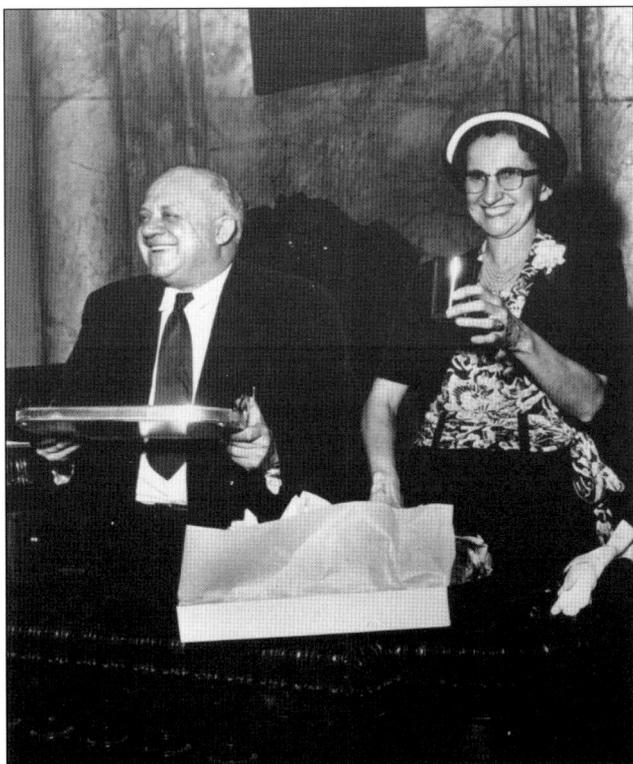

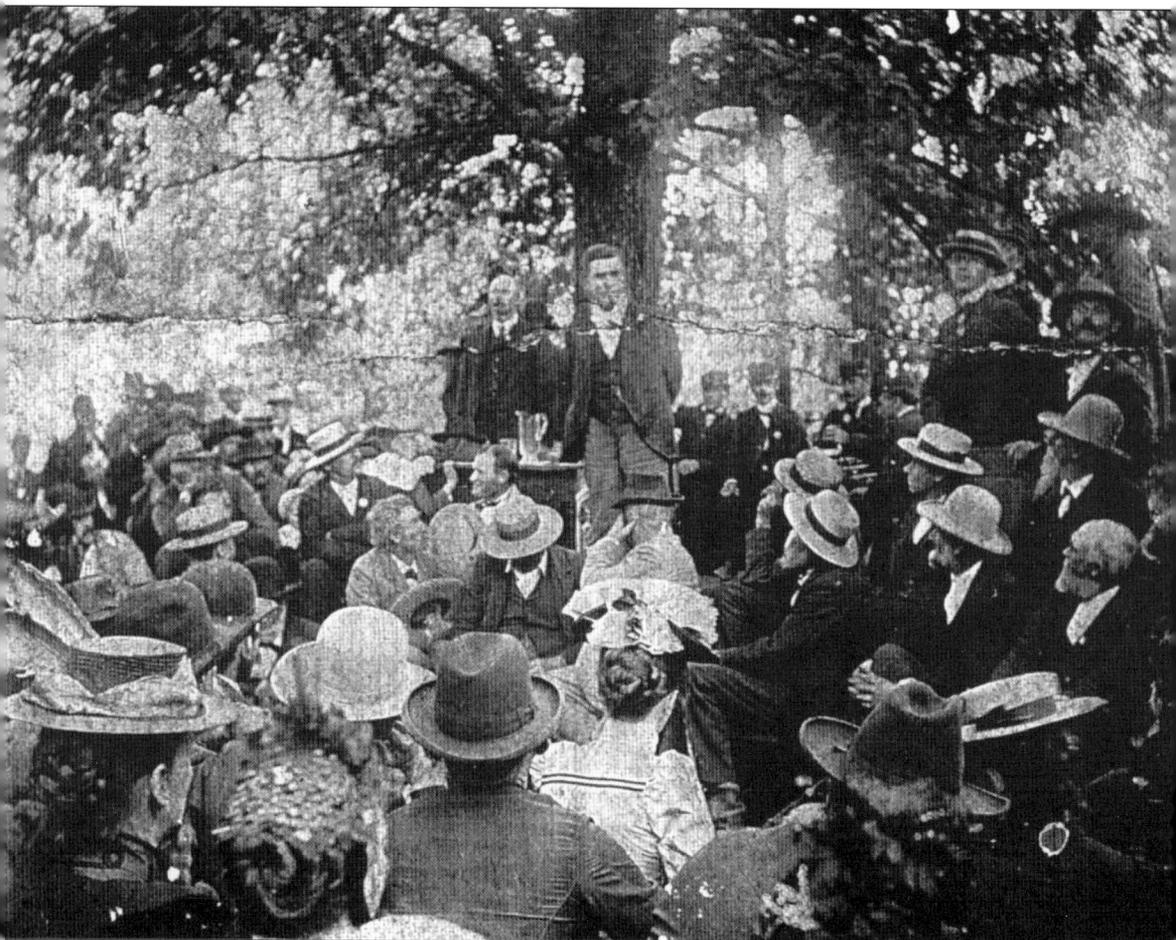

He is largely forgotten now, but once Logan Countians knew the name of Tom Rhea's brother, John, better than Tom. John Rhea (1854–1924, shown in the center at a rally) was called "one of the most brilliant men among the galaxy of great Kentuckians." He served in the House of Representatives. He was a powerful public speaker; anyone who debated against him lost.

Traditionally Logan Countians voted Democrat, with the exception of those living in the north part of the county, who usually voted Republican. Larry Forgy (standing at the podium below) is active in the Kentucky Republican party. In 1980, he chaired the state campaign to elect Ronald Reagan as president. Forgy ran for governor in 1995 and lost. Logan County isn't as Democratic as it used to be, and Republicans have been making headway. Sheldon Baugh (seated to the right of Forgy) was elected in 1994 as state representative. Ann Stuart (1912–2004, seated to the left of Forgy) was another big Republican supporter.

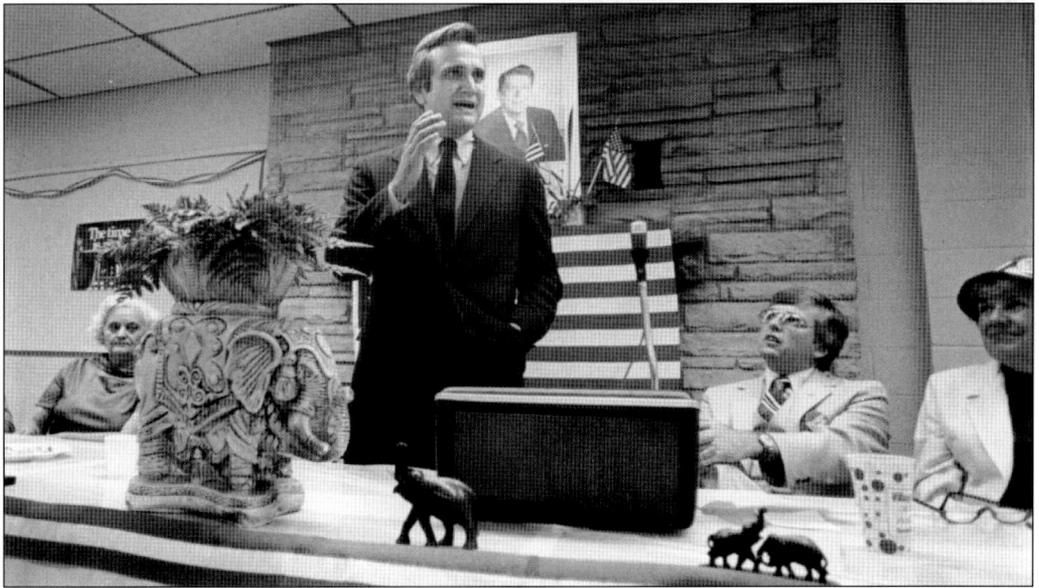

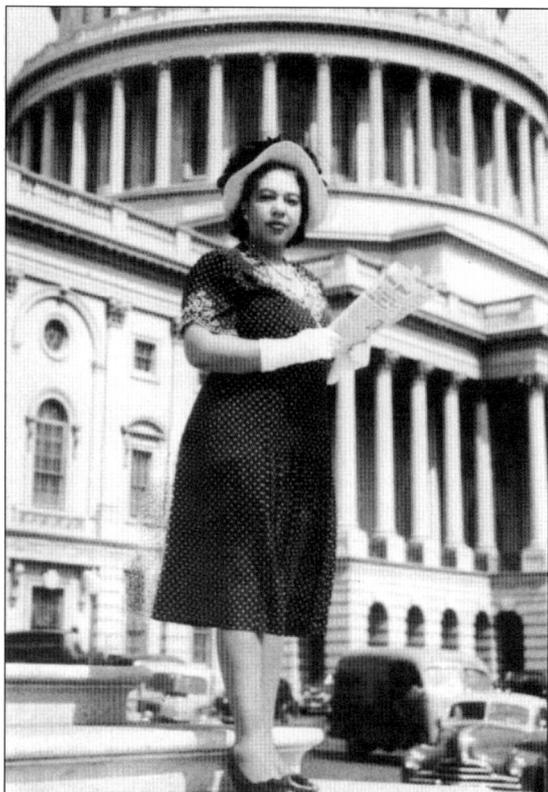

Alice Allison Dunnigan (1906–1983) served with the fourth estate of government, covering the presidential administrations of Harry S. Truman, John F. Kennedy, and Lyndon B. Johnson. Born in Russellville, Dunnigan began her career as a journalist writing one-sentence items for a newspaper in Owensboro. She was the first black journalist to accompany a U.S. president on travels. Her autobiography is titled *A Black Woman's Experience—From Schoolhouse to White House*. A museum (below) opened in her honor.

Five

RELIGION

Rev. James McGready came to Logan in 1796 to pastor. Under his guidance, the Second Great Awakening of 1800 was born. A great awakening is best described as when new religious thought is needed to address the needs of society. The First Great Awakening began in 1734 in Massachusetts as a way to return to Calvinism but also to encourage a personal relationship with God. The Second Great Awakening strengthened the Methodists and Baptists and introduced the concept of religious camp meetings. New denominations (such as the Campbellites, Cumberland Presbyterians, Disciples of Christ, and Christian Church) were spawned. The site of the original meeting was at Red River Meeting House (above), northeast of Maulding's Fort, the first settlement in Logan County. (Photograph by Mark Griffin.)

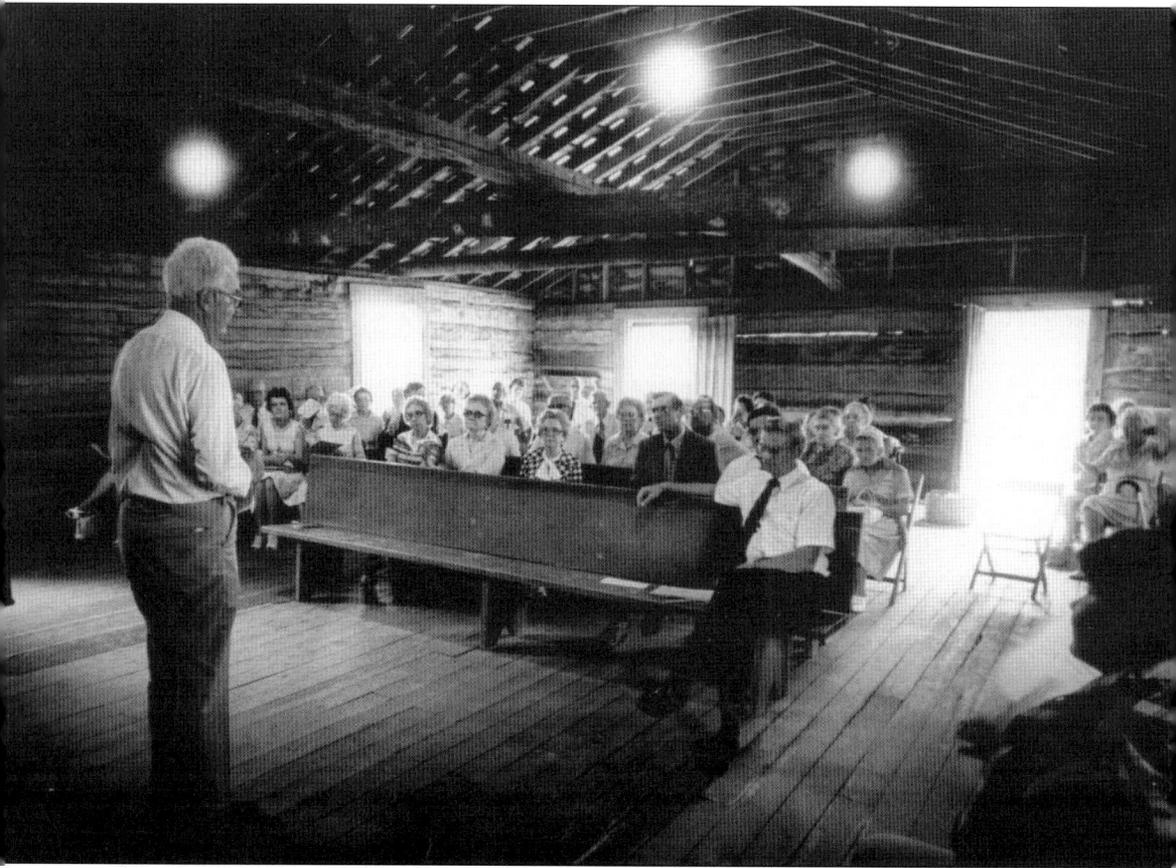

The Red River Meeting House was first erected before 1800. Revolutionary War soldiers are buried at the cemetery. The original log cabin church crumbled in 1856, leaving only a foundation. A replica of the church was built in 1959 but burned in 1992. Ruston Flowers and Top Orendorff (pictured speaking to the congregation) oversaw the erection of another meetinghouse in 1994, which is still standing today. Judge William G. Fuqua, court judge and civic leader, sits in the front pew.

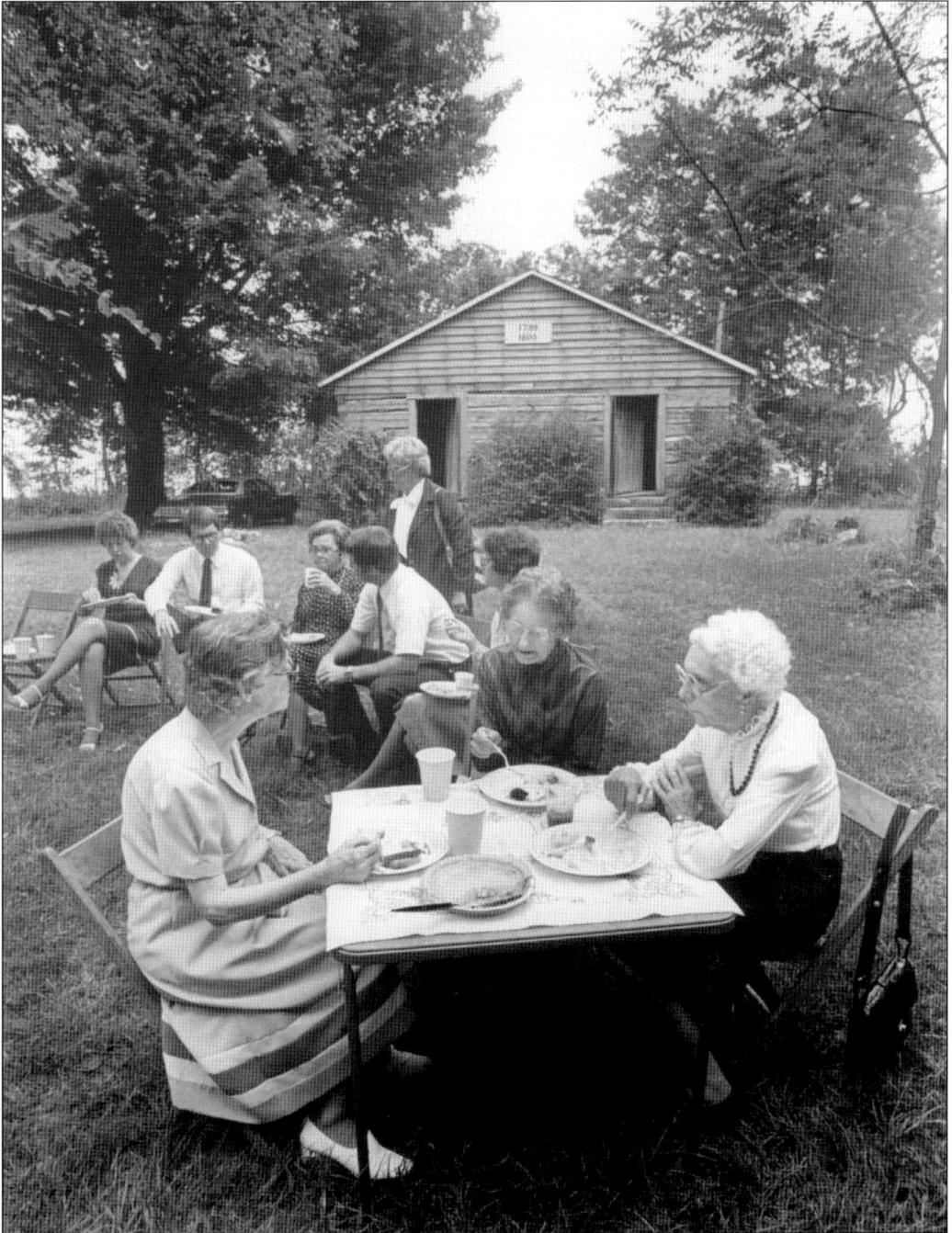

On the second Sunday in September, the Red River Meeting House Association holds a preaching and a dinner on the grounds. Sitting at the table from left to right are an unidentified woman, Mildred Davidson, and Mrs. Jess Price. The chimney of the meetinghouse came from a home belonging to ancestors of Pres. Lyndon B. Johnson.

A primitive camp meeting and rendezvous is held every second weekend in October in conjunction with the Tobacco Festival. Tom Ruley (left) organized the camp meeting as a way to demonstrate how the original camp meeting at Red River would have looked. Participants dress in the outfits of the time (such as Darlynn Moore, bottom) and live as persons would have in the 1800s, even down to cooking in kettles. (Photographs by Mark Griffin.)

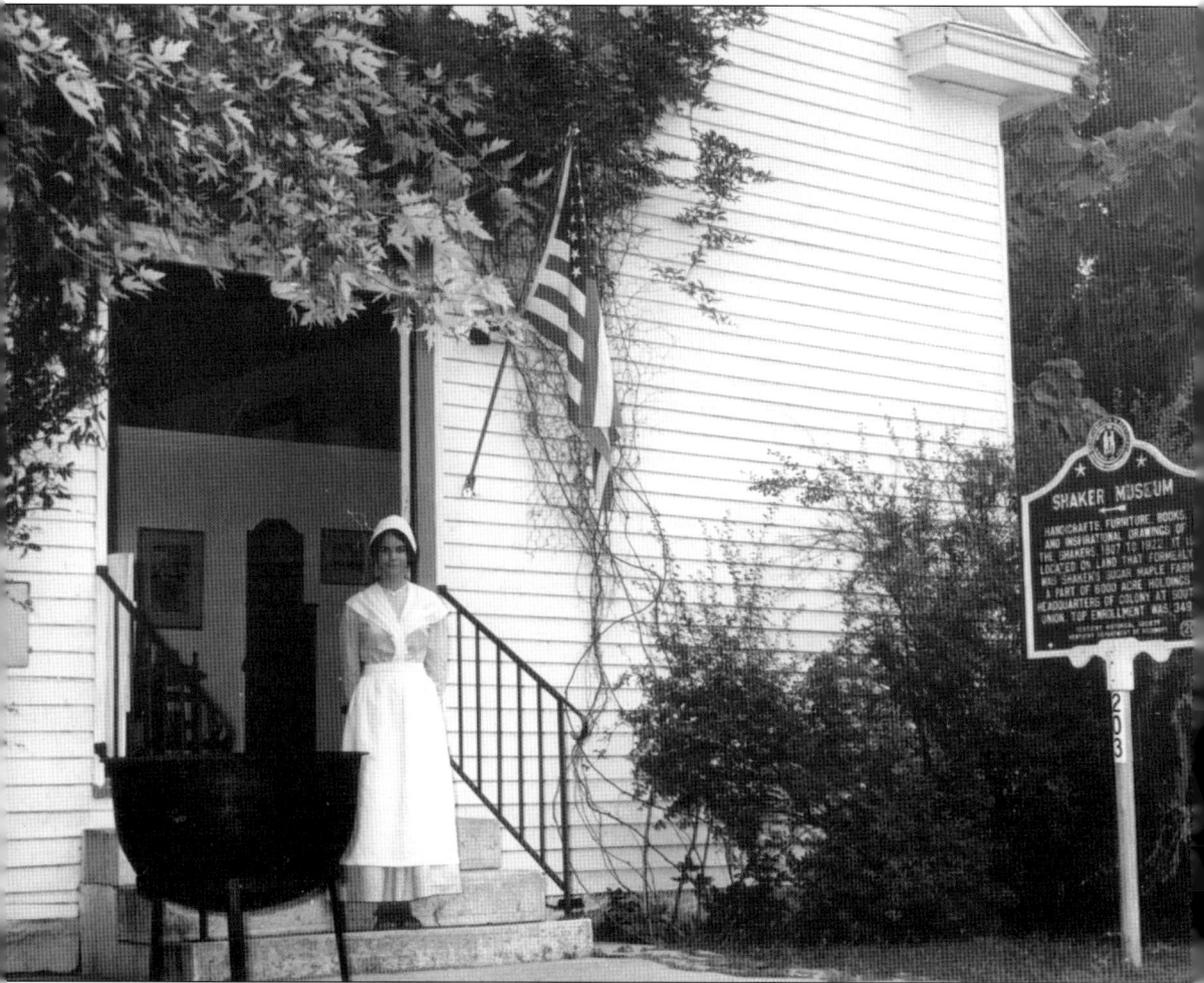

The United Society of Believers (or Shakers, as they are popularly called) started in mid-18th-century England. Its founder, Mother Ann, believed she was the female incarnation of Christ and harbinger of the end-time. They believe in hard work and celibacy and were known for their furniture and seed supply. They are called Shakers because during religious services they would start dancing, which outsiders described as shaking. The Shakers came to Logan County on October 17, 1807, to start a colony called South Union.

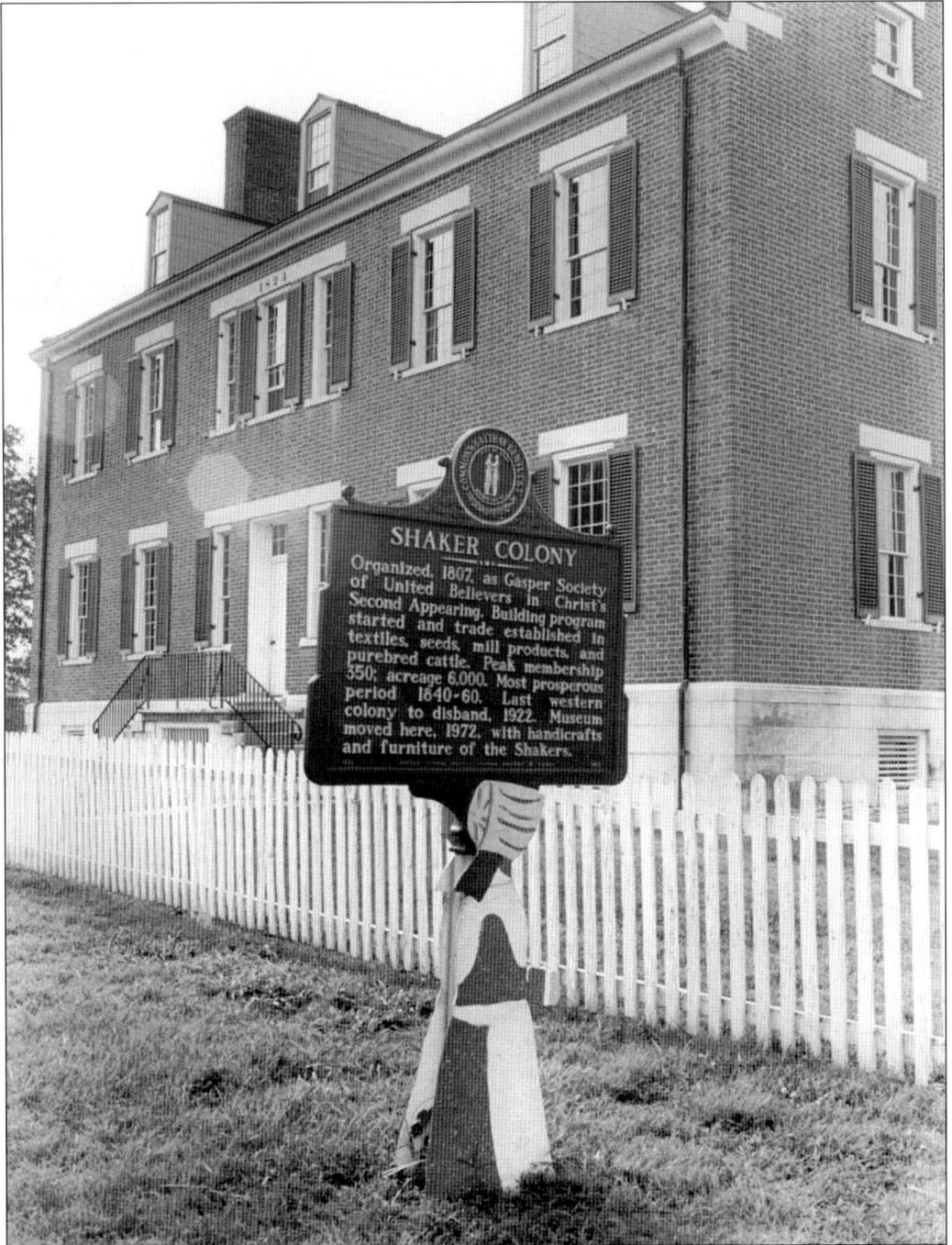

SHAKER COLONY
Organized, 1807, as Gasper Society
of United Believers in Christ's
Second Appearing. Building program
started and trade established in
textiles, seeds, mill products, and
purebred cattle. Peak membership
350; acreage 6,000. Most prosperous
period 1640-60. Last western
colony to disband, 1922. Museum
moved here, 1972, with handicrafts
and furniture of the Shakers.

No Shakers exist in Logan today. The remaining members sold South Union (above) at an auction in 1922. In 1960, the Shaker Foundation was started in Auburn.

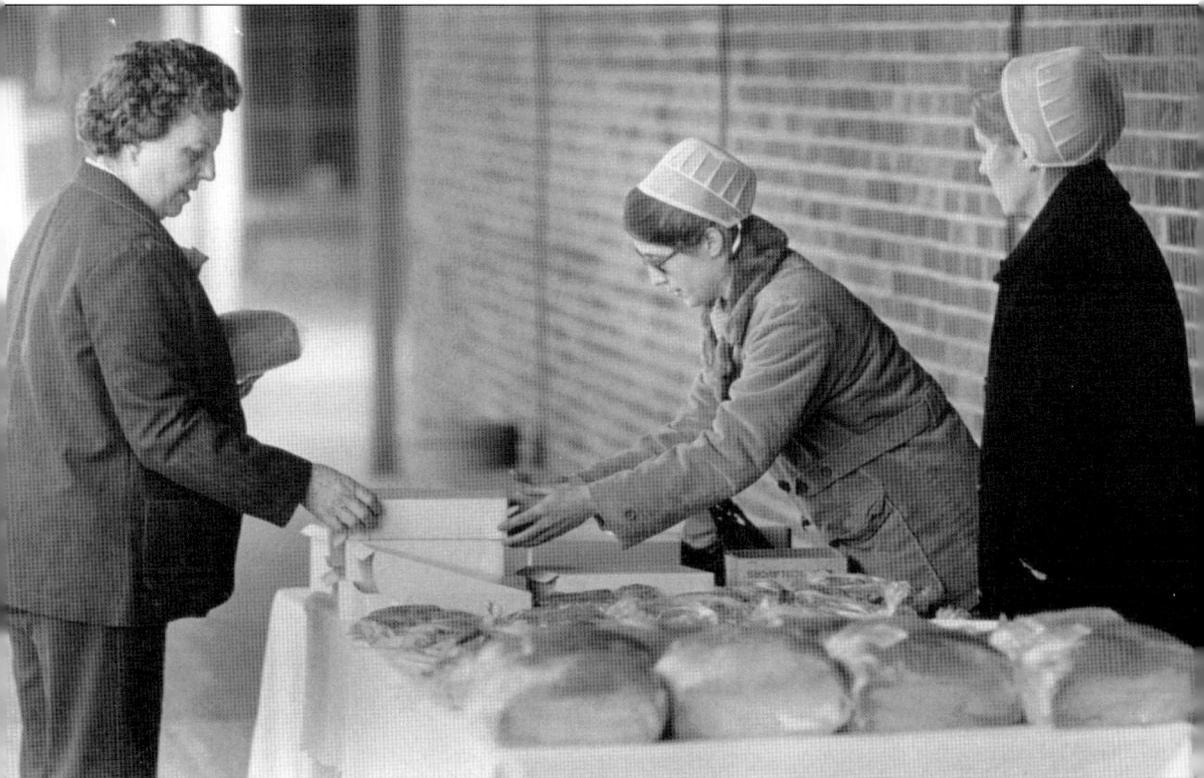

Mennonites settled Logan. They believe in frugality, hard work, piety, and mutual helpfulness. Traditionally Mennonites try to isolate themselves from modern culture but not completely. They sell bakery products (as the unidentified Mennonites are doing above in the 1980s), run businesses, and even use a few of modern technologies.

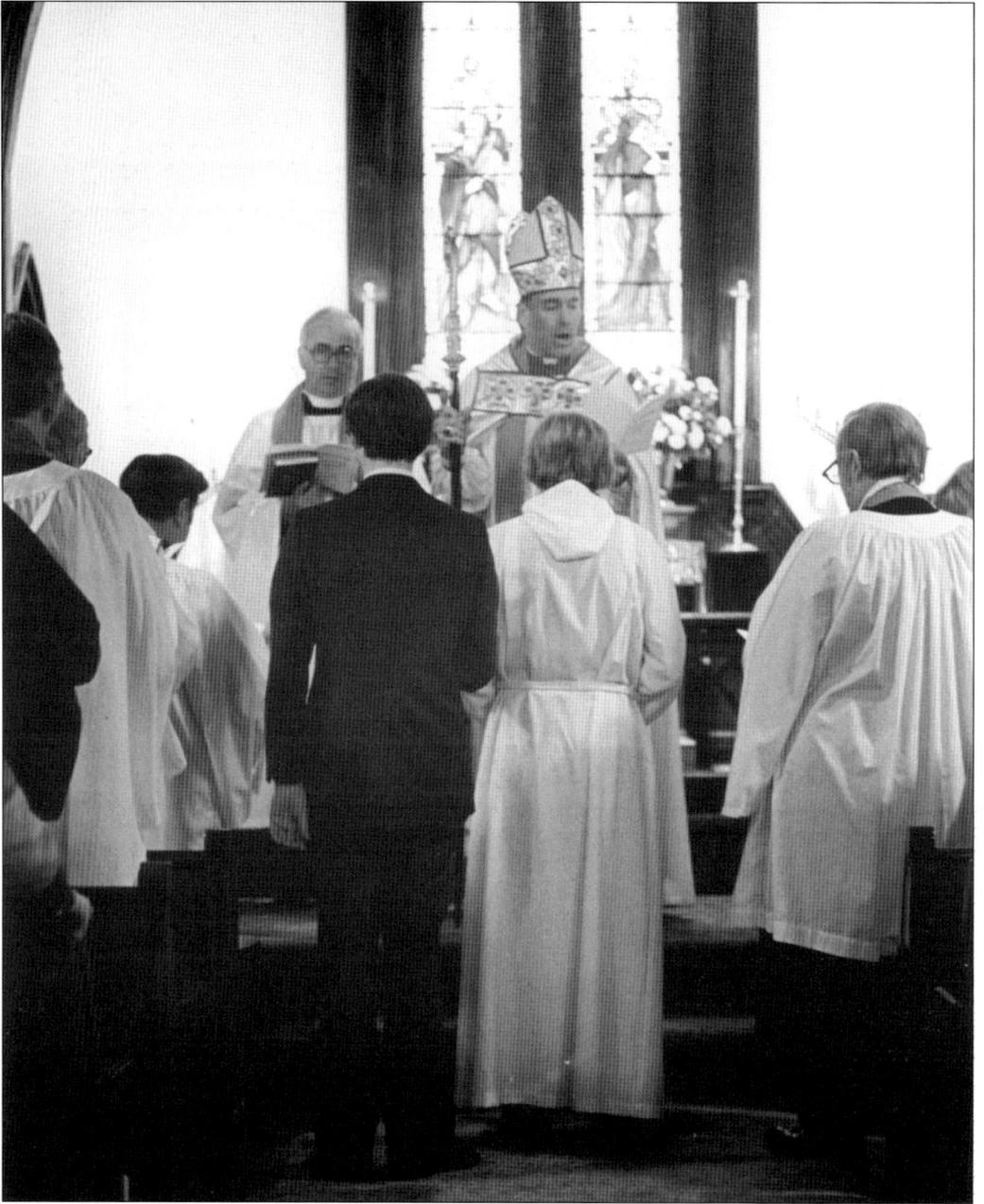

Trinity Episcopal Church, built in 1883, is one of the oldest churches still standing in Russellville. Bishop David B. Reed, reading the service, is ordaining Rev. C. I. Jones on December 10, 1977.

Predominately Logan Countians have been either Baptist or Church of Christ. Rev. Donald Zuberer (1932–2006) preached on top of First Baptist Church, established November 14, 1818, on Main Street. He promised he would preach from the location pictured above if the church drew in a certain amount of people to Sunday school. The church has spawned several other churches in the city, including a First Baptist Church on Fifth and Spring Streets, Second Baptist Church, and Eastside Baptist Church.

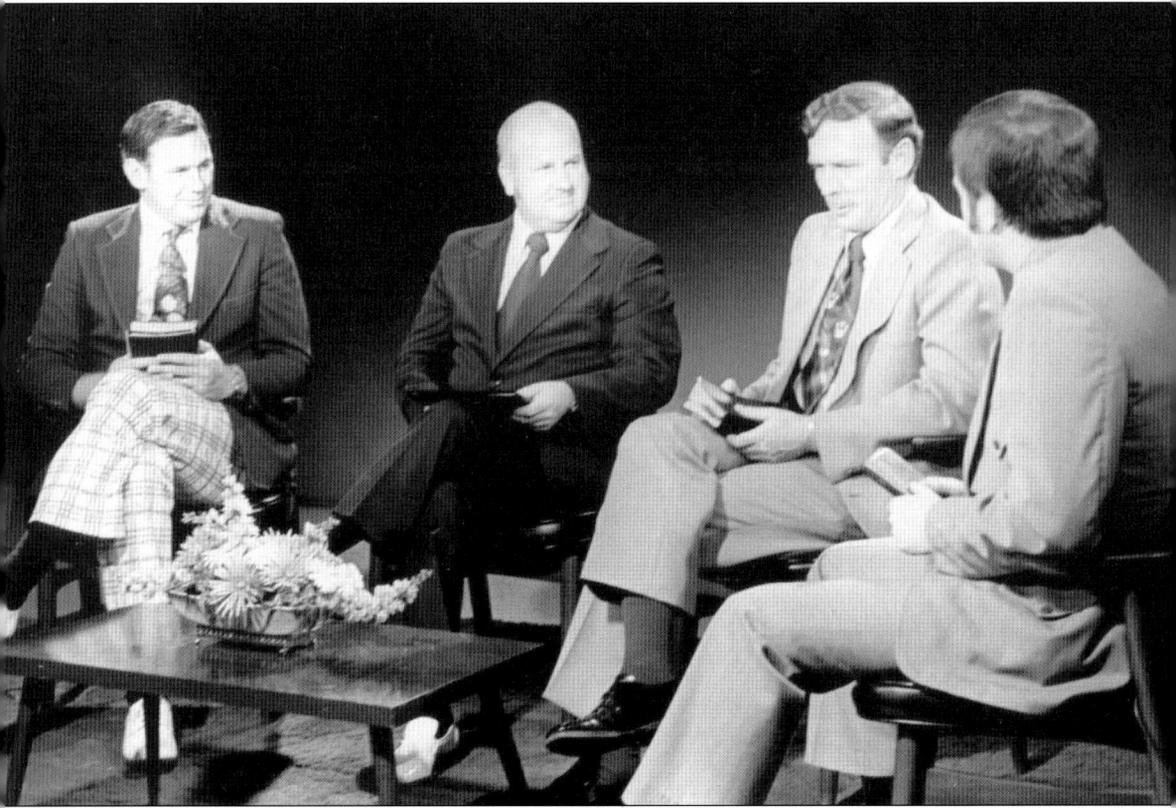

The Church of Christ believes everything its members do should be based on the scriptures, backed by chapter and verse. Members of the Crittenden Drive Church of Christ, started in 1927, appeared on Kentucky Educational Television to discuss the Bible.

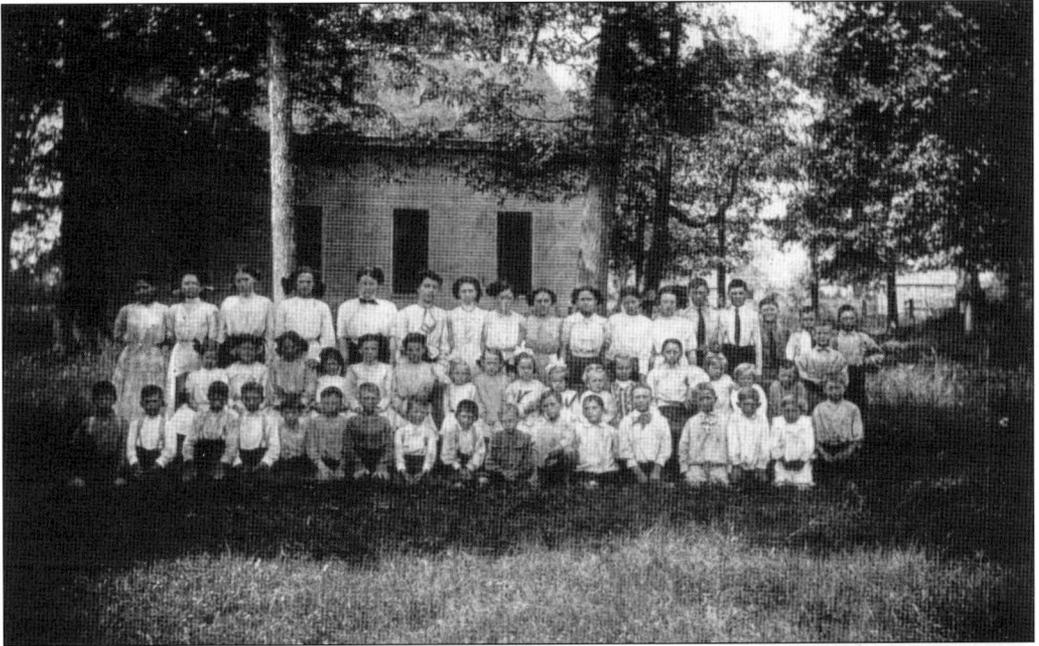

Methodists and Presbyterians come
in a strong second in Logan. Corinth
Presbyterian Church is shown above
at an unknown time. The United
Methodist Temple is shown at right in
1917 before it was remodeled.

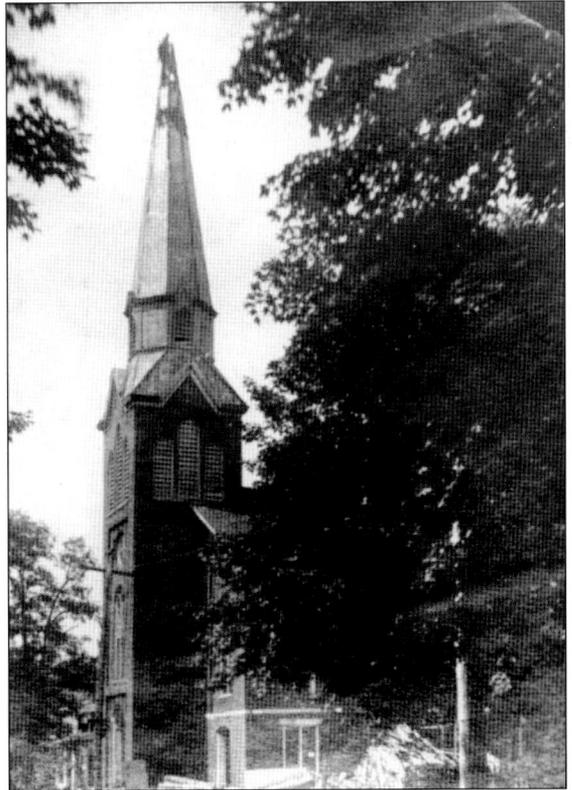

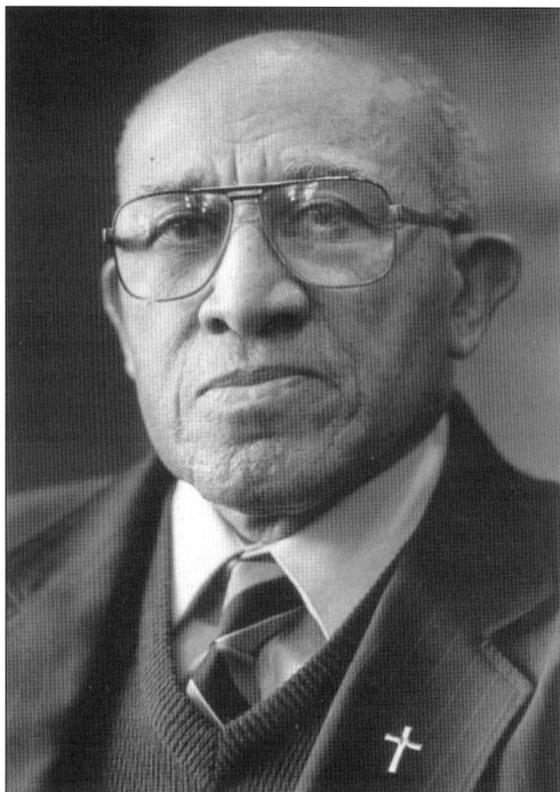

J. O. McKinney, as pastor of Mount Zion Baptist Church, championed many improvements for blacks in Logan County, such as access to sewage and the right to serve for jury duty, and he pushed to have Town Creek cleaned. He has encountered racism but chooses to focus on the positives of humankind. "Racism and discrimination. They are human vices old as civilization and must be overcome," he said in 1996.

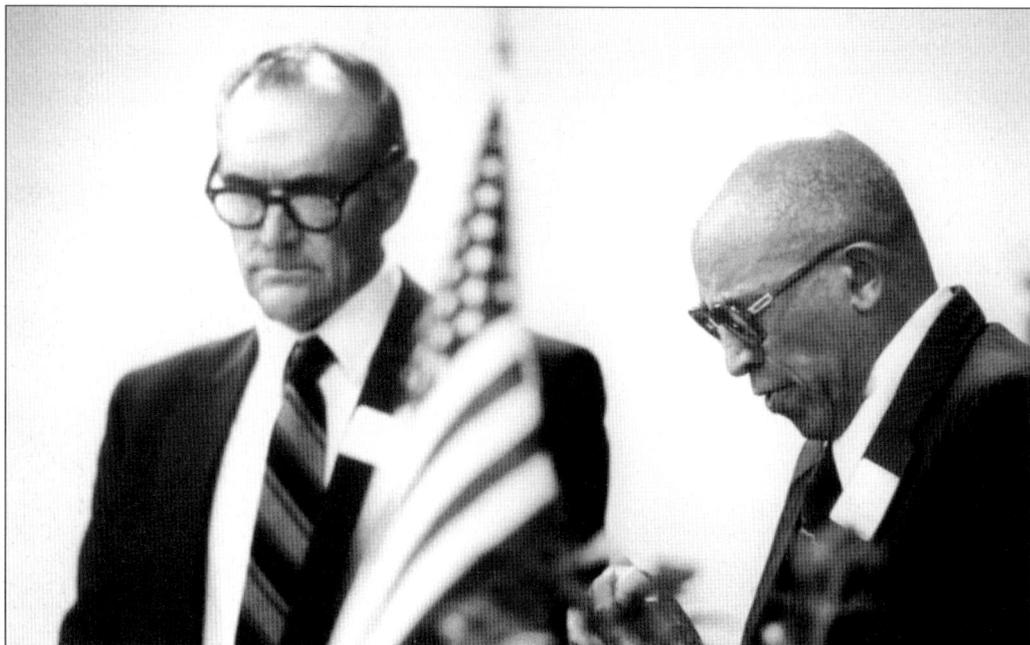

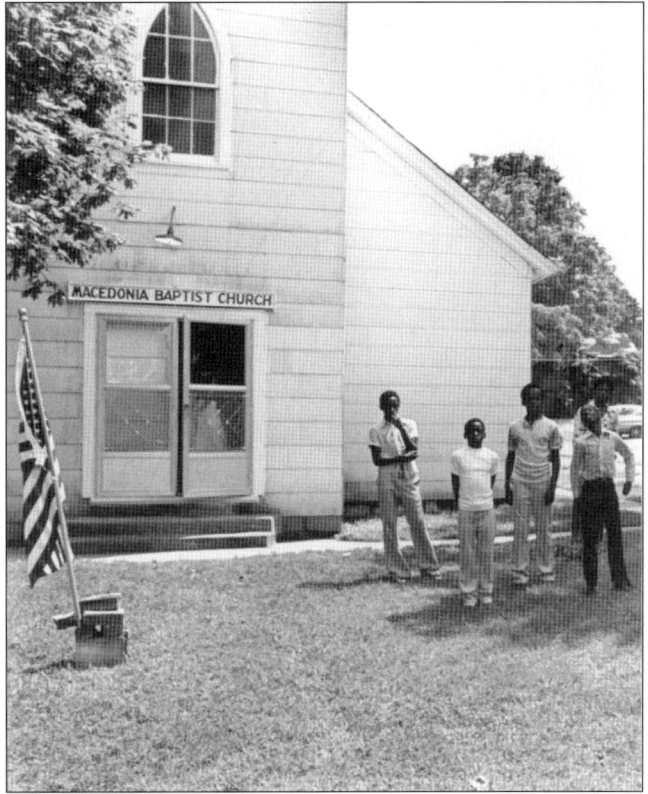

Logan County has a number of rural churches. Macedonia Baptist Church in Auburn is shown at right and First Christian Church in Russellville below. Small churches may be modest, but their members' faith runs deep. In the past, what church a person attended was considered part of his or her character.

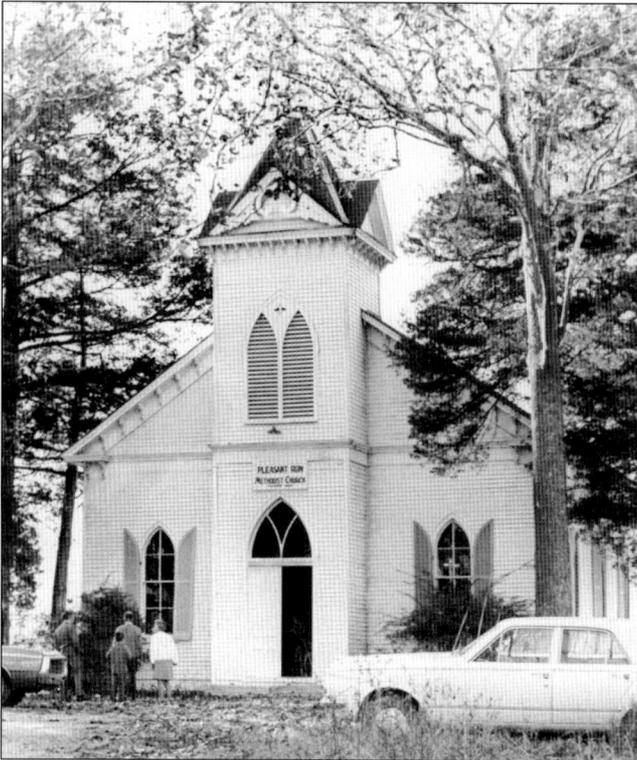

Not all the small churches have survived. Pleasant Run Methodist Church (at left), founded in 1808, is now a private residence. Red Oak Grove Methodist Church (below) still has active members. (Top photograph by Robert Stuart.)

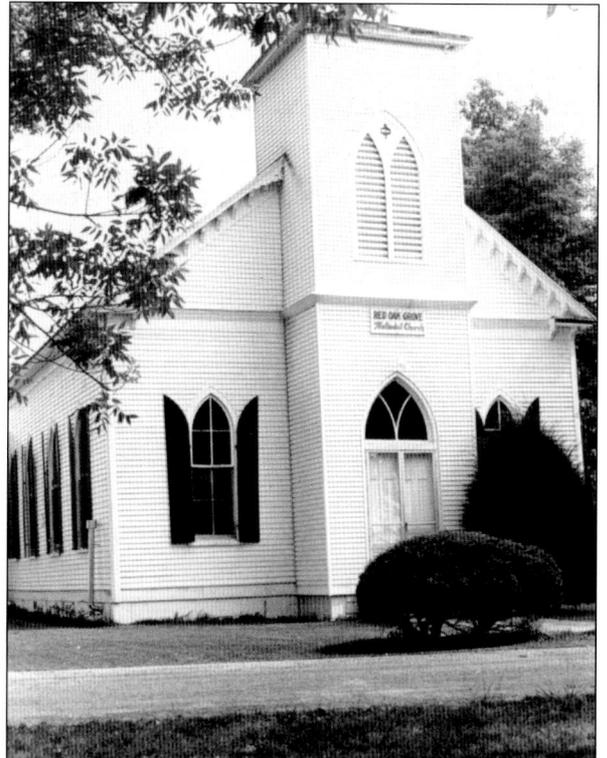

Because of the railroad, Irish immigrants came to Russellville. Sacred Heart Catholic Church was dedicated April 27, 1873, to serve them.

No one is said to have loved Logan County (or America) more than Rev. Oddvar Berg (1914–1999). Born in Oslo, Norway, Berg became a naturalized citizen in 1968. As a Presbyterian minister, he spent over 20 years as a missionary in the Belgian Congo. He gave speeches across the country on "What's Right With America" and was named an Ambassador of Good Will. In 1972, he married Margaret Sullivan (shown below), a home demonstration agent for Logan County. They moved to Arkansas in the 1980s but came back here eventually. "I can't tell you how happy I am to call Logan County home," Berg said in 1989. "This beats it all."

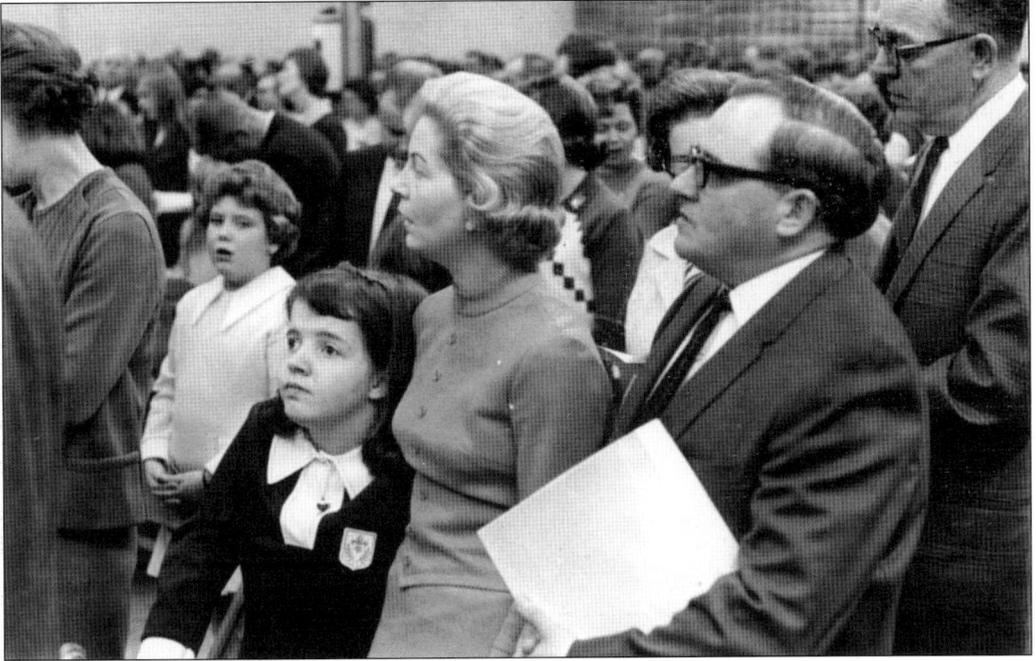

No one has taken care of Logan County better than Br. Joe Carrico (pictured with his wife, Leona, and daughter, Renee). He grew up in a Catholic home but became a pastor at Post Oak Baptist Church in 1954. He nurtured a connection with nearby Fort Campbell military base, and whenever an emergency, such as crippling snowstorms, hit Logan, soldiers came to assist. He is best known for his Toys for Tots (below), a drive to ensure every child in Logan receives a present for Christmas. Toys for Tots is currently headquartered at the Carrico Center, a ministry outreach. February 14, 1990, was declared Joe Carrico Day, and at the 2006 Flying Fish Festival, the square was officially named Carrico Park.

Gospel singing is popular, and many singing groups have formed. Pictured above are the Crusaders (from left to right are Milford Martin of Lewisburg, Melvin Chambers of Auburn, Therwin Sanders of Russellville, and R. K. Johnson of Auburn), who sang in the latter part of the 20th century. Other gospel groups of Logan are the Ambassadors Quartet and the Challengers.

Six

ODDS 'N' ENDS AND RECENT EVENTS

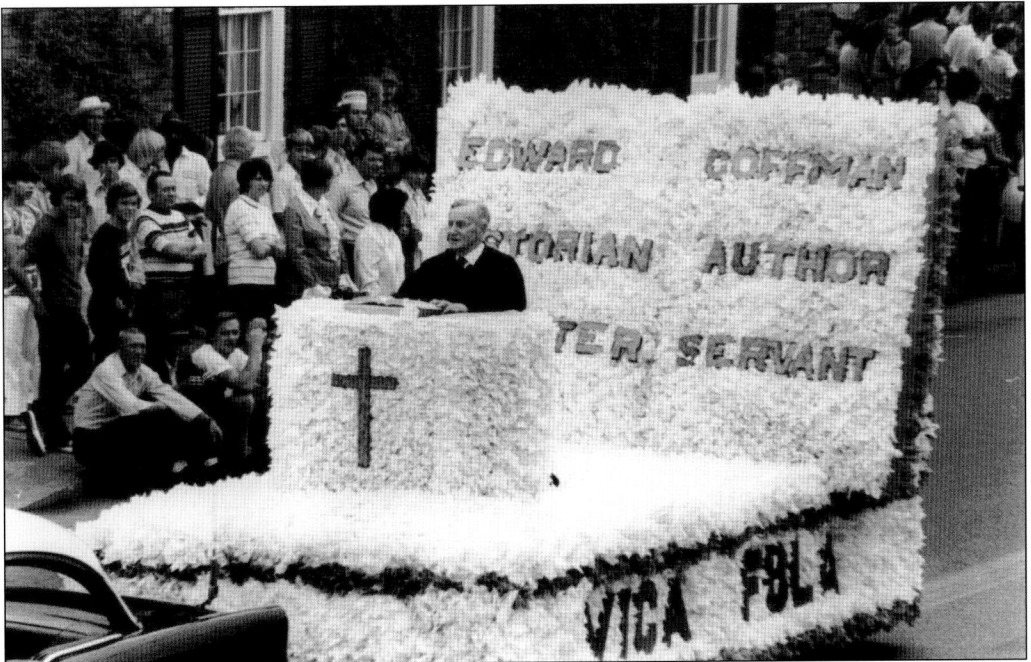

No historian was more beloved than Rev. Edward "Pyke" Coffman (1890–1987), as he was honored at the 1973 Tobacco Festival. His history, *Story of Logan County*, became the official version. A Christian Church pastor, Coffman first wrote his history when a student at Vanderbilt University in Nashville. It was first published in the local newspaper, *News-Democrat*, and later as a 72-page book titled *Story of Russellville*. In 1962, the history was printed as the *Story of Logan County* despite Coffman's failing eyesight. When he could no longer see, his wife, Emma, typed the book for him. (Photograph by Robert Stuart.)

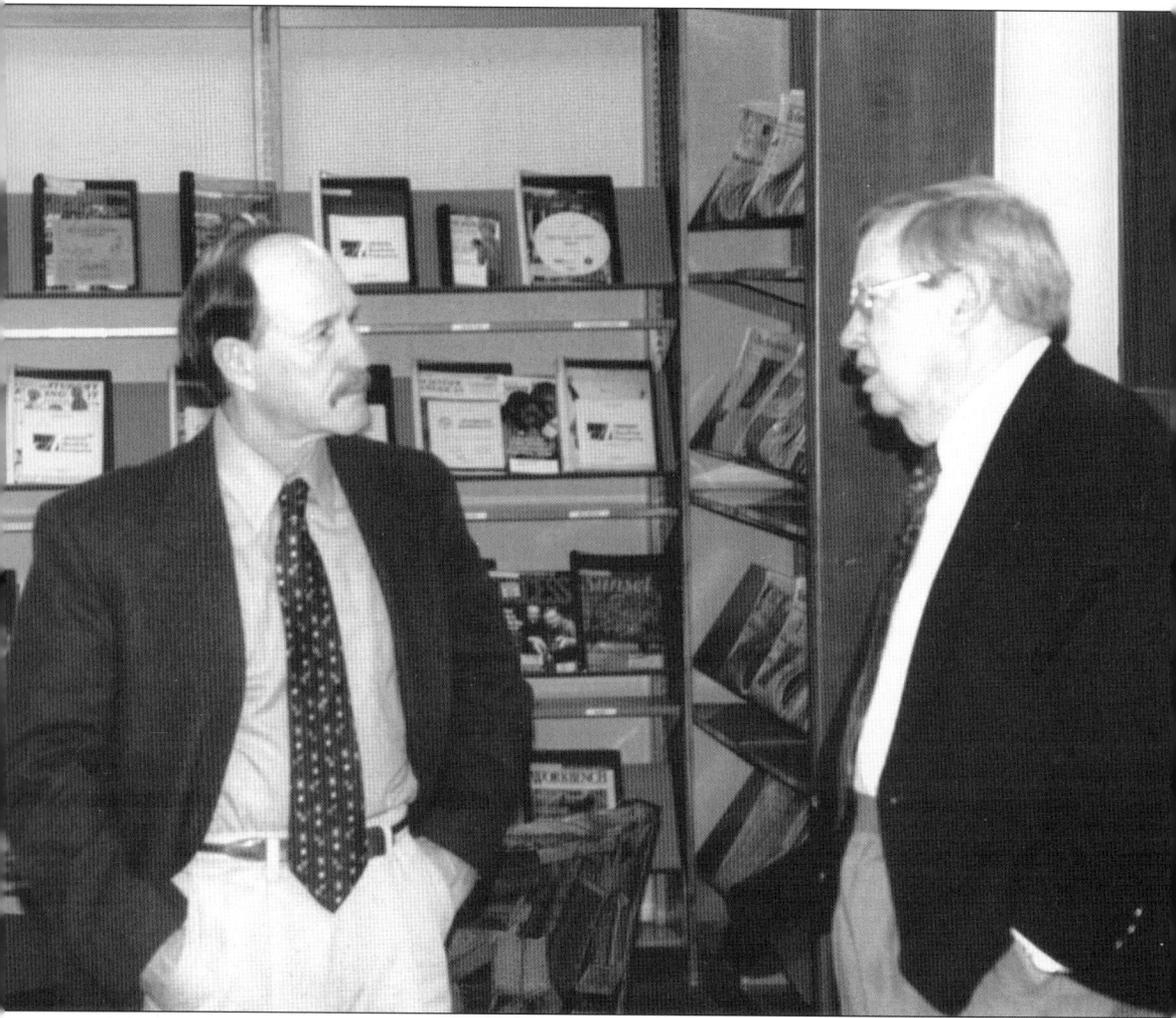

Edward Coffman Jr. continued recording the county's history with a sequel to his father's book, *Through My Father's Eyes—The Story of Logan County*. Coffman (at right) is talking to Joe Survant, who gave a poetry reading, in 1999 at the Logan County Public Library. Survant, named poet laureate of Kentucky in 2003, wrote a book of poems titled *Anne & Alpheus*, which was inspired by *The Heavens Are Weeping*, the Civil War diary of George R. Browder, a Methodist circuit rider from Logan County. (Photograph by Mark Griffin.)

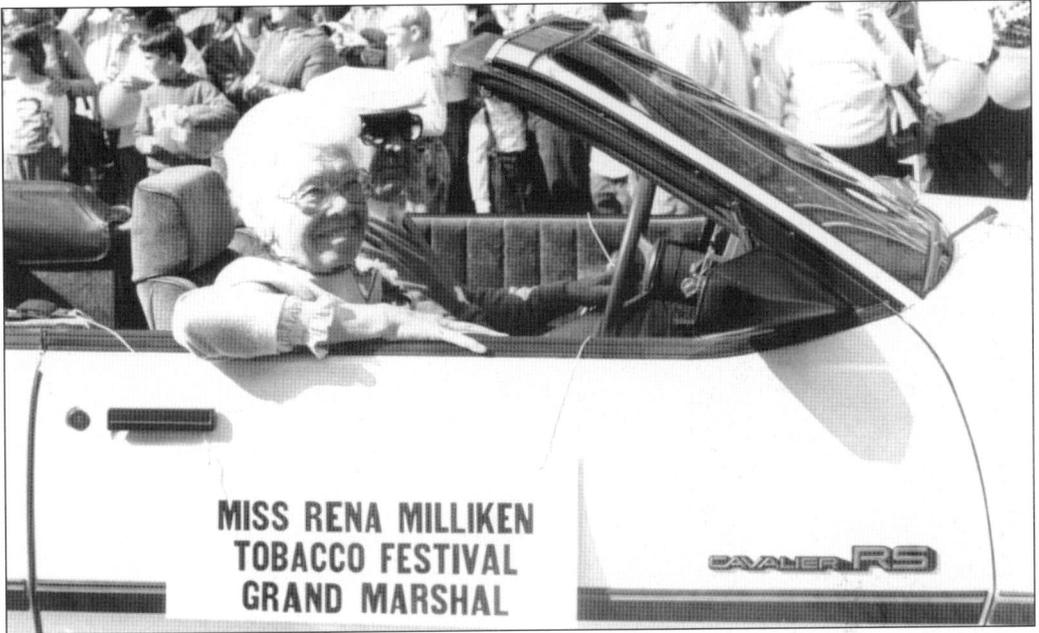

MISS RENA MILLIKEN
TOBACCO FESTIVAL
GRAND MARSHAL

Rena Milliken (1909–1998) was another historian honored during a Tobacco Festival on October 12, 1985. An educator by profession, Milliken wrote numerous articles on the history of Logan (about George Washington's cousins settling here and on the United Methodist Temple, for example) and advocated the erection of highway markers (including one on Valentine Cook, a prominent Methodist preacher who preached here from 1806 until his death in 1822). She made oral interviews of various Logan Countians of their memories, which are kept at the Logan County Public Library, Western Kentucky University, and state archives.

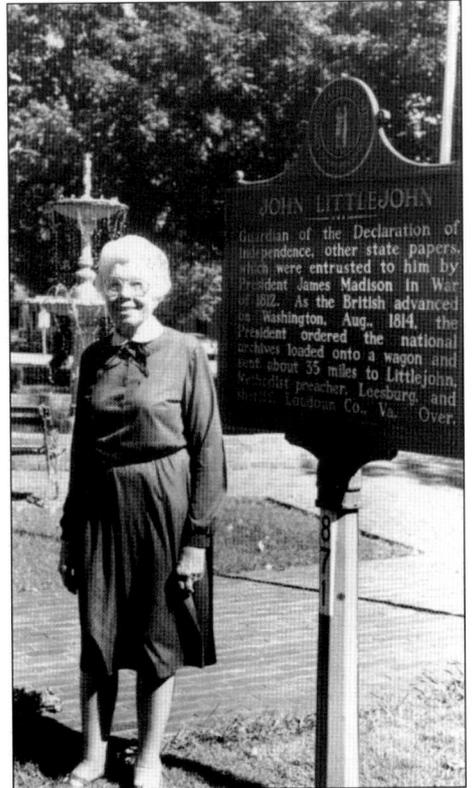

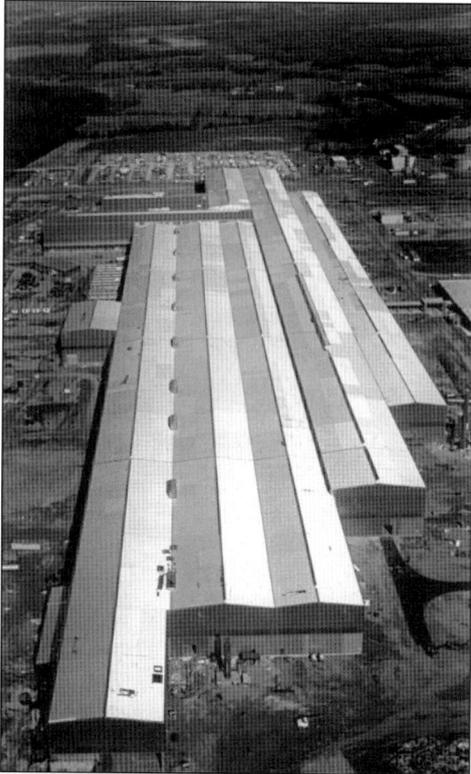

Logan Aluminum's arrival in Logan in 1983 was a historical event. Located between Russellville and Lewisburg on the Terry Wilcutt Highway, Logan Aluminum (left) is Logan's biggest employer. The plant, which spans for miles and has its own fire department, produces aluminum sheets used for aluminum cans and automobiles. Judge William Fuqua (below) helped to bring the plant here. After Logan Aluminum's arrival, the population increased, new businesses came, and a country music star got his start.

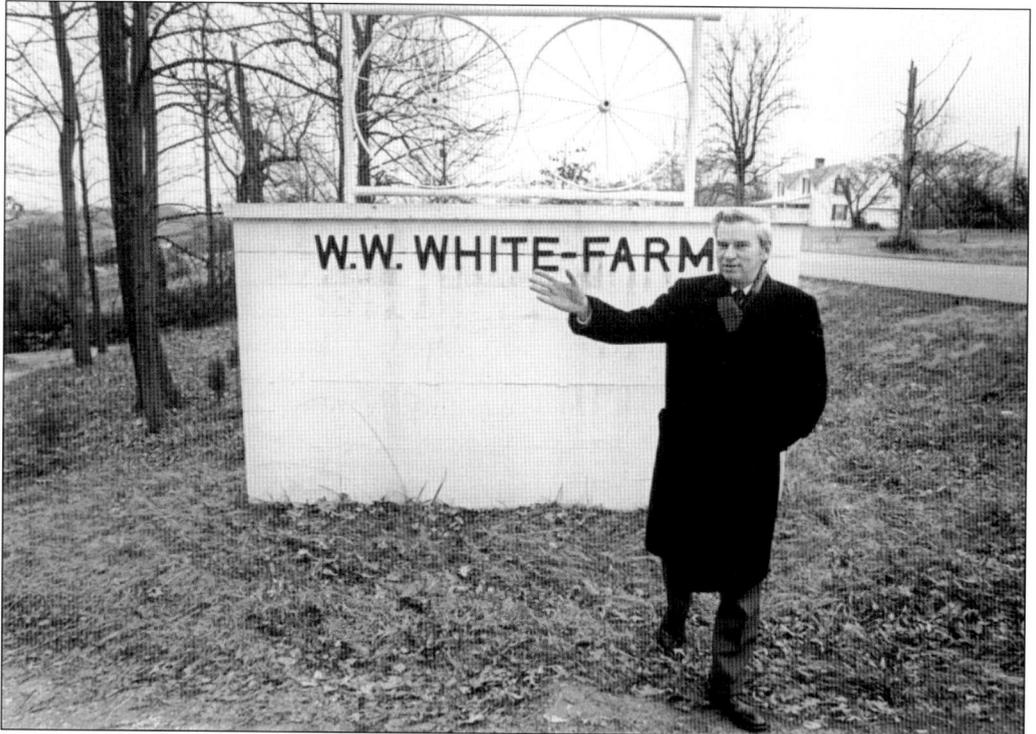

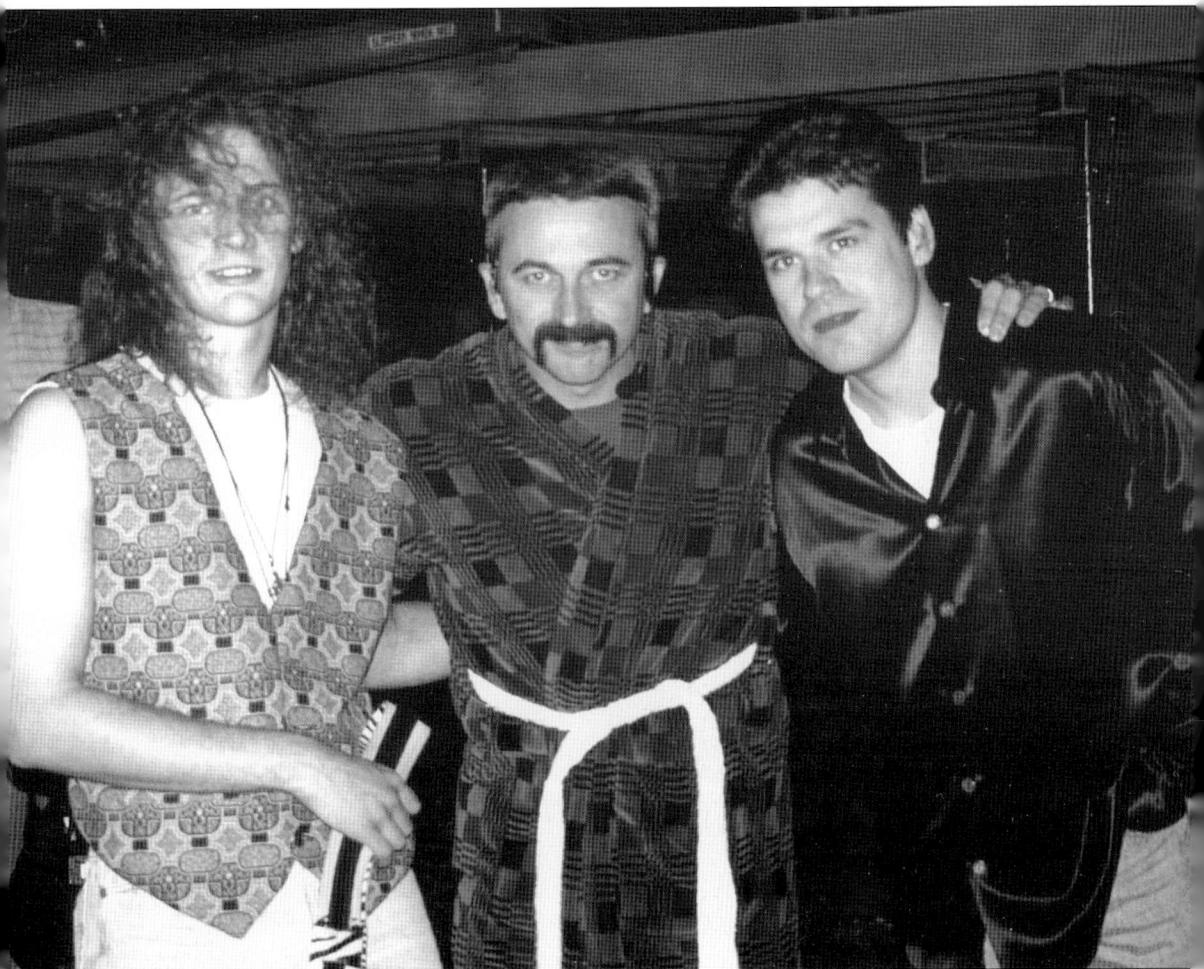

Aaron Tippin (center) worked the third shift as a mechanic in the hot mill during the mid-1980s while trying to break into the Nashville music scene. His drives between Russellville, where he stayed, and the Music City were opportunities for him to think up songs. After two years of working at Logan Aluminum, he took a full-time job as a songwriter. Then he got a record deal. His debut single, *You've Got to Stand for Something*, a tribute to the servicemen in the Persian Gulf War, earned him immediate success. Tippin came back to Russellville in 1998 for a concert at Rhea Stadium. At right is his keyboardist, Jared Decker, also a Russellville native, and Travis McIntosh (left) played with Decker in a 1980s high school rock band called Brydal Sweet.

Pictured on the far left, Tom Williams (with Steve Sansom, U.S. senator Wendell Ford, Steve Williamson, and Mike Posey from left to right in 1986) never found success as a musician. He was more of an actor and had modest success—such as appearing on a CBS miniseries called *Bluegrass*—but did sing in a barbershop quartet in high school.

Logan Countians staged a talent show called *Strictly Logan* in November 1986 at deGraffenried Auditorium (above). The Hello Guys (from left to right, Russell Burchett, Rev. Norman Witthuhn, Rev. Dan Sue, Rod Owens, Tim Menser, Roy Gill, Coach Ken Barrett, Don Firchow, Jimmy Parrish, Dr. Bill Webb, Buddy Linton, Jim Young, and Winky Sosh) sang a chorus. Prominent lawyer and civic leader J. Granville Clark (1919–1986, below at right) acted in a play version of the movie *Harvey* in 1970 with Jean Gill.

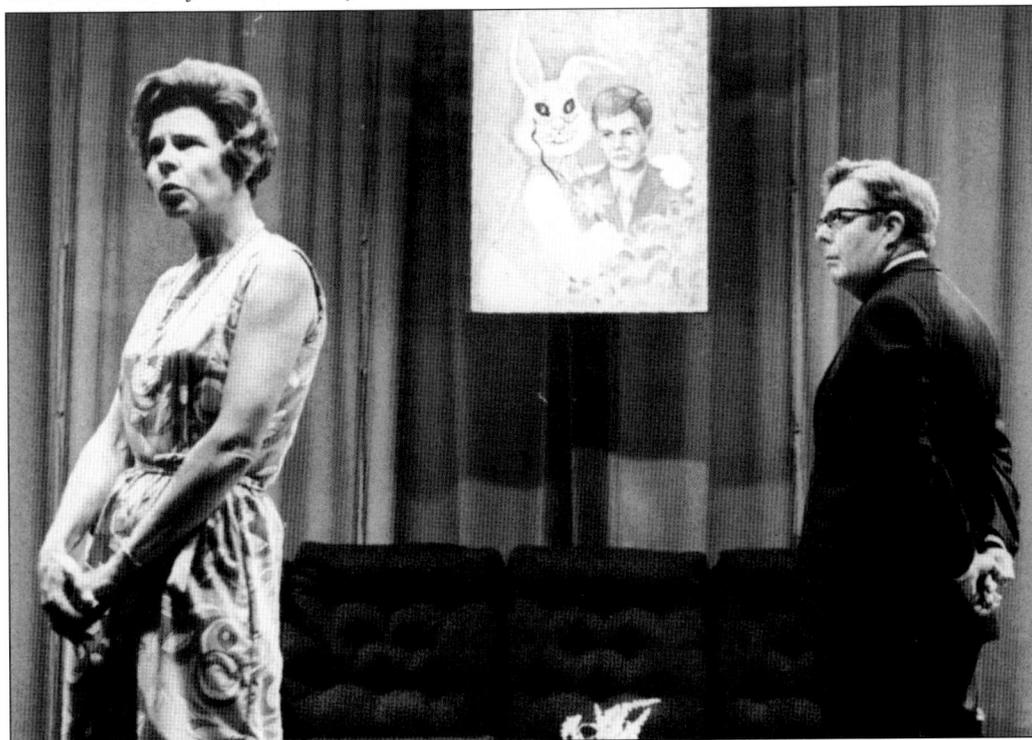

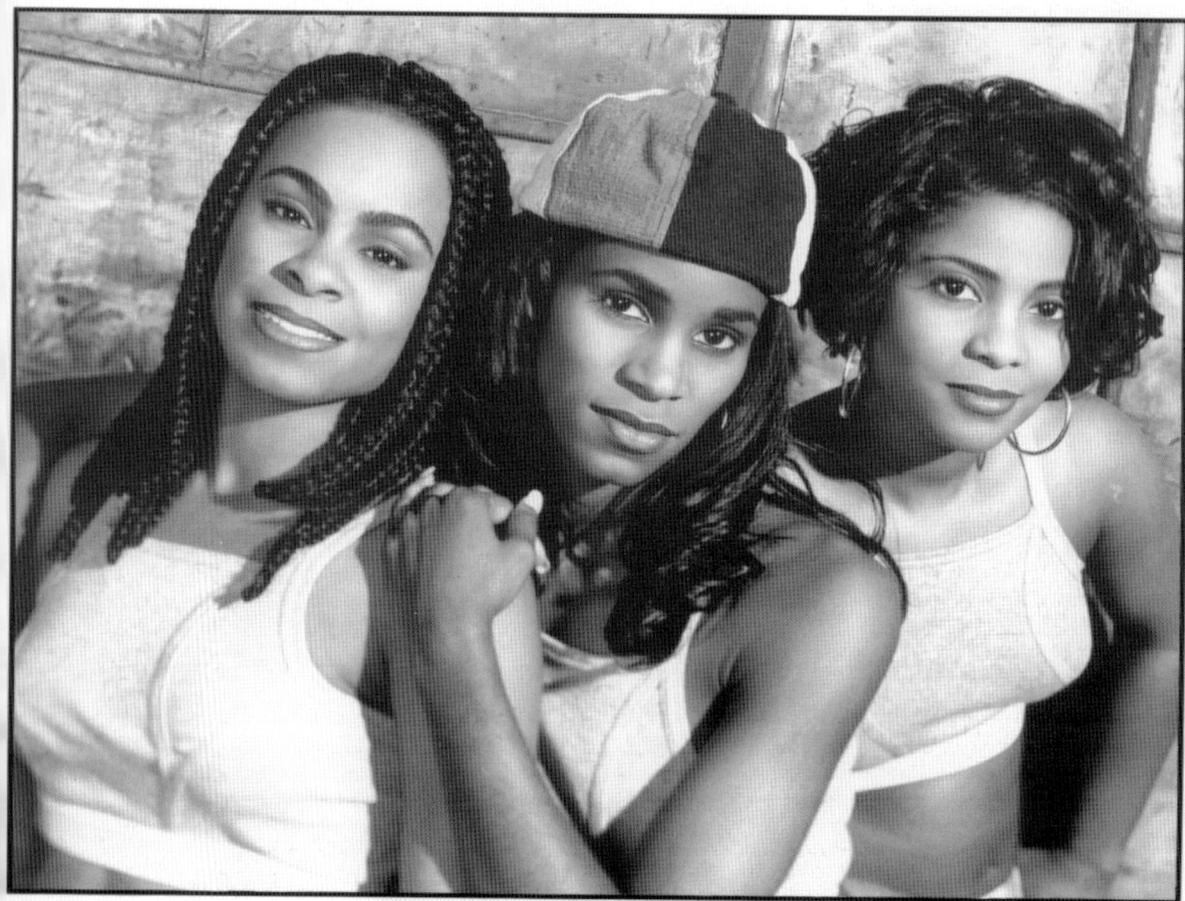

LAVON BATTLE TABITHA DUNCAN ATHENA CAGE

kut klose

KEIA
RECORDS

Elektra Entertainme

Athena Cage (right) sang in "Strictly Logan" before setting out into a musical career. She received her first break in the music business as part of the trio Kut Klose. Cage, born and raised in Russellville, sang "Nobody," a duet with Keith Sweat that reached the Top-40. When she went solo, her song, "All or Nothing" appeared on the sound track to the movie *Save the Last Dance*. Her music headquarters is in nearby Bowling Green, but she stays in contact with Russellville. She held a Christmas show with the deGraffenried Chorale. A street in Russellville is named Athena Cage Way.

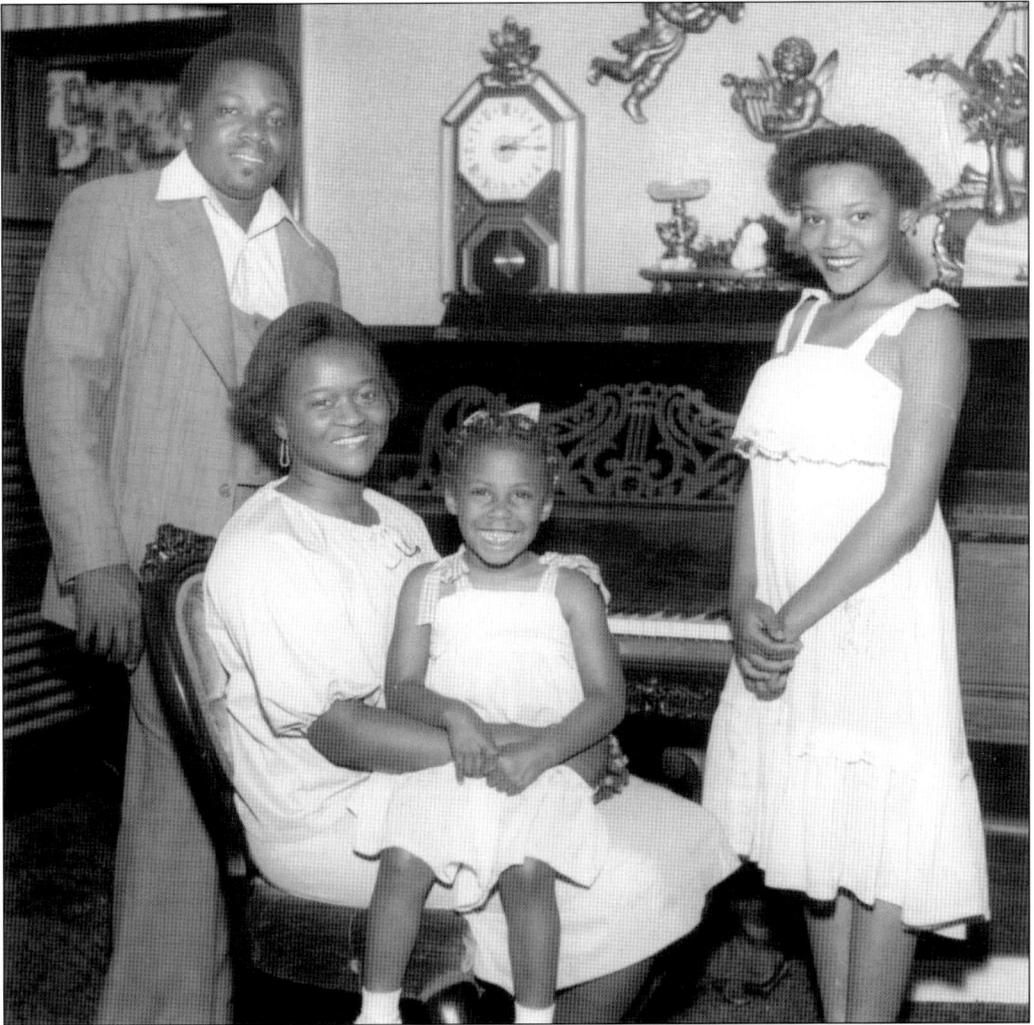

The Cross Family Singers earned acclaim for their gospel music, leading to a 1980 documentary, *Living the Life We Sing About*. Vickie Cross, seated with a child in her lap, was named citizen of the year in 1993 because of her involvement with community and foster parenting. She passed away in 1997. Also pictured are her husband, Willie Cross, and their children, Connie (seated in Vickie's lap) and Yolanda.

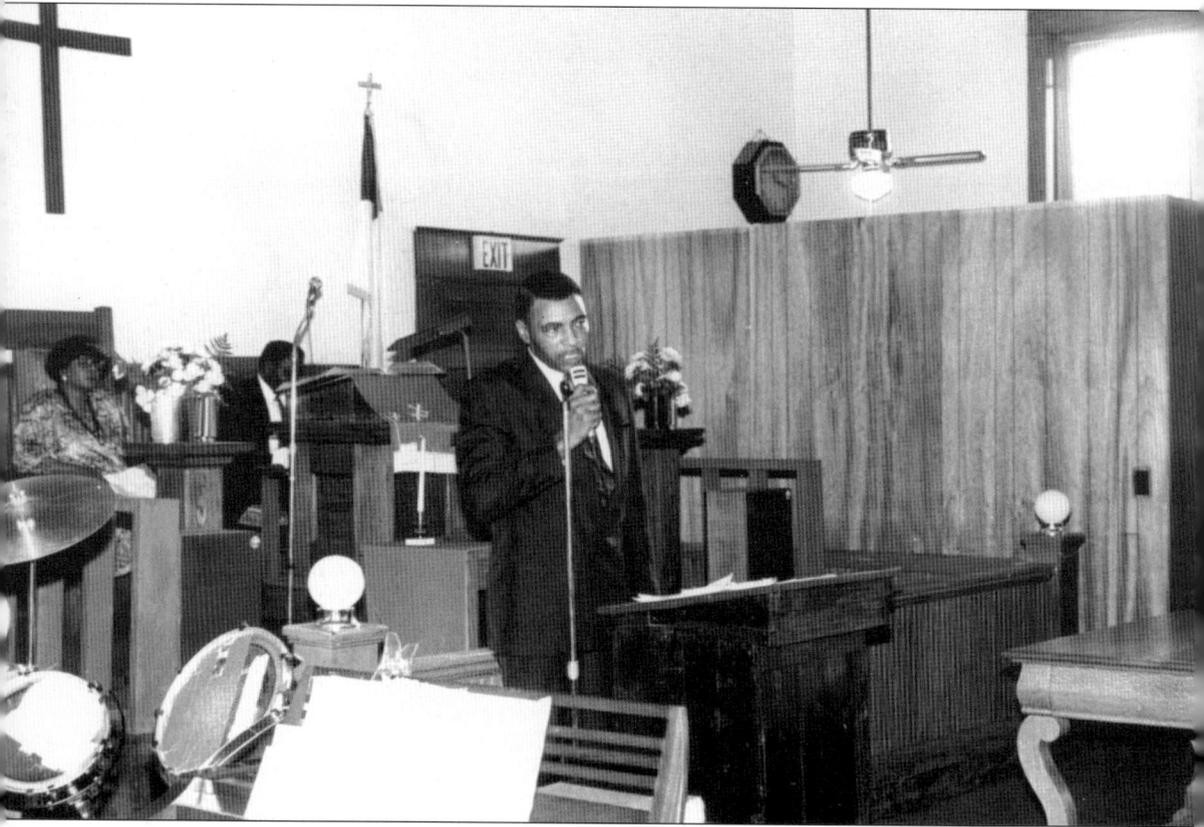

Charles Neblett sang with the Freedom Singers. The group traveled across the United States during the 1960s as part of the civil rights movement. Neblett was the first black magistrate elected in Logan, and his wife, Marvina, is involved in various civic projects. Both are active in improving the community.

Michael Gough is regarded as a blues legend in these parts. Born and raised in Russellville, he formed the Michael Gough Group in 1991. He is an active member of the Southern Kentucky Blues Society. "We never play a song the same way twice," he said for the *Amplifier*, a Bowling Green magazine. "How can we? We never have the same players. We never rehearse. You either speak the language or you don't." He played in Russellville for a New Year's celebration and the Flying Fish Festival. (Photograph by Mark Griffin.)

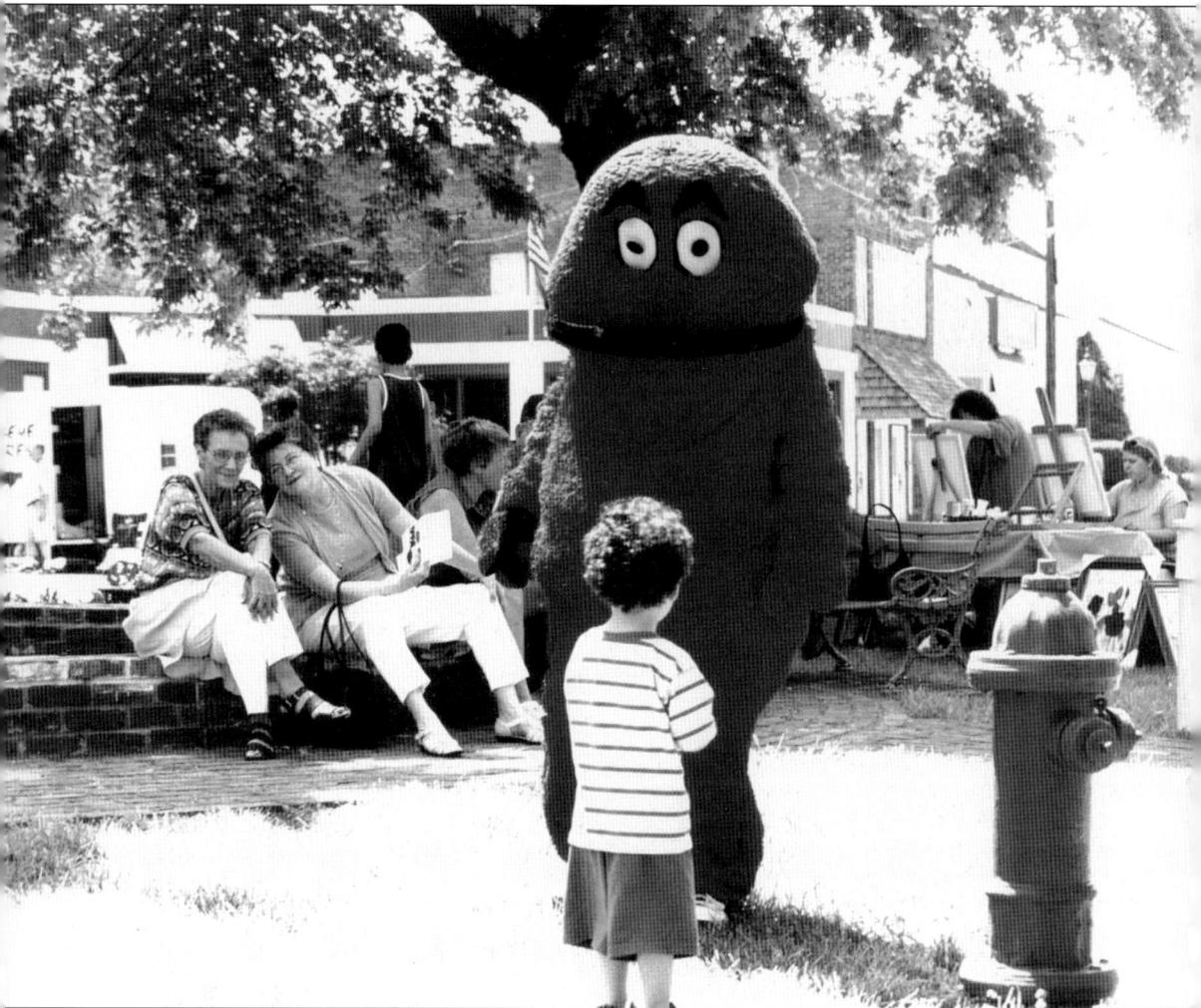

The Flying Fish Festival is the arts festival that promotes Logan artists. It is named after the fish weathervane shot by Frank James. The festival is held on the square and draws children and adults alike. One child (above) discovers Big Red, the mascot of Western Kentucky University. (Photograph by Mark Griffin.)

The Flying Fish Festival is a time when Logan Countians can enjoy themselves. Among those who come are Jayne Thomas (above)—an artist, writer, theater enthusiast, and deGraffenreid Chorale singer—and Krista Delany (right)—an artist and organic farmer whose portrait ran on bottles of Jones Soda.

Logan County is the home of several artists, living and dead: Frank and Alison Lyne (wood sculptures and paintings), Alla Gilbert (metal sculptures), Glenn Robertson (paintings), Keith Northern (metal sculptures), Sonny Green (paintings), Ellsworth Strickler (stained glass), Tim Rowh (paintings), King Simpson (urban art), Robbie McClean (her Christmas card is shown below), and Brenda Brown (above) who painted a mural near the old Village Cinema.

1942
Christmas Greetings

We're dreaming
of a white
Christmas
With trees and
gifts, according
to tradition,
But Santa's team
have gone to war,
and we'll just

Praise the Lord and pass the ammunition!

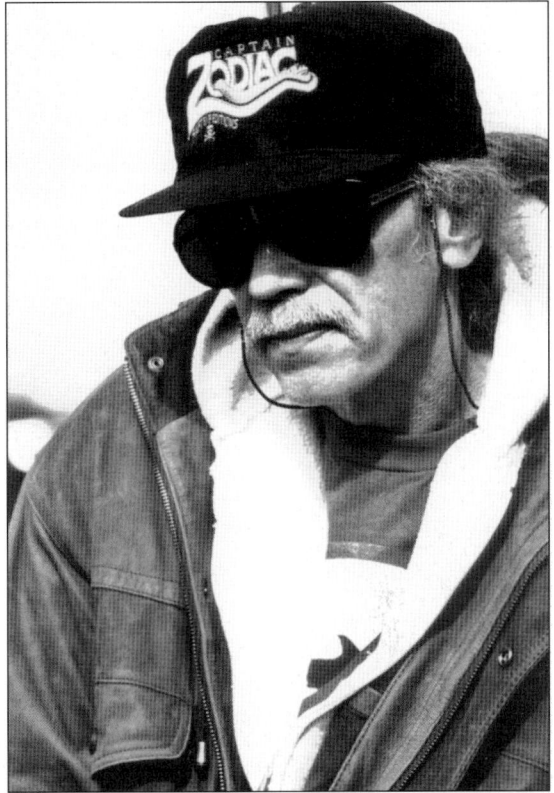

John Carpenter (at right), a horror movie director, came to the Village Cinema from Bowling Green to watch movies in his youth. He met Charlie Bowles (below), who owned the Village Cinema, and Carpenter made a reference to him in the movie *Halloween*.

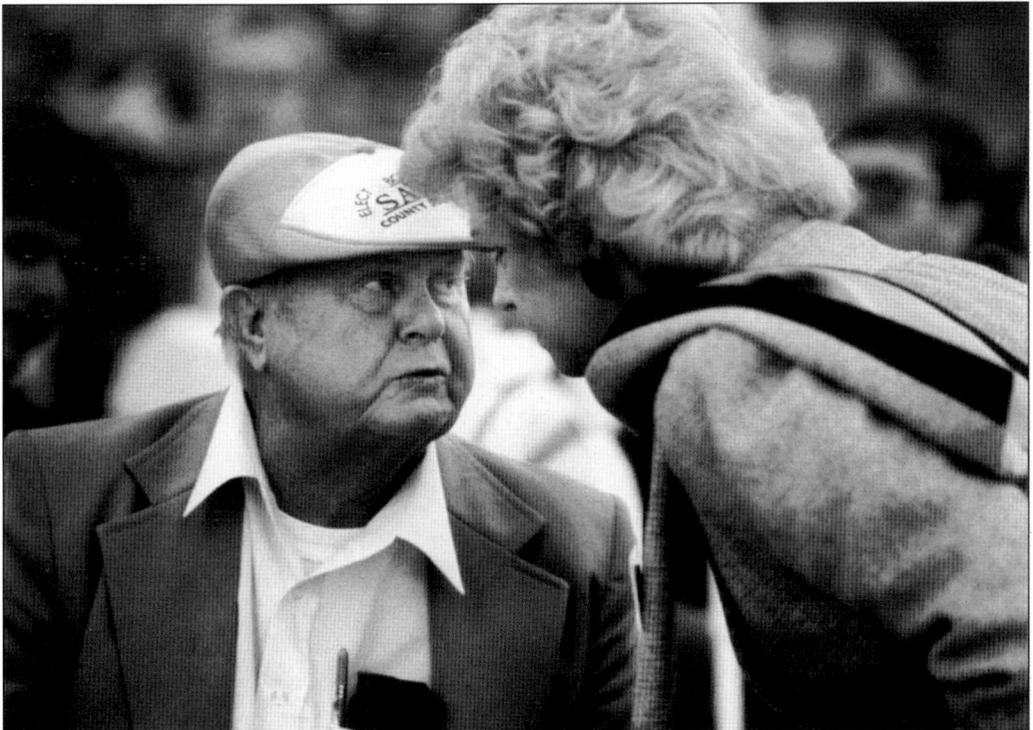

Albert P. Smith (above, with his aunt, Dollie) has been called a few names. John Ed Pearce of the *Courier-Journal* called him "the Darling and the Devil of Russellville, Kentucky." The founder of the *Logan Leader* newspaper and editor of the *News-Democrat*, Smith addressed the needs of the county and the state. He sold his interest to the newspaper in 1986 and later moved to Lexington, Kentucky, where he still hosts a Kentucky Educational Television program, *Comment on Kentucky*, where he interviewed the likes of Happy Chandler (below). His radio show, *A-OK Prime Line*, could be heard on the Russellville radio station, WRUS. (Bottom photograph by Robert Stuart.)

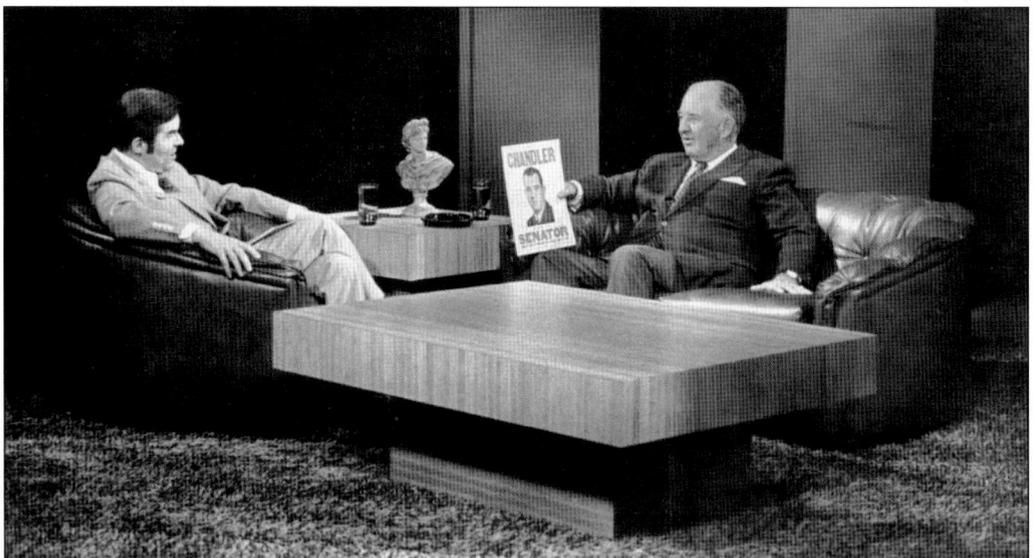

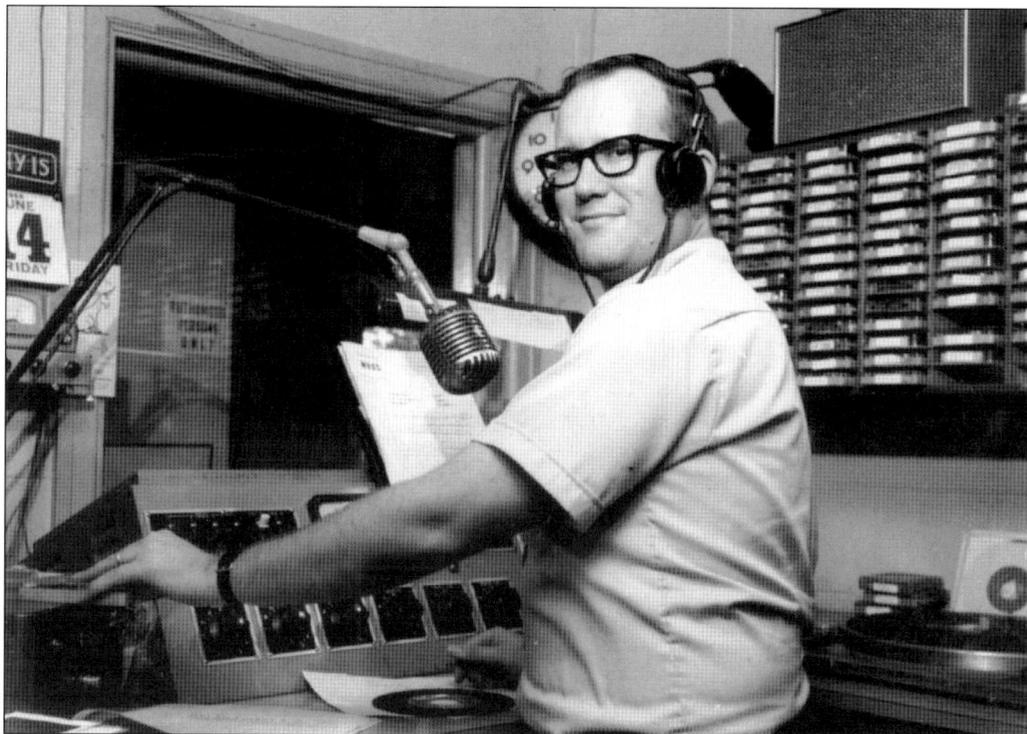

Don Neagle (above) came to Russellville the same year as Al Smith. "He [Smith] went on to become a media mogul and head of the Appalachian Regional Commission, and I get to do the Happy Birthday Club," Neagle said when interviewed for the October 2005 *Kentucky Living*. Neagle hosts the morning show on WRUS as well as *Feedback*, the local talk show. He was made grand marshal of the 1989 Tobacco Festival (pictured below with his wife, Vivian).

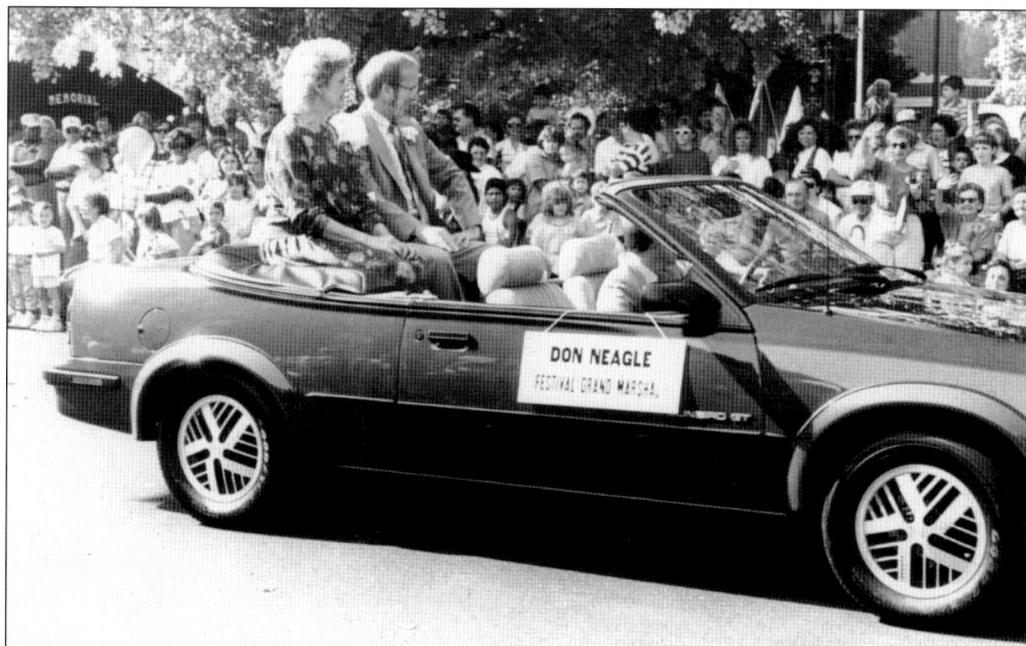

Feedback has covered many subjects, including the Sexton House, the local ghost story. A young woman was excited about a date with a young man and set out to wear her best dress. When a storm came, her mother told her she could not go out because her dress would ruin. Angry, the girl stormed upstairs to her room and cursed God by the window. Lightning struck her dead and her shadowy image remained. The window was replaced and eventually boarded up. To this day, her image can be seen. If you look hard enough, you may be able to see her.

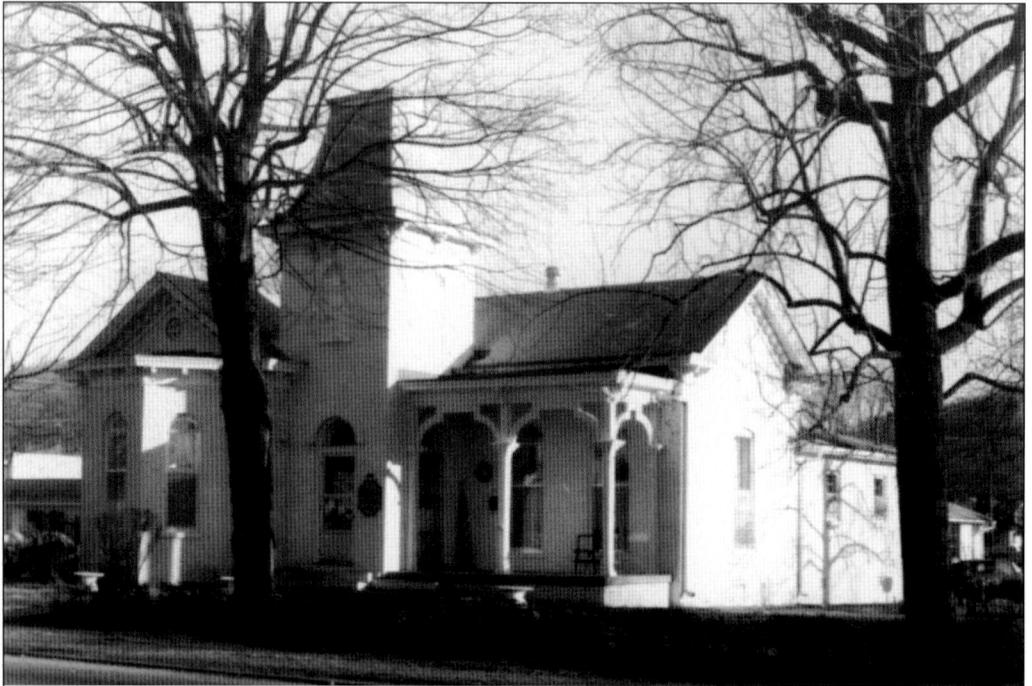

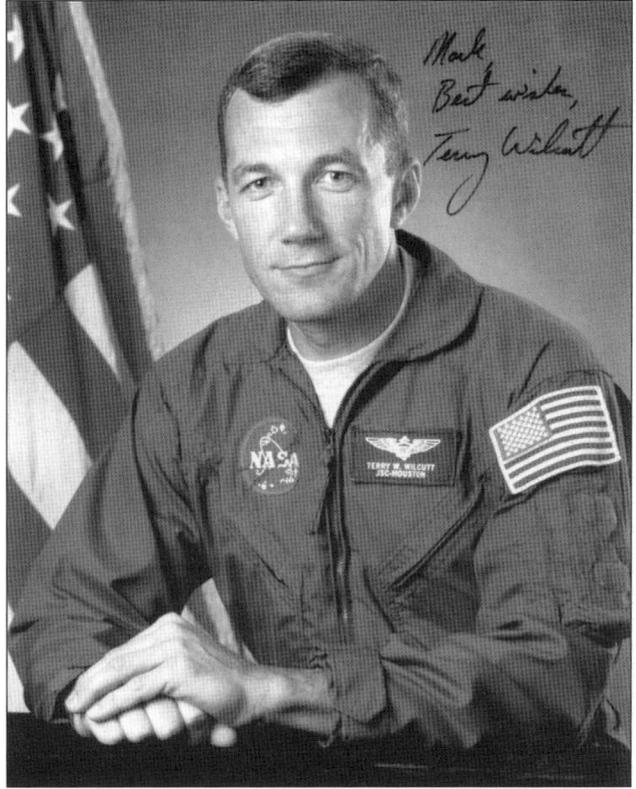

Where Alex Finley failed, Col. Terrence "Terry" W. Wilcutt succeeded. The native of the Spa community has been to outer space. Selected by NASA for the space program, Wilcutt piloted the space shuttles *Endeavor* and *Atlantis*, rendezvousing with the Russian space station MIR and the International Space Station. His last mission was in September 2000. "I would have never gone into space had it not been for someone in the past who one day wondered if space travel was possible—that person dreamed the dream and I was very fortunate to be able to fulfill his dream from long ago. That's an incredible process when you think about it. It applies to everything we do," he said for www.erbzine.com.

BIBLIOGRAPHY

Coffman, Edward and Edward Coffman Jr. *Through My Father's Eyes: The Story of Logan County*. Russellville, KY: Coffman Book Company, 2004.

Finley, Alex. *The History of Russellville and Logan County, KY*. Russellville, KY: O. C. Rhea, 1878.

Griffin, Mark. "John Carpenter: The Horror That Came From Bowling Green." *Amplifier*. October 1998.

Griffin, Mark. *Short Stories of Logan County*. Unpublished manuscript.

Griffin, Mark. *Stand There and Tremble: When the Night Riders Came To Russellville*. Unpublished manuscript.

Kleber, John E., ed. *The Kentucky Encyclopedia*. Lexington, KY: University Press of Kentucky, 1992.

Lewisburg/North Logan County Historical Commission, Inc. *History of Lewisburg and North Logan County, Kentucky*. Charlotte, NC: Herff Jones, printer, 1999.

Martin, Bess and Mark Griffin. *Arts in Logan County Scrapbook*. Unpublished manuscript, available at Logan County Public Library.

Stratton, Margaret Barnes. *Place-names of Logan County and Oft-told Tales*. Russellville, KY: News-Democrat, 1950.

Turner, Marie. *Churches of Christ, Logan County*. Printer's Plus, 1986.

INDEX

The Logan County Public Library was once housed at the Breathitt House and at the bank Jesse James robbed. It moved to its current location in 1967 thanks to the deGraffenried funding. Children come to the library for the activities.

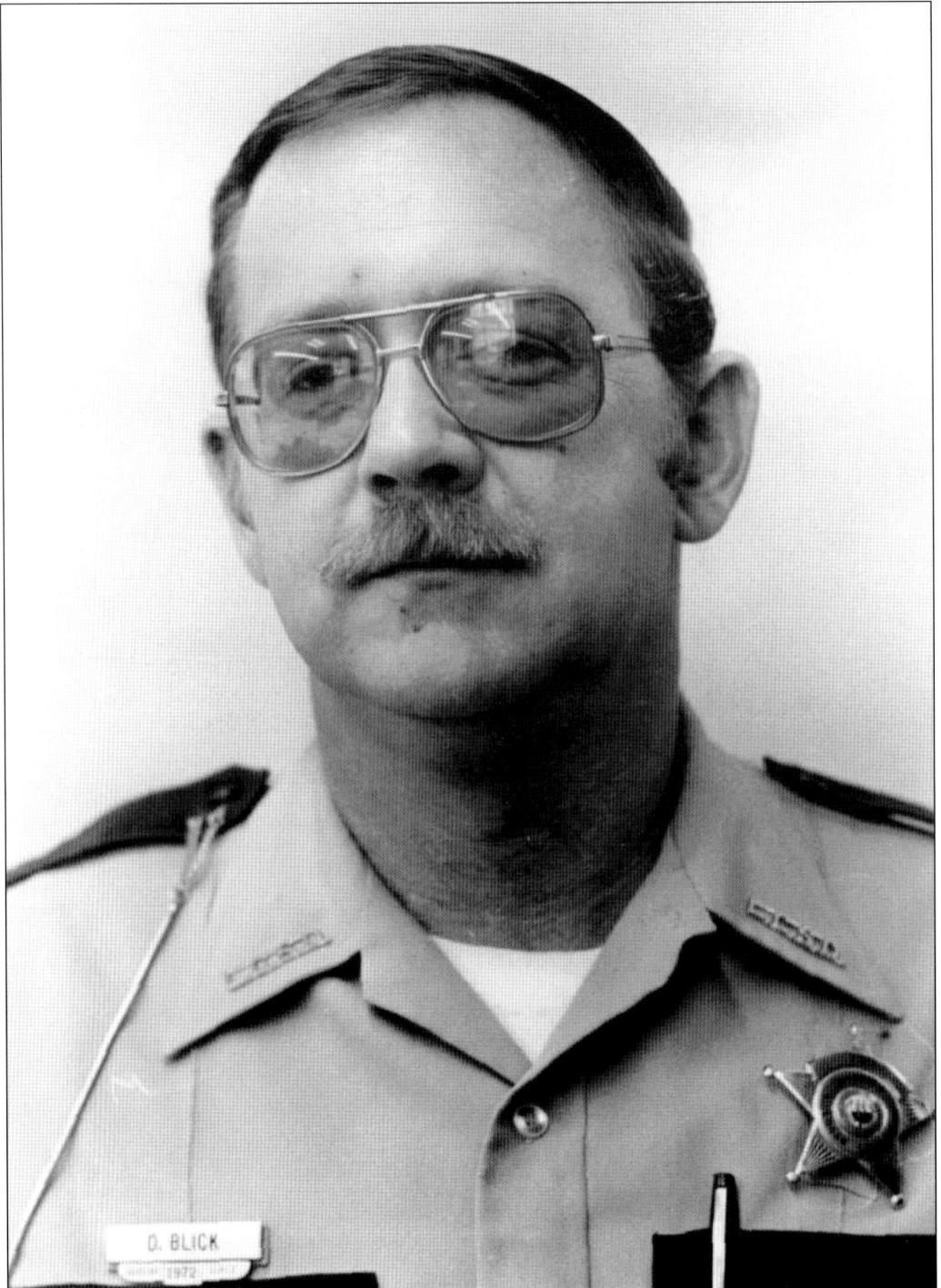

When Dannie Blick, retired sheriff, died suddenly in 2006 during his race for judge-executive, the whole community was shocked. With his level headedness and professionalism, he was seen as someone who would be progressive for Logan. He will be missed.

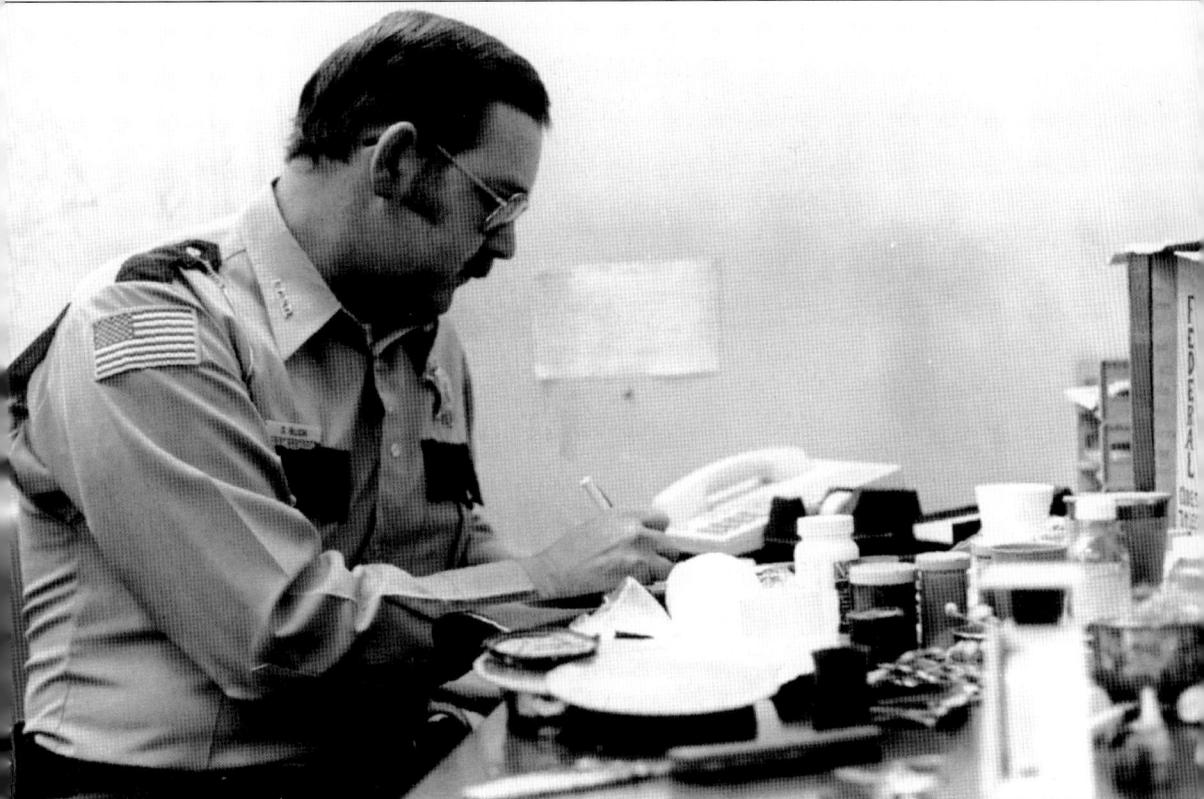

"I don't know what I'll do in the future," Blick said upon retiring as sheriff in 2002, "but whatever it is, I'll do it in Logan County."

ACROSS AMERICA, PEOPLE ARE DISCOVERING SOMETHING WONDERFUL. *THEIR HERITAGE.*

Arcadia Publishing is the leading local history publisher in the United States. With more than 3,000 titles in print and hundreds of new titles released every year, Arcadia has extensive specialized experience chronicling the history of communities and celebrating America's hidden stories, bringing to life the people, places, and events from the past. To discover the history of other communities across the nation, please visit:

www.arcadiapublishing.com

Customized search tools allow you to find regional history books about the town where you grew up, the cities where your friends and family live, the town where your parents met, or even that retirement spot you've been dreaming about.

MAP SEARCH